FIREFLY

ASTROPHOTOGRAPHY
THE ESSENTIAL GUIDE TO PHOTOGRAPHING THE NIGHT SKY

FIREFLY

ASTROPHOTOGRAPHY

THE ESSENTIAL GUIDE TO PHOTOGRAPHING THE NIGHT SKY

MARK THOMPSON

Firefly Books

A FIREFLY BOOK

Published by Firefly Books Ltd. 2015

Copyright © 2014 Vubock Limited
(Vubock Limited is a company of Mark Thompson)

All rights reserved. No part of this publication may be reproduced, stored in a retrieval system, or transmitted in any form or by any means, electronic, mechanical, photocopying, recording or otherwise, without the prior written permission of the Publisher.

First printing

Publisher Cataloging-in-Publication Data (U.S.)

Thompson, Mark.
 Astrophotography : the essential guide to photographing the night sky / Mark Thompson.
[160] pages : color photographs ; cm.
Includes index.
Summary: "A guidebook to photographing the night sky, including necessary equipment, and other helpful details such as location and timing" — Provided by publisher.
ISBN-13: 978-1-77085-575-5 (pbk.)
1. Astronomical photography. 2. Astronomical photography — Equipment and supplies. I. Title
522.63 dc23 QB121.5T566 2015

Library and Archives Canada Cataloguing in Publication

Thompson, Mark (Astronomer), author
 Astrophotography : the essential guide to photographing the night sky / Mark Thompson.
Includes index.
ISBN 978-1-77085-575-5 (paperback)
 1. Astronomical photography. I. Title.
QB121.T55 2015 522'.63 C2015-903763-8

Published in the United States by
Firefly Books (U.S.) Inc.
P.O. Box 1338, Ellicott Station
Buffalo, New York 14205

Published in Canada by
Firefly Books Ltd.
50 Staples Avenue, Unit 1
Richmond Hill, Ontario L4B 0A7

Printed in China

ACKNOWLEDGEMENTS
Alamy /B. A. E. Inc. 53, /Blend Images 38b, /Rolf Nussbaumer Photography 65, /Simon Stirrup 66, /Stocktrek Images, Inc. 48; **Celestron International** (www.celestron.com) 19; **Galaxy Picture Library** /Jamie Cooper 154, /Ed Grafton 87b, /Nick Hart 107cl, /Damian Peach 87t, /Steve Porter 3 (background), /Robin Scagell 10; **NASA/JPL-Caltech** 5, 6t, 12t, 38t, 68t, 88, 124t, 144t, 156t, 158; **Mia Stålnacke** 56; **Telescope House** (www.telescopehouse.com) 18b, 21. Photograph of Mark Thompson (© Philip's) taken by Darren Bell (www.darren-bell.co.uk): 3. Illustrations by Jonathan Bell (© Philip's): 18t, 20t, 22, 115, 139. All other photographs by Mark Thompson.

Conceived, designed, and produced by Philip's, a division of Octopus Publishing Group Limited, Carmelite House, 50 Victoria Embankment, London EC4Y 0DZ

CONTENTS

	Introduction	6
chapter 1	Choosing the right equipment	12
	CCD cameras	26
chapter 2	Getting images without a telescope	38
chapter 3	Solar System photography	68
	Mark's photographic Solar System tour	85
chapter 4	Deep-sky images	88
	Mark's top ten deep-sky targets	105
chapter 5	Astronomical image processing	124
chapter 6	A typical imaging run	144
appendix	Common autoguiding problems	156
	Index	158

INTRODUCTION

REGARDLESS OF THE THOUSANDS of years of evolution, our eyes are still not the most efficient detectors of light. They are quite adaptable though, and able to see even with quite significant changes in light level from a bright summer's day to a dark winter's night. I never cease to be amazed at how well I can see on one of those summer days, yet plunge my eyes into almost complete darkness and – given time for my eyes to adjust – I can still see! Try this out for yourself, but it will take nearly an hour for your eyes to adjust to the low light levels. However, there is a notable drawback to our eyes, and it is one that particularly affects the astronomer – notice how you can clearly detect colors in brightly lit conditions but in the dark it is very difficult to determine the color of objects around you. It turns out that the human eye is pretty rubbish at picking out color during low light conditions, so when you try and look through a telescope at a faint object, for example, you will not see it in glorious technicolor.

We can blame evolution for this because we are creatures who have developed for survival, and when in the dark it is less important to see the colors of objects around us but rather more important just to see them. To be able to spot a predator in the dark of night was much more use to us than to see the color of berries, for example. It is easy to understand why this works if we study the anatomy of the eye. During the day, when there is plenty of light, the receptors called "cones" are mostly used – these are great at picking up color but not so great at determining delicate shading. However, drop the light levels and receptors called "rods" kick in. The rods are brilliant at picking out faint detail or movement out of the corner of your eye but frankly terrible at picking out color. This is where astrophotography comes in – a camera is far

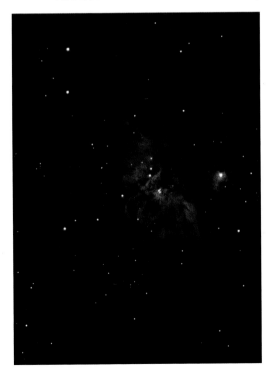

◀ *The human view of space is quite limited because we cannot easily detect the faint colors present. This is a simulated human view through a telescope of the Orion Nebula.*

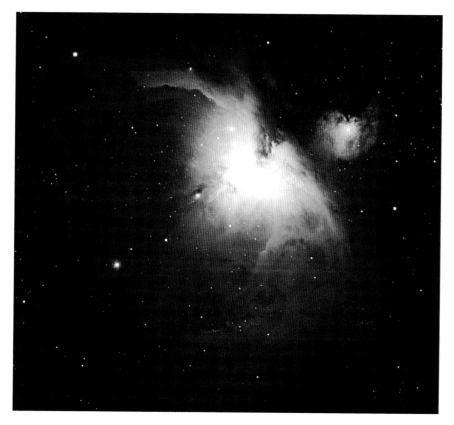

▲ *The full beauty of space is revealed when cameras are turned on the sky. This is how the Orion Nebula is captured by a digital camera attached to a telescope.*

better at recording faint detail and color, giving us the wonderful views of the Universe that we are all so used to seeing in books.

Some people who are new to astronomy can quickly get tired of looking at gray smudges of light when hunting down elusive gas clouds or distant galaxies, or waiting for perfect moments of stability in the atmosphere to see fine planetary detail. With the ease of access to many stunning images online from both professional observatories and amateur astronomers, it is natural for people to want to try and capture their own views of the Universe. At first sight it seems as simple as plugging a camera into a telescope or just using longer exposures to get fainter detail, but unfortunately the reality is that it is a little more tricky than that. Today's amateur and professional astronomers use digital cameras for this task, similar to modern digital SLR cameras, known as CCD (charge-coupled device) cameras – sounds complicated but they are just digital SLRs without many of the bells and whistles, though with a few other bits thrown in specially for the astronomer. Their appearance in the amateur world has revolutionized astronomical imaging since the dark and dizzy days of film photography.

The first time that anything resembling modern photographic film was used was in the first half of the 19th century, in a process developed by Louis Daguerre. Instead of the flexible film we are all used to seeing, Daguerre used a thin plate of polished silver which was on a copper base. In order for it to record an image, it had to somehow be sensitive to light which was achieved by placing it silver side down on top of a container with a little iodine in it. The vapor produced by the iodine created a thin yellow deposit of silver iodide on the plate. The plate was then exposed to light in the normal way and developed by placing it in magnesium vapor, which would stick to the parts of the plate that were exposed to light. Finally, the plate was immersed in a bath of sodium thiosulfate to remove the remaining silver iodide. This process sounds pretty laborious but is not too dissimilar to modern-day film development techniques.

The major drawback of these silver plates, which were known as "daguerreotypes," was their very poor sensitivity to light. One of the first astronomical daguerreotypes was taken in 1840 of the Moon – for a modern-day astrophotographer, lunar images are often recorded in a fraction of a second, but for American J. W. Draper it took 20 minutes to capture! For pictures of stars or anything fainter, then exposures would run into many hours and this brought with it a whole host of other difficulties. It seemed that daguerreotypes were clearly not suited to astronomical uses so alternative techniques had to be found.

An improved processing technique was published in 1851, known as the "wet collodion" process. This new process resulted in more sensitive plates but the plates had to be used straight after they were made, unlike the earlier daguerreotypes which could be stored. The first step in getting the plates ready involved reacting sulfuric acid with potassium nitrate on a piece of cotton to create a substance known as guncotton. This was then dissolved in alcohol mixed with ether, iodides and bromides. The resultant chemical was spread on to glass plates and left to evaporate, leaving a film containing the iodides and bromides on the glass. Once the glass was dry, the plates were dipped into a tub of silver nitrate that contained silver iodide. This step in the process converted the iodide and bromides on the plate into tiny crystals of silver which were sensitive to light, much more sensitive than previous plate preparation techniques, but they had to be used immediately. After the plate was exposed, additional development steps were taken to bring out the image before a coat of varnish was applied to protect it.

For photography to become a really useful tool for astronomers, more work was needed to produce a plate that was both sensitive and dry – and, in many ways, it was astronomy that pushed forward the

◀ *Before the digital camera was invented, astrophotography was a much more labor intensive and frustrating task using film to record objects in the night sky.*

▶ *Modern CCD cameras allow much more flexibility than their film predecessors. This image of the Pelican Nebula is composed from light collected through narrowband filters.*

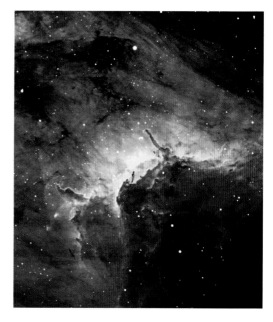

development of several techniques and technologies that have been key to modern film photography. Finally, in 1874, the precursor of the modern photographic negative film was invented that not only was sensitive to light but was also dry and physically flexible due to the use of gelatin as the medium rather than plates of glass or silver. However, these newly developed photographic films still suffered one pretty fundamental drawback for astronomical purposes: doubling an exposure time of just a second or two meant the film would capture and record twice the amount of light. This did not work for longer exposures because the film would lose sensitivity, an effect known as "reciprocity failure," and it is an effect that was just as common in modern photographic films when I used them as it was back in the late 1800s. However, in 1874, a new process was developed known as "hypersensitization" which reduced the effects of reciprocity failure, making film much more suited to the longer exposures demanded by astronomical photography. One of the first techniques to be used involved soaking the film in gas, usually hydrogen or nitrogen, and often subjecting it to higher temperatures at the same time. After leaving the film in this condition for a few hours, it was removed and used as normal but with the added advantage that it was now less susceptible to reciprocity failure.

Not only was reciprocity failure a problem but photographic films also suffered from "graininess," with faster films giving a grainier image. For normal daytime use this was not a big issue but it certainly degraded the quality of an image full of stars! A new processing technique was developed in the middle of the 20th century when it was recognized that the graininess was random and different in each image. By taking a number of different images of the same object, the only common data would be that from the object – the grains would be different in every image. The negatives would then all be stacked in the darkroom when being printed to remove the grains. We now use a very similar process in digital imaging to remove the effects of noise in the digital chip.

I started taking pictures of the night sky when film was the only way to capture astronomical pictures, and while aspects of getting an electronic picture are challenging now, it used to be a whole different ball game back then. Let me paint the picture for you. The film used for astronomical photographs was the same stuff as you would normally get from the high street, and while it was more sensitive than the eye, it was still not that great.

Film is still available and you will notice that it comes in a variety of different speeds. Slower films with a lower number are better when there is a lot of light, but faster films with a higher number are great for darker pictures (such as astronomical objects). However, they have a much larger "grain" in the resultant image, which means instead of a nice smooth background it becomes speckled. This sounds perhaps OK in principle, but with a star field you ideally need a small grain size so as not to detract from the image. This was the first challenge and compromise: on the one hand, fast films were perfect, but on the other hand the grain size made them far from perfect. It was possible to increase the sensitivity of a slower film through the process of gas hypersensitization that we looked at earlier. The modern equivalent was quite fiddly and involved "cooking" the film in a pressurized gas-filled container before it was used. Exposure times with film were still quite long even with hypersensitized film, of the order of tens of minutes, occasionally running into an hour or more. Then, to secure the picture of that faint galaxy meant attaching camera to telescope and starting the exposure.

Now for the real challenge: as the Earth rotates on its axis and is therefore spinning during the exposure, so objects move slowly across the sky and thus across the film of the camera, causing the image to streak. Taking an exposure of a few seconds or more means the telescope has to track objects across the sky, which is achieved with motors attached to the axes of the telescope mount. The motors are mechanical though, so are subject to inaccuracies which can temporarily cause the mount to move too fast or too slow. This can be corrected through a process called "guiding," where the speed

▲ *Tracking systems that attach to a camera tripod allow you to freeze the motion of the stars, although as you can see in this picture the foreground trees are blurred as a result.*

> **Film versus digital … which is better?**
> This is a question I am asked surprisingly often! Those die-hard purists will argue that film, attached to a top-quality optical system, will be able to produce a higher resolution than the best digital camera available on the high street. It is hard to disagree with a statement like that as a piece of film against a CCD chip will win hands down; however, digital offers a whole lot more. The digital revolution means cameras can now guide themselves and significantly reduce the astronomer's workload, they can be cooled to reduce the noise, and then there is the whole world of processing which can turn a mediocre image into a work of art. Taken as a package, digital is most definitely the way forward.

of the motors is adjusted to compensate. In the days of film, guiding involved looking through the telescope or an attached guiding telescope and manually making adjustments through the course of the exposure. If you made an error such as correcting the drive in the wrong direction, as I did on many occasions, even right at the end of the exposure, it could be ruined. Believe me, on a one-hour exposure it tests anyone's metal! Fortunately, this can now all be done electronically, leaving the astronomer free to enjoy a cup of tea or get on with other tasks while the picture is slowly building up.

Getting the focus right was also a bit of a fine art, because it was often difficult to see the object you were wishing to photograph. The trick was to get the system focused up on a bright star nearby, but it was not unusual for the mirror in the telescope to move slightly as you slewed it to the target object, causing it to go out of focus again. With this and guiding to trip you up, it was always a bit of a lottery and I recall many occasions getting my pictures back to find fuzzy stars because the focusing was a little off or streaky squiggles for stars because my guiding went awry. It was also not unusual for an entire film to come back from the developers having been cut up into tiny strips, even right across the center of one of your finely focused and guided shots. So there was another trick: take a normal daytime picture of your cat or something so the developers knew where to start chopping your film up! I do recall one beautiful shot of the Whirlpool Galaxy which was cut right down the middle – *arghhh!* I would often get notes from the developers saying, "Nothing on this film," so they did not print anything! My mantra was the same, having learned from all of this: "Do NOT cut the negative up" and "Please print everything, whatever you think of it." That did usually work, but it was not unusual to get 24 pictures back that were complete and utter rubbish, and which ended up in the bin! It is fair to say that taking astronomical pictures with film was fraught with frustrations. Not so much now with the digital age, but there are still plenty of pitfalls in the road ahead. But if you are tempted to throw away your camera in despair before you have even started, there is some great news. With this book and with me as your guide, I will take you through everything you need to know and how to do it so you can learn from my mistakes. And believe me, there have been plenty! Together we will look at how to capture astronomical images using the humble mobile phone all the way through to the high-end specialist cameras, all brought to life with my own experiences and many of my own astronomical images.

chapter 1
CHOOSING THE RIGHT EQUIPMENT

IF YOU ARE A KEEN photographer who is used to taking pictures in the light of the day, then you may be surprised to learn that getting good astronomical images is a totally different set of skills. Or you may be a complete newcomer, wielding a camera for the first time, and have turned it skyward to snap your first night-time picture and have probably been very disappointed with the result. I think nearly everyone goes through that experience – take a camera, point it at the sky and get a good slap around the face by the reality that it is not as easy as it looks. I recall trying to get a picture of a stunning Moon rising in the east many years ago with my old film camera. Due to the so-called "Ponzo illusion," it looks a lot bigger in the sky when low down near the horizon than it really is and our subjective brains think it looks amazing. It turns out that it is just an illusion and any picture you try and take will be woefully disappointing. Getting great shots of the Moon is difficult because of the actual size of the Moon in the sky which can only be improved by increasing the focal length of the lens that you are using, since long-focal-length lenses make a bigger image than shorter-focal-length lenses. To get a decent shot of the Moon requires a focal length of at least 500 mm and good-quality lenses like these are not too common, and those that are around are pretty expensive. As my experience shows, having the right equipment is crucial for getting great astronomical images.

Astronomical pictures fall into two categories: those taken through a telescope and those taken without a telescope. The latter are by far the easier to do, since the higher magnifications of a telescope need greater levels of accuracy when it comes to tracking objects across the sky and focusing them. So it is in this area that the beginner should start – with a good DSLR camera and a sturdy tripod you will be getting amazing images before you know it, and then it will be time to look at the more advanced techniques using telescopes.

Before we can look at how to get those beautiful pictures of the night sky and the equipment you will need, it is appropriate to look first at the real powerhouse behind most digital cameras, the CCD chip. The CCD, or "charge-coupled device," has one simple function: to convert incoming light into an electrical signal. The chip itself is usually a square sensor upon which are millions of

◄ *A close-up of a CCD chip. These electronic components are light sensitive and are at the very heart of the digital camera, be it an astronomy-specific CCD camera or a DSLR.*

> **CMOS chips**
> There is another type of chip that offers an alternative but very similar solution to the CCD, which is called the CMOS (complementary metal-oxide semiconductor) chip. These work in much the same way as the CCD but with a slightly different approach to reading the information off the chip. Both have their pros and cons, but, for our purposes, the CCD is a much better choice because it tends to suffer from less electronic noise or interference in the image and is more sensitive to light. CCDs have been around for a much longer period of time too and have been mass-produced, leading to a much lower cost so making them attractive to the amateur budget.

tiny little receivers, all of which will respond to light. A great analogy is to think of a solar cell that sits on top of a house collecting light and turning it into electricity. If you imagine the CCD chip covered in millions of tiny solar cells, all collecting different amounts of light and all generating a slightly different electrical signal based on the amount of light they receive, then together these cells are used to create an electrical representation of the final image. Each one of these tiny receivers is known as a "pixel" – once an exposure is complete, the value of each pixel is read from the chip. In a very fast process, the value is read from one of the corner pixels so it can then effectively forget its value before the value of one of the neighboring pixels is transferred to it, before it is then also read. The process repeats until all of the values in the pixels have been read off. This all happens without your intervention, of course, and the next step (which fortunately we are equally oblivious to) is to convert the analog value of each pixel into digital. The digital signal is then sent out to a computer where the image is displayed and manipulated.

Choosing a DSLR camera

A CCD chip is found inside nearly all DSLR cameras and at first glance the multitude of different brands might seem perfectly suitable for astrophotography. Just think of all the makes of camera – I can come up with about 20 without really trying – but there are two brands that stand out from the rest: Canon and Nikon. It may well be that there are other manufacturers with models

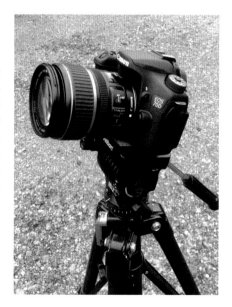

▶ *DSLR cameras are great for capturing the night sky and are a really good way to get started in astrophotography.*

▲ *Use of composition and exposure settings with a DSLR on a tripod can produce some beautiful night-time shots.*

equally suited to astronomical imaging, but the majority of amateurs use either of these brands. Canon was the first manufacturer to produce a DSLR camera with a CCD chip inside which generated a particularly low level of noise. They even recognized the need in the market for a product suitable for astronomy and thus launched the Canon 20Da, although this model has now been superseded by the Canon 60Da.

Nikon cameras are becoming more popular, though many models generally have a few drawbacks. Their cameras have a filter known as a "blur filter" integrated in the camera, which is there for normal daytime photography to remove lines that appear when certain patterns are in the image. These blur filters can be removed but it can be an expensive job. However, leaving them in place means that fainter stars can be missing from images. The other drawback, which is unrelated to the blur filter, is that it is not possible to use a computer to control the length of the "bulb" exposure setting on Nikon cameras. This setting is really useful when taking long-exposure photographs, and while this is not a big issue, it can be quite an inconvenience. Neither of these are major problems but they mean that Nikon cameras are just a little less suitable for astronomical imaging. Another niggle with many Nikon models is that there is no ability to use a wired remote control. They employ infrared technology instead, which generally has pretty simple functions. Canon models, on the other hand, have the ability to accept a wired remote which has many more functions, such as the ability to take multiple exposures with a defined pause between them, great for getting multiple images which can then be stacked with special software.

If you are looking to get your first DSLR, and plan to use it solely for astronomy, then I would recommend the Canon range as nearly all of the models on the market are excellent for our needs, with a low level of noise and no blurring filters. "Live view" is another great

feature that many DSLRs have, which allows you to see on the LCD panel at the back of the camera just what the camera can see. This makes focusing the image, whether using it through a telescope or not, significantly easier.

One common factor among nearly all DSLR cameras, regardless of their make, is the infrared filter which cuts out infrared radiation. This is ideal for daytime use as it makes the image look "normal," but if you are trying to take images of nebulosity, in particular red-emission nebulae, then you will be disappointed with the result. The filter not only blocks infrared but also most of the radiation emitted by these objects, so many amateurs go down the road of having their DSLR modified, or "modded," by having the infrared filter removed.

The DSLR camera that I use is the Canon 450D and I have produced some lovely astronomical shots with it. The next range up includes the 20D, 30D and 40D models, and then beyond that is the range usually favored by professional daytime photographers, including the 4D and 5D models. The 5D is certainly an excellent camera for astronomical work but it has a hefty price tag, so, for a beginner, stick with the 350D or 450D models and you will not be disappointed.

Choosing DSLR lenses

Taking images of stars has to be one of the most technically demanding challenges for a camera! Getting pinpoint images of stars across a wide field of view is no mean feat and the higher the resolution of the chip, the better quality the lenses need to be. You therefore need to make every effort to choose the right lenses and then use them properly to maximize the chances of getting sharp images. Unless you bought your camera body second-hand, you will almost certainly have got a lens with it, but these lenses are pretty cheap in design and manufacture so are not ideally suited to the demands of astrophotography.

Camera lenses are generally specified with a focal length and a "speed" rating, so you might see a lens described as 52 mm at $f/2.8$, for example. This means the focal length of the lens is 52 mm and its speed or fastest focal ratio is $f/2.8$ (pronounced "ef 2.8"). The focal ratio is a term familiar to astronomers as it refers to the mathematical relationship between aperture of lens and its focal length – so the lens above, when operating at $f/2.8$, has an aperture of 52 divided by 2.8, which is 18.5 mm. Clearly, if you change the aperture you change its focal ratio or its speed, so operating with an aperture of 4.7 mm means you are working at $f/11$, much slower.

On a camera lens, this value is usually changed by twisting a dial on the lens which reads "f/number," but what you are doing is reducing or increasing the aperture as you do so. A smaller aperture has a higher

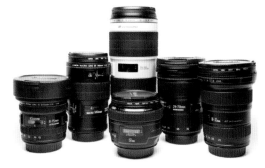

▶ *There are many camera lenses on the market. Choose a few lenses to add to your kit bag to ensure you have a good range available.*

f/number but means the lens will be slower than when it has a larger aperture and lower f/number. The definition of fast and slow comes from the fact that a larger aperture can collect light faster than a smaller aperture.

If you are an experienced astronomer then you will know that aperture is all-important when it comes to telescopes as the larger the aperture, the greater the amount of light the telescope can collect. The same is true of camera lenses, but to get a really sharp image you often need to choose an aperture slightly less than fully open. So, when you look at camera lenses, you need to choose ones with a low f/number as they are the fastest lenses and closing down the aperture a little will not have so much of an impact as it would on a slower lens. You will also find lenses that note more than one focal length – for example, 18–55 mm is a common one – and these are zoom lenses which allow you to alter the focal length and hence the size of the image. I am not a great fan of these as the quality of the image seems to be a little better on fixed-focal-length lenses compared to zoom lenses.

There are quite a number of high-quality lenses on the market now in addition to the cheaper versions. Canon have their L series lenses and Nikon have a range known as the ED series, but while they are of superb quality the high costs are quite prohibitive and they still suffer from image-quality issues when fully open.

Choosing lenses amongst the huge range available is no mean feat. I would go as far as to say it is harder to choose a lens than it is to choose a camera. Like telescope eyepieces, it is necessary to have a couple of camera lenses to allow you a little variation in image scale for different objects. I have three lenses for my Canon camera that I use for astronomical imaging: a wide-angle 24 mm f/1.4, a rather more standard 50 mm f/1.8 and a telephoto 200 mm f/2.8 lens. This selection gives me a great choice of image scale and are all fast, allowing me to shut the aperture down a little and operate at around f/4 or f/5 and still get good light-gathering and pinpoint stars.

Choosing a tripod

Compared to choosing a camera or a lens, choosing a tripod is ridiculously easy. If you are aiming just to have a camera fixed to the top of a standard tripod for static shots then you will simply need to choose a tripod that is really steady. For normal daytime

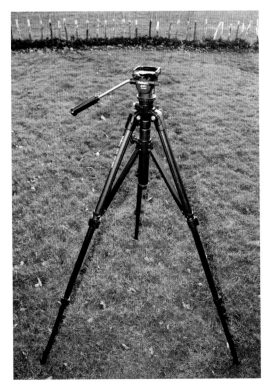

◀ *A good sturdy tripod is essential to keep the camera rock solid when taking images of the sky.*

▶ *Devices like the iOptron SkyTracker are great for counteracting the rotation of the Earth, allowing you to capture lovely shots of the constellations and the Milky Way.*

photography you can get away with quite a flimsy system for your camera, because the exposures are typically fast enough to eradicate any wobble in the system. However, because astronomical image exposures take place over many seconds or minutes, an inadequate tripod will show in the final image. Just look for one which is nice and solid and has good locks to enable you to fix the position you are pointing and you will not be disappointed.

You can get some wonderful pictures using just a standard camera and tripod, but you can enhance the pictures by bolting on a tracking platform to the tripod. This will enable the camera to move to follow objects across the sky. Systems like these require you to adjust the angle of the head of the tripod so that the whole system can be aligned to Polaris (more about that process later – see page 90). To do this you often need to buy an extra tripod "three-way head" which allows you to point the camera at all areas of the sky. There are two great camera tracking systems on the market: the iOptron SkyTracker and the AstroTrac, which both come with their own systems for polar alignment. Either of these will enable you to significantly increase exposure times by counteracting the rotation of the Earth.

Choosing telescopes for astrophotography

If you want to get close-up and personal to astronomical objects then the only solution is a telescope. In imaging terms, a telescope effectively acts as a very long-focal-length camera lens which gives you big images. Choosing the right telescope boils down to two decisions: identifying the right telescope tube and picking the right mount for it.

Choosing the right telescope mount is moderately easy – it needs to be capable of holding the tube steady and also have the ability to track objects across the sky. In reality, this means you need what is known as an *equatorial telescope mount* rather than an *altazimuth telescope mount*. The altazimuth mounts are simple in design and are the same as a camera tripod because they allow the telescope to be moved up and down in altitude and from side to side in azimuth. These terms are probably new to you but easy enough to understand. Altitude refers to height above the horizon where the horizon is 0° altitude and the point

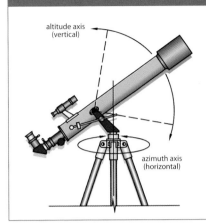

Altitude and azimuth

The altazimuth telescope mount shown here is typical of the type of mount used on smaller or budget refractors. It will be familiar to camera tripod owners as it has one axis that allows movement up and down (in altitude), and the other which rotates horizontally around the horizon (in azimuth). Be aware, though – these mounts are not ideal for astronomical photography. An equatorial mount is a much better choice.

overhead is 90°; azimuth is an angular measure around the horizon, starting due north, which is said to be at 0° azimuth, through east at 90°, south at 180°, through to west at 270° and back to north. Using an altazimuth mount allows you to point a telescope at all points around the sky, although it is often difficult to look through one when overhead because the mount itself can get in the way.

As you may already have noticed, objects in the sky rise in the east, move across the sky and set in the west. It is possible to fit motors to both axes of an altazimuth mount to enable you to follow objects across the sky automatically. This is fine for visual observing, but if you have ever looked through a system like this you may have noticed that objects tend to rotate slowly as the mount follows them across the sky. Clearly, this is a problem if you wish to take a photograph, because you will end up with a blurred image as the object slowly rotates during the exposure. Now, it is possible to attach a device between the camera and the telescope called a *field derotator*, whose job it is to rotate the camera slowly to counteract the rotation through the telescope, but a much better solution is to use an equatorial mount instead.

◀ *Some altazimuth telescope mounts like the one shown here are attached to motors and a tiny computer. These allow you to find objects in the sky but they will not allow you to take long-exposure photographs.*

chapter 1 CHOOSING THE RIGHT EQUIPMENT

These still have two axes about which the telescope can turn but with one crucial difference: one of the axes points in exactly the same direction as the rotational axis of the Earth. If you live in the northern hemisphere you might have noticed that there is one star that never seems to move its position. This star is Polaris and it marks the position in the sky that the Earth's axis of rotation points, known as the *north celestial pole*, and it is here that the polar axis of an equatorial telescope must point. By aligning one axis in this way, it can be turned slowly at the same speed as the Earth's rotation but in the opposite direction to make the telescope track objects across the sky. It does not stop there, though – take a look at a mount of this type in a shop or at your local astronomical society and you will see that by turning the one axis in this way, it makes the telescope follow an arc across the sky. This means the telescope is effectively now slowly rotating as it moves and thus magically following the rotation of objects in the sky. This is what makes equatorial mounts excellent for astronomical imaging.

As you go through the process of aligning the mount to the north celestial pole, which we cover in Chapter 4 (see page 90), you will realize that its height above the horizon is equal to the latitude you are observing it from. If you are at the Equator with a latitude of 0°, it will be found on the horizon with an altitude of 0° – use an equatorial mount here and the polar axis must be horizontal. At the North Pole with a latitude of 90°, it will lie overhead with an altitude of 90° and the polar axis will be vertical. At any location between these points, the polar axis is tilted by an appropriate amount to align with the north celestial pole. Interestingly, an altazimuth mount has one axis vertical which means it would work fine as an equatorial telescope if you were observing from the North Pole!

We have just seen how one motor is enough to turn the telescope to follow objects across the sky, but most mounts of this style have two, so what is the other for? Well, it has two functions: the first allows you to make fine adjustments to the pointing of the telescope while you are trying to center an object on the chip of your camera. The chips are usually pretty small so a fine level of control is needed to tweak the location of the object and center it. When added to an onboard computer system, which many telescope mounts come with, such as my Losmandy G11 with its Gemini

▶ *An equatorial telescope mount is essential to allow long-exposure photographs of objects in the night sky.*

> ### Equatorial mount aligned on Polaris
>
>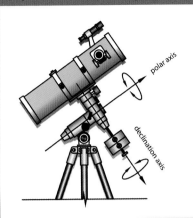
>
> The movement of the stars and planets across the sky from east to west is a result of the rotation of the Earth. When setting up an equatorial telescope mount, one of its axes is aligned so that it points parallel to the Earth's axis of rotation. Attaching a motor to that axis then allows the telescope to follow objects across the sky, making long-exposure photography much easier.

system, the mount will take commands to point at a particular object, which it will do for you. These Go To telescope mounts make for a powerful imaging system because, once accurately set up, you can get objects on the center of the imaging camera chip by just selecting them from a list. This saves you from having to take the nicely focused camera out of the telescope, replace with an eyepiece, center the object, remove the eyepiece, replace the camera and refocus before you can even start to take images. You can see it can be a bit of a hassle so it is a great bonus to have this feature.

For those of you interested only in imaging planets or other high-resolution objects, that will be all you use that second motor for. If you are planning on longer exposures of fainter deep-sky objects, then you will find that the polar alignment you so diligently set up is never perfect and tiny adjustments are needed to keep the object in the center of the field of view as the exposure progresses. These adjustments will also be needed on the polar-axis motor, as your wonderful new equatorial mount has manufacturing flaws in it! By that, I mean it is

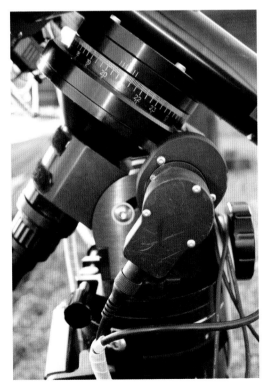

◄ *Motors are attached to the axes of an equatorial telescope to follow objects across the sky.*

not possible to build a mechanically perfect mount. As you try to follow objects precisely across the sky, there will be inaccuracies in the drive which means it sometimes speeds up and sometimes slows down, so you would need to speed up or slow down the motor to compensate. In the old days this was a manual process, but now you can use a second camera to "watch" the telescope and make tiny corrections to keep the object centered.

The ideal equatorial mount for imaging is one that allows all of these functions – motors to both axes, some means to control them to center objects, and the ability to connect up a secondary camera either directly or through a computer to automatically make guiding corrections. This may sound like a lot but there are loads of good mounts on the market which can do that and they do not cost a vast amount of money. Certainly, you will need to spend upward of around $800 for a good-quality mount, and this price will go up the heavier your telescope is because the mount needs to be more robust.

There will be a range of different types of equatorial mounts to consider from fork mounts to German equatorials, but in my opinion the latter are by far the best. I used to have a Meade LX200 fork-mounted telescope and it was a great imaging scope, but you had to be really careful with the amount of cameras and accessories attached at the eyepiece end, because it was not unusual for the whole telescope to try and swing through the mount only to find there was so much stuff on the back that it got stuck and would not fit through. Indeed, if you are going down the route of a mono camera and a color filter wheel to produce full color images then you will need to consider their bulk.

Making sure that your telescope is perfectly balanced is crucially important to ensure you get good tracking results out of your telescope. German equatorial mounts do not generally require extra balance weights, but fork mounts will usually need some extra weights to gain perfect balance. You can buy balance systems for fork telescopes which usually take the form of a bar that runs the length of the telescope upon which weights can slide forward or backward. They usually come with a selection of weights that can be individually added or removed. Exactly what weights will be needed will be determined by the mount and the amount of weight you have added and where.

Choosing the mount is easier than choosing the telescope as there is a whole range of good instruments on the market. Things are probably made a little simpler because we can focus our

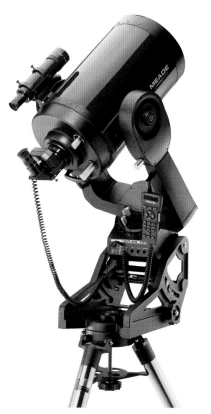

▶ *The LX200 fork mount with equatorial wedge attached is a popular model of telescope for astrophotographers.*

attention on telescopes that are ideal for astrophotography rather than just general observing. There are three distinct types of telescopes, but perhaps the cheapest and by far the most common amongst amateur astronomers is the *reflecting telescope*.

As their name suggests, they operate on a principle that relies on the reflection of light, so mirrors are the main optical component. In a typical reflecting telescope, light passes down the tube where it reaches a large circular primary mirror, which bounces light back up the tube. Just before it reaches the open end of the tube again, it strikes a smaller secondary mirror, which is angled at 45° to the incoming beams of light so they get redirected out the side of the telescope tube, where they are observed or captured on camera.

Reflecting telescopes have lost out a little in popularity for astronomical imaging in recent years in favor of *refracting telescopes*. These differ in their use of lenses rather than mirrors, so incoming starlight passes through a lens which in reality will be a number of lenses fixed together to work as one. Multiple lenses are used to overcome an effect known as *chromatic aberration*, which ruins an otherwise great image.

Lenses work by bending incoming beams of light and the amount of bend or refraction is determined by its wavelength and the material doing the refracting. In the case of a telescope lens, which is trying to focus all incoming wavelengths of light from a distant object, the point of focus for the various wavelengths will be different, so you will be unable get a nice sharp focus on all colors at once. If you were to look through a telescope with one lens, you would see a sharp image surrounded by a halo of colored light. By introducing more lenses with different curves it is possible to correct for this and get nice sharp images at all wavelengths.

Light paths of reflecting and refracting telescopes

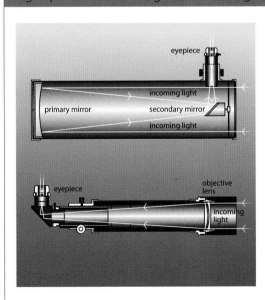

The reflecting telescope shown at the top of the diagram uses two mirrors (a parabolic "primary" mirror at one end and a flat mirror mounted diagonally to the primary) to bring incoming starlight to a focus, while the refracting telescope (bottom) uses lenses. Both have benefits for astronomical photography but small wide-field refracting telescopes are becoming a very popular option, especially for those wishing to capture large deep-sky objects.

▶ *The author's Vixen VMC260L telescope system with 80 mm refractor, which is used as a guide scope for long exposures.*

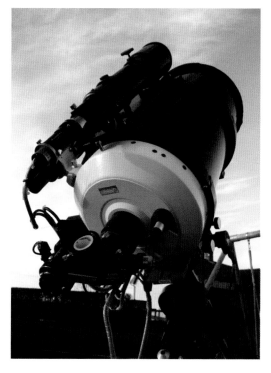

An alternative to the reflector or refracting telescope is a combination of the two, known as a *catadioptric telescope*. There is quite a range of different catadioptric telescopes, some of which are reasonably well suited to astronomical imaging, but essentially they employ a combination of lenses and mirrors.

My current telescope is known as a modified Cassegrain telescope – after bouncing off the 26 cm mirror, light passes back up the tube and through a lens just in front of the secondary mirror, before heading down the tube again and out through a hole in the primary mirror. This design is great for imaging as it gives a large and flat field of view.

Of the different types of telescope available, they are all described in a similar way through the use of a number of terms. The first is the *aperture*, which simply tells you the size of the main collecting lens or mirror – my telescope has a large mirror 26 cm in diameter so it is said to have an aperture of 26 cm. A larger aperture means a larger mirror or lens to collect light, so you will get to see fainter objects and a finer level of detail. The distance it takes for the mirror or lens to focus the incoming light to a point is known as the *focal length*. It is quite possible to see two almost identical telescopes of the same aperture but with different focal lengths, which will make them perform differently. Typically, a longer-focal-length telescope is more suited to higher magnifications and brighter objects, whereas a shorter-focal-length telescope is better for fainter objects and lower magnifications. This is an important point when choosing a telescope for astrophotography as focal length also determines the brightness of the image and therefore how long exposures need to be. If you are trying to get images of fainter deep-sky objects then a system with a shorter focal length is better than one with a longer focal length, which is more suited to planetary imaging. We will look at focal length again toward the end of this chapter when we look at choosing a CCD camera, as focal length will determine how much of the sky your CCD will see when attached to your telescope (see page 29).

I actually use two telescopes for imaging now. The main instrument has a focal length of 3,000 mm, but I can reduce this to get a wider field of view with a lens attached to the camera end known as a *focal reducer*. This brings the focal length down to 1,840 mm, turning it into an instrument more suited to deep-sky work. Next to this telescope is a smaller refractor which has a focal length of just 545 mm, so between the lot of them I can get a good image scale for most objects.

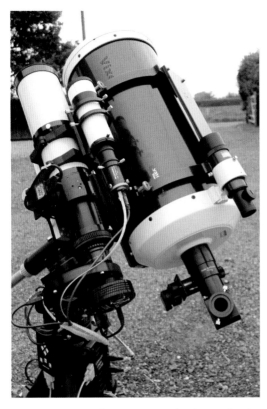

◀ *The author's full imaging system showing the two imaging telescopes – 260 mm aperture (green) and 80 mm aperture (white) – with the guiding telescope on top. They are on a German equatorial mount.*

Another term that relates to both aperture and focal length is the *focal ratio*. This phrase tells us the "speed" of the telescope and comes from photography where faster lenses meant shorter exposures (see page 15). The focal ratio is found by dividing the focal length by the aperture – using my main telescope as an example, it has an aperture of 260 mm and a focal length of 3,000 mm, so it works at a focal ratio of 11.5, or f/11.5. Because the focal ratio is related to aperture and focal length, it helps to understand whether longer or shorter exposures are needed – in just the same way that a photographic lens with a lower focal ratio is faster and thus requires shorter exposures compared to a system with a longer focal ratio that requires longer exposures.

With all these different types of telescopes it is perhaps difficult to choose one for your first imaging experiences. The catadioptric telescopes are great for imaging but they are not well suited to the beginner in my experience, as their longer focal lengths mean they are much less forgiving because any errors or problems in driving or tracking are magnified significantly with the longer focal length. The tubes are bigger and heavier too, which means the mount needs to be more heavy duty yet precise enough to drive it accurately across the sky. In short, they are not a great choice as your first telescope for imaging purposes.

A better option is to start with a wide-field refractor, ideally an apochromatic telescope that has had the majority of its chromatic aberration removed. You may see telescopes of this style referred to with ED lens elements. This is a special type of manufactured glass known as "extra-low dispersion," which is much better at removing if not almost eradicating the chromatic aberration, so is a great choice – but they do come with a higher price tag. Any apochromatic refractor with an aperture around 70 mm and a focal length of about 450 mm will have a focal ratio of f/6 and would be a great starter scope for imaging. For the rest of this book, I will assume the use of a telescope of this type such as my own 80 mm refractor, which operates at 545 mm and f/6.8.

There is one final point about telescopes to be aware of before moving on to choosing cameras for astronomical use. It relates to another deficiency in telescope optical design

as many can suffer from a curved field, which essentially means pinpoint focus cannot be achieved across the entire field of view – when stars in the center are sharp, stars at the edge may be slightly out of focus. However, this can be resolved through the use of a *field flattener*, which is a lens inserted at the eyepiece end of a telescope and, as its name suggests, flattens the field to give nice sharp star images across from edge to edge. It is not usually a problem for visual observing but is more of an issue for imaging, so if you are working without a field flattener and suffering from fuzzy star images at the edge of field, then it is best to focus on stars about one-third out from the center to get a good overall focus.

Choosing cameras

Now comes the really tricky bit – choosing cameras for use through a telescope. We have already looked at the different options for choosing DSLR cameras for shots with tripods, and those tips will guide you well if you are choosing a DSLR to use through a telescope. You will need to get an adapter to convert the camera lens mounting connector to facilitate connection to the telescope eyepiece holder – these are known as T-adapters and usually come in two parts: the standard adapter, and then a converter that allows your specific camera to attach to it. On the telescope end they present a tube that slots into the eyepiece holder which is either 31.7 mm or 50 mm diameter, depending on your telescope.

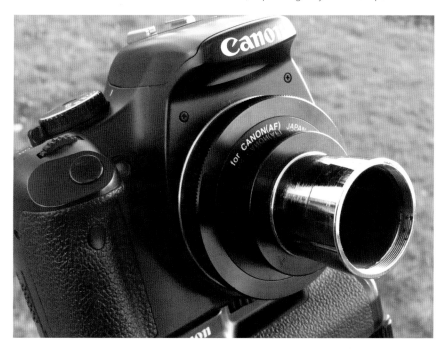

▲ *A DSLR can be attached to a telescope by removing the lens and replacing it with an adapter that allows it to slot into a telescope eyepiece holder.*

CCD CAMERAS

Deciding on which CCD to buy can be a daunting task, and while there are lots to choose from with loads of things to consider, in my opinion the most important factors are the size of the CCD chip and the size of the pixels. The chip size determines how big an area of sky you will capture and the pixel size determines the resolution. The list below shows some of my favorite brands and the models currently available together with their specification, plus whether they are available as monochrome only or as a one-shot color camera.

Brand	Model	Chip type	Chip dimensions (mm)	Pixel size (microns)	Monochrome/ One-shot color
Atik	Atik GP	Sony ICX445	6.2 × 5	3.75	Mono/OSC
	Atik Titan	Sony ICX424	5.8 × 4.9	7.4	Mono/OSC
	Atik 320E	Sony ICX274	8.5 × 6.8	4.4	Mono/OSC
	Atik 314L+	Sony ICX-285AL	10.2 × 8.3	6.45	Mono/OSC
	Atik 383L+	Kodak KAF-8300	17.6 × 13.5	5.4	Mono/OSC
	Atik 420	Sony ICX-274	8.5 × 6.8	4.4	Mono/OSC
	Atik 450	Sony ICX655	8.7 × 7.1	3.45	Mono/OSC
	Atik 428EX	Sony ICX674	10.7 × 9.2	4.54	Mono/OSC
	Atik 460EX	Sony ICX694	12.4 × 9.9	4.54	Mono/OSC
	Atik 490EX	Sony ICX814	14.6 × 12.8	3.69	Mono/OSC
	Atik One 6.0	Sony ICX694	12.4 × 9.9	4.54	Mono/OSC
	Atik One 9.0	Sony ICX814	14.6 × 12.8	3.69	Mono/OSC
	Atik 4000LE	Kodak KAI 04022	16.6 × 16.0	7.4	Mono/OSC
	Atik 4000	Kodak KAI 04022	16.6 × 16.0	7.4	Mono/OSC
	Atik 11000	Kodak KAI 11002	36 × 24.7	9.0	Mono/OSC
SBIG	ST-402ME	Kodak KAF-0402ME	6.9 × 4.3	9.0	Mono
	ST-1603ME	Kodak KAF-1603ME	13.8 × 9.2	9.0	Mono
	ST-3200ME	Kodak KAF-3200ME	14.9 × 10	6.8	Mono
	STF-8300	Kodak KAF-8300	17.6 × 13.5	5.4	Mono/OSC
	STF-8050	Kodak KAF-08050	18.3 × 13.7	5.5	Mono/OSC
	STT-8300M	Kodak KAF-8300	17.6 × 13.5	5.4	Mono/OSC
	STT-1603ME	Kodak KAF-1603ME	13.8 × 9.2	9.0	Mono
	STT-3200ME	Kodak KAF-3200ME	14.9 × 10	6.8	Mono
	STXL-11002	Kodak KAI-11002	36 × 24.7	9.0	Mono
	STXL-6303E	Kodak KAF-6303E	27.6 × 18.4	9.0	Mono
	STX-16803	Kodak KAF-16803	36.8 × 36.8	9.0	Mono

Brand	Model	Chip type	Chip dimensions (mm)	Pixel size (microns)	Monochrome/ One-shot color
Starlight Xpress	Trius-SX814	Sony ICX814	14.6 × 12.8	3.69	Mono/OSC
	Trius-SX694	Sony ICX694	12.4 × 9.9	4.54	Mono/OSC
	Trius-SX674	Sony ICX674ALG	8.8 × 6.6	4.54	Mono/OSC
	Trius-SX9	Sony ICX285AL	10.2 × 8.3	6.45	Mono/OSC
	Trius SX35	Kodak KAI-11002	36 × 24.7	9.0	Mono
	Trius SX36	Kodak KAI-16070M	36.3 × 24.2	7.4	Mono
	SXVR-H16	Kodak KAI-4022	16.6 × 16.0	7.4	Mono/OSC
	Trius-SX25C	Sony ICX453AQ	23.4 × 15.6	7.8	OSC
	Trius-SX26C	Sony ICX493AQA	23.4 × 15.6	6.05	OSC
	Lodestar	Sony ICX429AK	6.4 × 4.7	8.6 × 8.3	OSC

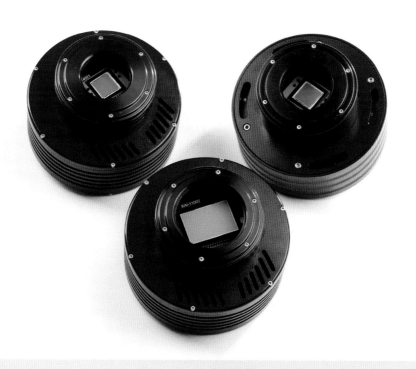

▲ *There is a huge range of different CCD cameras on the market, like this selection from the Atik range. Choose the one that's right for you based on the specifications of your telescope.*

▶ *Webcams are great for planetary imaging. Attaching a special adapter allows them to be fitted to a telescope.*

If you want to get some great shots of the planets then a DSLR will do quite a good job, but you will get a much better result from a webcam. Choosing the right webcam for planetary imaging is not really all that difficult. Perhaps the biggest deciding factor is how easy it is to modify it to attach to a telescope. As with most applications, connecting a camera to a telescope involves removing the camera lens and replacing it with an adapter of some sort to allow it to slot inside the eyepiece tube. I have seen people attempt the modification by removing the lens and then gluing in place a hacked-about 35 mm film canister to the webcam. This is most definitely *not* a recommended approach! You are embarking on a fun yet precise science and there is no way to ensure you have got the makeshift adapter square with the camera's chip – as a result, the images are likely to be poor. For the cost of about $30 it is worth buying one of the off-the shelf adapters. They are easy to install on webcams that have lenses that simply and easily unscrew from their holder, so it is then a matter of screwing in the adapter to get you up and running.

There are other webcams, however, whose lenses do not simply unscrew so these are worth steering clear of. Probably the best webcam for astronomical purposes was the Philips ToUcam, but these are now sadly only available on the second-hand market. It is difficult to recommend particular brands other than this, though, as they change so readily and by the time this book goes to print there will probably be a whole new range on the market. Stick to finding one with a removable lens and you will not be too disappointed. While we are on the subject of buying webcams, it is worth buying an infrared blocking filter to screw on to the adapter. Using one of these will sharpen your planetary images a treat.

When it comes to choosing a CCD camera, things become a little more tricky and I'm afraid there is a tiny bit of maths involved in choosing the right one for your telescope. If you have already started to look around at the cameras on the market then you may have noticed that the CCD chips inside them vary quite a bit, but the key to

◀ *A close-up image of a CCD pixel array. The CCD is at the heart of most commercial astronomical or DSLR cameras.*

choosing the right one is to match the chip to the focal length of your telescope. In order to do this there are a couple of facts you need to dig out about the cameras: the size in millimeters of the chip and the size in microns of the pixels. A micron is a tiny measurement and there are 1,000 of them in a millimeter. With these values and the focal length of the telescope you can now work out two items: the field of view that you will get and the resolution of the combined telescope-and-camera system.

The calculations are easy so do not run away in a cold sweat. Probably the easiest to work out is resolution, which tells you how much of the sky will be recorded by a single pixel of the camera, or, in other words, the level of detail that can be detected. The area of sky is measured in angles and in the case of this calculation we refer to arc seconds per pixel. An arc second is a tiny area of sky and to visualize just how small imagine the size of the full Moon, which covers half a degree. If you could shrink the Moon down so it was 30 times smaller, it would measure 1 minute of arc (or 1 arc minute) in diameter. If you could then shrink this miniature Moon down still further so it was 60 times smaller, it would measure 1 second of arc (or 1 arc second) across. So, in summary, there are 60 arc seconds in an arc minute and 60 arc minutes in a degree, and through a simple formula we can see how much of the sky 1 pixel can cover for a telescope with a given focal length. To work it out, divide 206.265 by the focal length of your telescope in millimeters. Now take the answer and multiply it by the size of the pixels in microns and you will get an answer in arc seconds per pixel. My smaller wide-field telescope has a focal length of 545 mm and my CCD camera has a pixel size of 6.4 microns. Plugging these numbers into the formula gives my wide-field system a resolution of 2.42 arc seconds per pixel.

▲ *The author's Atik 314L+ CCD camera, which was used for most of the deep-sky images in this book. It has a CCD chip measuring 8.9 × 7.6 mm, with pixels just 6.4 microns across.*

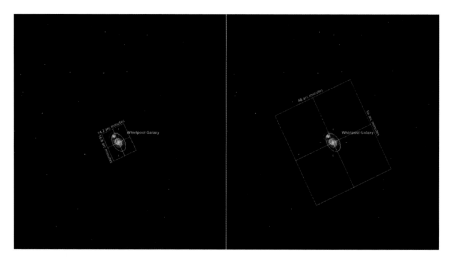

▲ *Getting the right field of view for a shot is key to great astronomical images, but it is dependent on telescope focal length and the size of the CCD chip. The image on the left shows a grid representing the field of view with my CCD and main telescope at 1,840 mm focal length, while on the right the image is through the wide-field refractor with a focal length of 545 mm.*

It is easy to see how focal length changes things as my main scope has a focal length of 1,840 mm when the focal reducer is in place, which gives me a much higher resolution of 0.72 arc seconds per pixel. If I did not use the focal reducer and had the telescope running at its full focal length of 3,000 mm, I would have a resolution of 0.44 arc seconds per pixel. Ideally, you want to aim for a resolution of no higher (lower number) than around 1 arc second per pixel – anything too high and you will find that your guiding system will be chasing the guide star around the chip as the turbulent nature of the atmosphere causes the star to jump around. At these high resolutions you will find guiding a real challenge, even if it is automatic. I actually had a bit of a dilemma when it came to choosing my camera as I was looking for something that would work with both telescopes. In the end I had to compromise, as larger pixels would have been ideal for the larger telescope but would have meant the resolution was too low on the

◀ *The author's CCD attached to the wide-field refractor with USB and power cables connected, ready for a night's observing.*

wide-field scope. Finally, I settled on 6.4-micron pixels, which would give reasonable resolution on the wide-field scope but still had a resolution that was slightly too high on the main scope. I had, however, concocted a cunning plan! With CCD chips you can do something rather wonderful called "binning." This essentially allows you to combine a number of pixels together so that they work as if they are just one pixel, and as luck would have it, most cameras will allow you to "bin" 2× or even 3×. If I used my CCD with 2× binning, I could effectively get larger pixels and so bring the resolution on my main scope down to a much more manageable 1.43 arc seconds per pixel – perfect!

Now that we have worked out the resolution of the camera, it is also worth working out the field of view the camera will give you when attached to your telescope. There are two sums to do here but that is only because some CCD chips are not square but rectangular. You need to perform the same calculation for each of the dimensions, this time using millimeters. Take the length of one side of the chip in millimeters and multiply it by 3,438. Then take the answer and divide it by the focal length of your telescope, also in millimeters, to get an answer in arc minutes. Now repeat it for the other dimension of the chip to get another answer. Confused? Let us work through my own setup to help explain. My CCD has a chip that measures 8.9 × 7.6 mm and is mostly used with a focal length of 545 mm. First, I take 8.9 mm and multiply that by 3,438 before dividing the answer by the wide-field scope's focal length to give me 56 arc minutes. Then I repeat the calculation with the other side of the chip, which measures 7.6 mm, giving me 48 arc minutes. So combining the two answers means that the camera will have a view on the sky of 56 × 48 arc minutes.

Using these values we can now take a look at some objects and see if they would fit in the field of view. One of my favorite objects is M51, the Whirlpool Galaxy in Canes Venatici, which measures about 11 × 7 arc minutes so it will more than easily fit on the chip – in fact, it is almost too small for this optical setup. However, if I apply the same maths to my main scope with the focal reducer then I get a field of view of 16.6 × 14.2 arc minutes, which is perfect to fit in M51.

One of the reasons I went for the dual telescope setup is because there really is not one optical system that is perfect for all objects, but by using two telescopes with one CCD I can get just about the right resolution and field of view on any object I am interested in. For those of you just starting out, though, stick with one telescope, preferably a short-focal-length refractor, and you will soon be producing beautiful images.

It is not just resolution and field of view to consider, though, when choosing a camera, as there are other features to look at too.

▶ *All CCDs generate their own noise and a dark frame like this (enhanced for this book) must be taken so that its impact can be removed from the final image.*

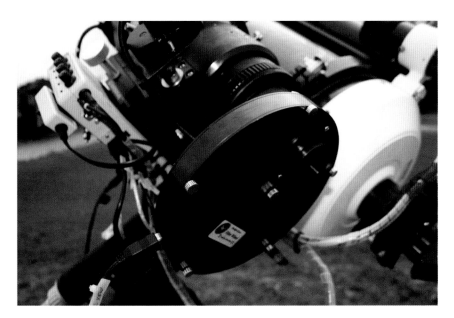

▲ *Color filter wheels, like the one pictured here, fit between a mono CCD and the telescope to allow you to take color images.*

One of the more important ones in my opinion is something called *set-point cooling*. Like all digital cameras, CCDs operate better if they are cooled because the effects of thermal energy can be enough to excite the production of electrons in the chip, and these extra electrons are indistinguishable from electrons generated by photons of light striking the chip. This unwanted "noise" in the final image is known as *dark current*. The source of this thermal energy can be the ambient air temperature, or the heat generated by the CCD itself as it runs, so cooling it down can reduce the dark current. It can only be completely eradicated at temperatures around −100°C, but for amateur cameras this is costly and impractical. Most off-the-shelf CCDs come with the ability to cool and set-point cooling allows you to cool the camera down to a specific temperature, rather than a specified number of degrees below the ambient air temperature. From an operational point of view, set-point cooling makes your life as an imager considerably easier.

I will look at ways you can remove some of the noise generated by the dark current later in the book, but for now it is useful to know that for every picture of an astronomical object you take with a CCD camera, you will also have to take a "picture" of the dark current, which is then subtracted with computer software to remove the noise. Because you will have a different level of noise for different temperature settings, you can build up a library of these so-called "dark frames" for different temperatures and use them as necessary. Otherwise, you will need to take a dark frame after every image you take and that is time consuming.

Perhaps one of the biggest decisions you will need to make when choosing a camera is whether to go for a mono camera or a one-shot color version. This choice is best made at

the start of your search before considering pixel and chip sizes. It is probably fair to assume that anyone getting into astronomical imaging has the sole aim of securing beautiful color images of the night sky. And while at first you may think a one-shot color camera is the best for this, you may be surprised to learn that this is not the one that will get you the best results. There are two ways you can get color images: the first is called "tri-color imaging" and you use a mono camera (which gives you a black-and-white picture) to take at least three images through red, green and blue filters before combining them with software. This method is certainly my preferred approach as it means you are operating the camera at full resolution. The downside is that you will need to purchase a set of filters and a filter wheel to hold and select the filters as you take your images – more on that later in this chapter.

The other approach to getting color images is to use a one-shot color camera, which is effectively a mono camera with filters permanently attached to the pixels in what is known as a "Bayer matrix." This is certainly an easier approach because you can get away with taking just one image of the object and you do not have the additional expense of a set of filters and filter wheel. However, because of the permanently attached filter matrix there is a loss of sensitivity and a little loss in resolution too.

As my friends will attest, I took ages deciding which camera to go for, but the color versus mono decision was pretty quick and easy. Certainly, a mono camera requires more accessories and more effort on your part to take the images and then process them, but I much prefer to be able to work at maximum resolution and sensitivity than to compromise. Mono cameras with filter wheels also give you the added flexibility of being able to use narrowband filters – hydrogen-alpha (H-alpha), oxygen-III (O III) and sulfur-II (S II) – on regions of nebulosity to get even more levels of detail, which is not so easy to do with one-shot color.

If you do decide to go for a mono camera and set of filters then I am afraid there is another decision required – manual or electric! The key here is to be able to hold securely and accurately position the filters in the light path of the camera. You will need to decide how many filters you are likely to use because most filter wheels provide slots for 5 or 7 filters. I have seen many people waste money on a 5-position wheel only to upgrade it in the future to a 7-position, so just go for the 7-position style. Mine is a 7-position wheel and it allows me to have a full set of color filters (including luminance filter – see overleaf) and narrowband filters. Modern manual wheels are pretty good now and do allow quite a level of accuracy, but their major drawback is that part of the wheel which houses the filters tends to protrude out the side of the casing. This means the filters are open to the elements, leaving them susceptible to dust and

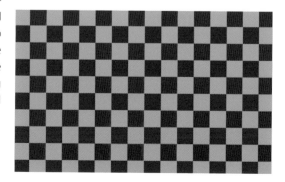

▶ *A Bayer matrix schematic representation of a one-shot color CCD chip.*

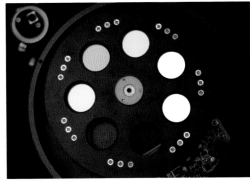

▶ *The inside of a color filter wheel showing luminance, red, green, blue, H-alpha, O III and S II filters.*

other artifacts, unlike the electrical systems where the filter housing is completely enclosed. The real beauty of electrical filter wheels is that you can usually adjust them from a computer, which means you do not have to touch the telescope and risk knocking it out of alignment. There are a number of electrical systems on the market now that do not require separate power leads but instead draw their power through the USB connection that connects them to the computer. Cables are troublesome, so if you can get away with fewer of them it is definitely a real bonus.

As for the filters, it is worth investing in a red, green, blue and luminance filter for your first set. We have already looked at the concept of tri-color imaging but in reality there are four images that we need to take. The fine detail of the object is recorded through the luminance filter, which blocks some of the infrared radiation. The color from images taken through the red, green and blue filters is then applied to this image at a slightly lower resolution to turn the mono luminance image into glorious full color. Once you have mastered this set of filters, then you can start experimenting with the narrowband filters mentioned earlier.

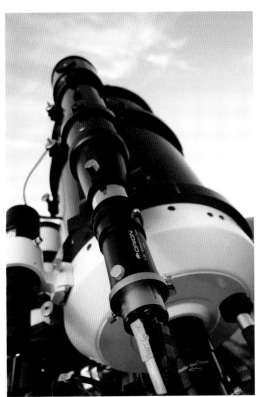

There are other gadgets and accessories you can purchase that will help to make imaging through a telescope easier. A guide scope fitted to the side of the main telescope will give you something on which to attach a guide camera to track objects across the sky. We already looked at why you would need to do this earlier in the chapter (see page 19). No matter how accurately you polar align, there will be tweaks needed to ensure that objects stay in exactly the same place, so a guide scope (which is usually just a lesser quality telescope of no more than 500 mm focal length) will do the job just fine.

◀ *Attached to the top of the author's main imaging telescope is a smaller telescope with a QHY5-II mono CCD camera which is used for guiding.*

It is then attached to the side of the main telescope with a set of rings that fix it rigidly. Another option is to use an off-axis guider, which essentially takes a tiny portion of the light coming through the main telescope and uses that to guide upon. I prefer the former option but it is a matter of personal choice.

A guide camera is needed to attach to either the off-axis guider or the guide scope and provide an output to either a computer or the telescope mount in order to affect the necessary changes to your tracking. There are a number of these on the market but do not get too hooked up on the options. Some people even use webcams as guiders, although this is tricky as it means the PC then has to translate the video from the webcam into telescope movements. It is a complication that, as a beginner, you really do not need. It is useful to look at the resolution of your chosen guide camera and guide scope or off-axis guider because you do not want this to be too high, as we saw earlier, otherwise it will end up chasing the star around the chip if the air is a little turbulent. My guide camera gives me a resolution of about 1.6 arc seconds per pixel which is ideal for guiding, but anything between 1 and 2 will work fine.

Electronic focusers can be a real help too, and they are not only useful if you are setting up a remote system at the bottom of your garden. Even if you set up your equipment and sit right next to it, being able to tweak the focus electronically rather than by hand means you are not disturbing the telescope. No matter how lightly you touch it, the image can start to jump around, leaving you twiddling your thumbs before checking the focus only to find you need to adjust it again. There are even systems that will focus a camera automatically for you – these make the whole job really easy.

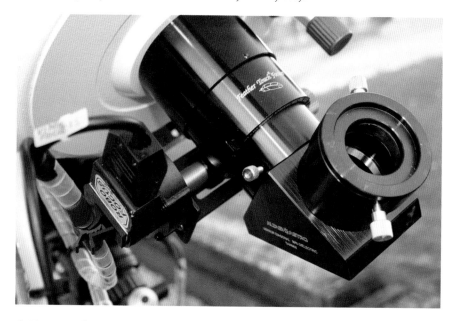

▲ Using an electronic focuser makes focusing the camera much easier. Some more advanced systems will even focus automatically for you.

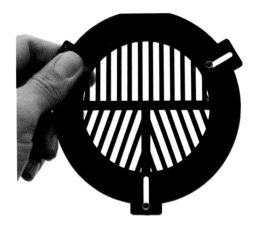

◀ *The Bahtinov mask is a brilliant and cheap aid to focusing. It attaches to the front of the telescope and makes stars appear to have spikes coming out of them, so that adjusting the focus is much easier.*

As an alternative to the automatic focusing systems, the Bahtinov mask offers a great and cheaper, though manual, solution. The mask is a large plastic disk that has three sets of lines cut into it, each at different angles. The mask fits over the front end of the telescope and when an exposure is taken of a bright star, it shows it with three spikes sticking out of it. As you adjust the focus, the central spike seems to move left and right, and when perfect focus is achieved, it sits bang in the middle of the other two. I used a similar approach many years ago by attaching two thin metal poles (only about 5 mm in diameter) across the open end of the telescope tube and parallel with each other. This had a similar effect by producing two spikes which, when they merged, meant the telescope was focused perfectly. It was a bit of a lash-up, to be fair, but it did work.

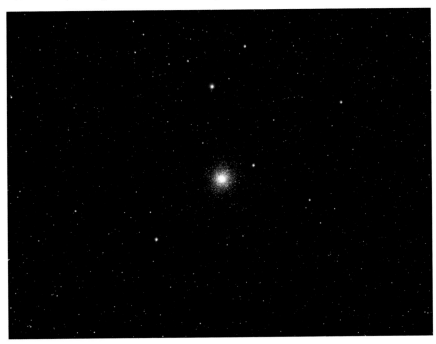

▲ *M15 is a beautiful globular cluster in Pegasus. Careful use of accessories such as a guide camera and filter wheel can help to capture images just like this.*

▶ *RegiStax is a great (and free) piece of software that helps you to process your webcam footage for fabulous planetary images.*

Choosing software

Taking the pictures is actually one of the easiest bits – after you have secured either your webcam footage, your DSLR image or your set of four images to be combined, then you have potentially many hours of image processing to be done. Do not panic! I'll help you with this too, but you will need software to do this. You can use your camera's proprietary software to grab your images out of a normal DSLR camera, but once it is in the computer, then Photoshop is great at manipulating it.

Once you start delving into planetary or high-resolution imaging with a webcam through a telescope, then stick with the proprietary camera capture software or a piece of freeware called SharpCap. However, once you have your videos, then another great piece of free software called RegiStax is available to download from the Internet that will help you turn the video into high-resolution images. You can then use Photoshop for further tweaking.

CCD cameras tend to come with a whole range of image-capture software of varying degrees of quality – some are great, others worthy only of the bin. There is a great piece of software that I use called Maxim DL, and although it is a little expensive at around $500 depending on the version you buy, it will allow you to control telescope, cameras, focusers, filter wheels, etc, and also allow you to do some pretty impressive processing. A combination of this software and Photoshop will allow you to do some powerful stuff to get the most out of your beautiful new images.

chapter 2
GETTING IMAGES WITHOUT A TELESCOPE

TO GET BEAUTIFUL night-time sky shots you do not even need a telescope! Some of the most stunning and inspirational astronomical shots that I have seen were taken with nothing more than a DSLR camera attached to a tripod. Images in this style seem somehow to be more accessible to people because it is easier to connect with a familiar sight of a star-filled sky than a distant spiral galaxy that they have never seen before. I started taking images like this nearly 20 years ago when film was the thing; however, there are still plenty of challenges today, but with my help you will soon be heading down the right road and starting to churn out some wonderful shots.

We have already looked at equipment for this kind of astrophotography so you should already have a DSLR camera and a tripod, and hopefully some means of remotely operating the camera, although this is not essential. Perhaps the hardest part of taking astronomical images like this is deciding the settings to use on your camera! As with most modern DSLRs, you will find they come with a number of predetermined settings profiles for portrait, sport, night-time and a host of other modes, but if you are taking astronomical pictures then unfortunately you have to use the manual setting and configure the camera yourself. If you have taken a look through the menu system, you will know that there are dozens of settings for you to choose from in addition to the usual ones – some of them will help you while others will make no difference at all.

A good starting point is in deciding what format the image should be stored in! Generally, you can choose between RAW or JPEG. If you are a computer user then JPEG may well be a familiar file format to you, but RAW may be a new one. RAW images are stored with minimal processing having been done to the image data, but they also store information about the exposure settings. You can think of the RAW image as the negative produced from a film camera that needs further work to produce a proper full-color image. JPEG files, on the other hand, are analogous to the

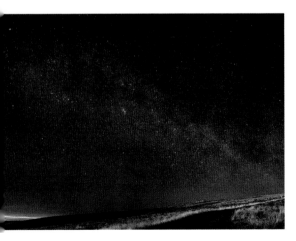

◀ *The Milky Way taken with a DSLR on a standard tripod. Not much can be seen as this technique limits exposure times due to the rotation of the Earth.*

▶ *A "high ISO speed noise reduction" menu option is available on most modern DSLR cameras, which reduces noise in the final image.*

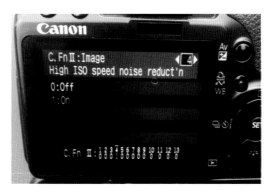

final result and have already been processed by the camera. The benefit in using a RAW image as opposed to a JPEG is that less data will be lost due to compression, but conversely JPEG file sizes are smaller since the image is compressed. For the newcomer it is best to stick with the JPEG format, but as experience is gained, particularly in image processing, then RAW can be selected but there is really no great benefit at this stage. Switching between RAW and JPEG is done in the menu system of the camera so check with your camera's instruction manual to identify how to do this. Once you have set it to JPEG, you will also see a setting for quality which relates to how much compression is applied to the image, where high quality means low compression but a larger file size. Assuming image storage is not an issue, this should be set to the highest quality level for lowest compression.

Whether you are working with RAW or JPEG file formats, there are a couple of settings that are also worth looking at. For both formats it is worth turning on "long exposure noise reduction." You will see later in the chapter that I refer to taking dark frames when using long exposures. The reason for this, as we saw in Chapter 1, is that a CCD produces a level of noise in the image that comes from interference and not from the light from stars. The level of noise is also dependent on the temperature – as the camera warms up or the ambient air temperature changes, then so too will the noise, which will look like a gentle sprinkling of dots over the image and, as you can imagine, with images of stars this is more than a little annoying. There are two options then: either wait until you have got a good image and, immediately after, take another corresponding image of the same length of time but with the lens cap on, or use the "long exposure noise reduction" option. With this setting turned on, the camera will take its own dark frame and subtract it from the resultant image for you. But be warned – it will do this after every single shot while turned on, so every exposure will take twice as long as your intended duration. It is a useful function and does save effort in image processing later, but it can be time consuming when in the field so turn it on only when you have experimented with, and identified, the correct exposure settings.

The "300" rule

The rotating Earth causes difficulties when taking images of the night sky, but you can still get pretty good results on a standard tripod. In order to get an approximate maximum exposure time for a given lens before stars start to trail, we can divide the figure "300" by the focal length of the lens. This is only a rough gauge, though, as you will need shorter exposures near the celestial equator where the movement of the stars is greater.

The other setting that is worth turning on is "high ISO speed noise reduction," but only if you are shooting in JPEG format. If you are using RAW then you may as well leave it turned off as you can achieve the same results in image processing later. As its name suggests, there is a level of noise artificially produced in images with high ISO speeds in excess of 1600 and it can be particularly noticeable in the blackness of the sky. By turning this setting on, the noise is reduced in JPEG images. This one can be left on as it has no great impact on your productivity while capturing pictures.

Another setting that is very useful for astrophotography, but not available on all cameras, is "mirror lock." If you have ever looked at the mechanics of a DSLR camera you might know that as you look through the view finder, you see an image which has come through the camera lens, bounced off a mirror and then been deflected, usually by a prism, out of the camera and into your eye. That is assuming you use a camera by looking through it rather than looking at the digital image displayed on the back of it. When you depress the shutter, having focused the image, the mirror flips up so the light coming through the lens lands on the chip rather than bouncing up and into your eye. The movement of the mirror flipping up and out of the path of light will impart a small amount of vibration in the camera, which can cause the whole camera to shake by a tiny amount. This is not a problem for daytime photography because the exposures are short enough that the movement is not captured; however, it is a problem for the longer exposures used for astrophotography. Instead of nice pinpoint stars you may well end up with tiny squiggles. If you are trying to capture star trails this could ruin them as the trails show a wiggle at the start while the camera settles down after flipping up the mirror, but you can also get tiny squiggles on brighter stars at the end as the mirror comes down at the end of the exposure. The "mirror lock" function allows you to depress the shutter to raise the mirror, then depress it again to start the exposure once the camera has settled down. This is usually accessed by a menu setting so check with the instruction manual for your camera to locate it.

With file format set and any "mirror lock" enabled, the basic functions of the camera are now ready for imaging so let us turn our attention to getting some images! It is best to get your camera attached to your tripod and set up outside during the late afternoon – this not only means that you have the advantage of being able to see easily what you are doing, but also that you give your camera and lenses a chance to cool down to the ambient air temperature as night falls, before it starts to get damp. If you set your camera up indoors

◄ *Dew will form on camera lenses if the air has a lot of moisture so consider dew protection options like dew shields or heaters.*

▶ *Electronic dew heaters are great at keeping dew at bay on damp winter nights.*

during the evening or night, then you will find that taking it outside into the cold night air will leave you with your first problem – dew!

Taking a warm camera out into the cold air will mean that any surfaces like glass will dew up as the warm and cold air mix. This is a very unenviable situation, so take your camera outside before nightfall and let it cool down with the air. There will be times when dew will form on your optics however careful you are; in these conditions you have a number of options, but the easiest is to use a hair dryer on its lowest heat setting to blow warm air gently across the lens, which will get rid of the dew. An alternative solution, which works better on longer-focal-length lenses, is to make up a dew shield that fits around the lens, extending out in front by a few inches. This will tend to keep dew formation at bay for a little longer, although be careful with this as, depending on the focal length of the lens, you may be able to see your dew shield through the lens and thus have it obscuring the camera's view of the sky.

My preferred solution came from a friend of mine and while it is a bit of a lash-up, it does work like a charm. Get hold of some of those chemical hand warmers from an outdoor shop, which you either shake or pop a tiny metal disk inside to initiate the warmth, and then stick them inside a sock which you wrap around the lens, being careful not to obstruct the focusing or zoom function of the lens. These will keep warm for a good few hours and will keep the lens warm too, so that dew formation is kept at bay. You can get proper electrical dew heating systems and these are great for a telescope but are a little pricey for a camera. Like the telescope systems, they have straps which wrap around the lens, but they run from 12-volt power which means a decent battery system is needed.

Now your camera is ready and you are prepared for the dew, so it is time to attach camera to tripod, let it cool and wait for nightfall. You will need to use a red torch to allow you to see what you are doing while you operate your camera. Red torches are useful as opposed to white or other colored torches as they do not affect your dark adaptation. It takes about an hour for your eyes to get used to seeing in the dark and exposure to bright, particularly white, lights can instantly ruin your eyes' adaptation. The various camera exposure settings need to be set dependent on the type of picture you wish to take, so let us look at some examples and how to set them up.

Star trails

Probably the easiest type of astrophotography involves taking pictures of so-called "star trails." Once attached to a tripod and pointed at your chosen part of the sky, a long-exposure image of the stars will reveal the rotation of the Earth. The rotation means the camera is slowly moved by the rotation of our planet to point at different parts of the sky. Long-exposure images mean this rotation is recorded in the star trails left behind as the camera moves. We have always perceived this as the rising and setting of stars as they seem to move around us but in reality it is the movement of Earth. Capturing your own star trails is easy.

Step 1 Focus

First things first, you need to get your camera focused. Choose a wide-angle lens to capture as much sky as possible, turn "autofocus" off, and then focus the lens on infinity, which is shown as a number "8" on its side! Now set your lens aperture to about f/5.6 or a couple of stops down from fully open. Doing this will help to get sharper images as most camera lenses will not give sharp star trails when fully open. Set the film speed to about 800, point the camera due north and toward the north Pole Star, Polaris. You can find Polaris by following the two pointer stars in the end of the bowl of Ursa Major. It is useful to use this part of the sky to focus because the stars move the least in that direction, so you should be able to get pinpoint star images with exposures of around 30 seconds or so. Now you need to take a picture to check the lens is focused. If you have a remote control then use that to operate the shutter; if not, then the easiest way of doing this is to place a piece of card in front of the

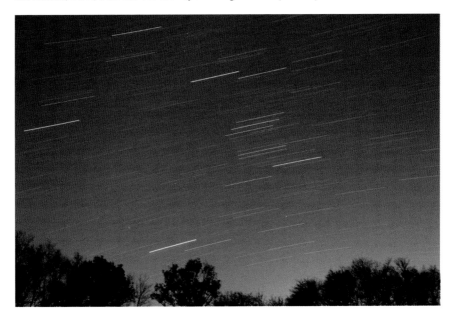

▲ *Star trails can be captured by using a DSLR attached to a tripod and taking a long exposure of the sky.*

▶ Polaris is found by following the "pointer stars" in the Big Dipper (part of Ursa Major). Identifying Polaris is key to achieving polar alignment.

lens, but not touching it, depress the shutter release, count for a couple of seconds to let any vibration die down, and then remove the card for the rest of the exposure. You should get nice pinpoint star images. Zoom in on the final image to look closely at the stars to check they are pinpoints. If they are a little squiggly then it is likely the movement of the mirror could have affected it, so put the card back in front for longer. If the stars are not sharp then you may need to tweak your focus a little, as I have seen many lenses which do not give sharp images when set to infinity, and repeat a test exposure.

An alternative approach is to switch on the "live view" function available in most cameras, which will give you the same view on the LCD panel at the back that the camera can see. Be cautious using this where others are doing astronomy, as the light from the panel can have an adverse impact on their ability to see in the dark. With "live view" turned on, line up the camera on the brightest object in the sky, ideally the Moon or a bright star, and zoom in as much as you can using the camera controls. Note that this technique only works on very bright objects and is unlikely to work on all but the brightest stars. While carefully looking at the view, adjust the focus until you have a nice sharp image. Having completed any of the techniques above and are happy that you have sharp pinpoint stars, you can move on to taking star trail pictures.

Step 2 Set exposures

Now you are focused, point the camera at the portion of the sky where you wish to capture star trails. It is worth considering the foreground when taking star trails as long exposures will almost certainly pick out foreground objects. Trees, interesting buildings or telescopes can add a lot to the aesthetics of your picture, so get creative and hunt down some nice scenes. Now turn off your flash and set your camera to its manual setting, as the pre-programed settings are of no use to astronomers, and set the exposure to "B" or "bulb," which will allow you to expose the camera as long as you like. Do be sure that your camera batteries are fully charged though, as you will need all the power you can get and they will not last indefinitely – be prepared to expect them to fail after a while, just hopefully not halfway through an exposure. You can get adapters for some cameras that allow you to plug them into the mains or you can get spare batteries so you can be charging one while using the other. Set the film speed or ISO setting to around 800, as the extra sensitivity will allow you to use a smaller

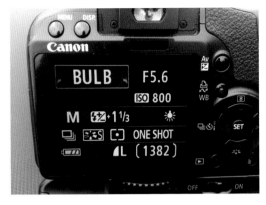

◀ Set the exposure to "bulb," the f/ratio to around f/5.6 and the ISO to 800 – and then experiment with different length exposures of the sky.

aperture on the lens, which means sharper star trails. Set the aperture to around f/5.6 or f/8 and, using the same technique as before, open the shutter using a piece of card to hide any vibration. If you can lock the mirror up then of course that will help enormously, and if you can get hold of an intervalometer (which counts intervals of time), you can do the whole thing remotely and not worry about vibration. I tend to connect my laptop to my camera and lock the mirror up so that I can be sure that there are no vibrations. Now, leave the camera exposing on the sky for about 10 minutes to start with. If you are pointing south then this will be plenty long enough to pick up star trails. Examine the image to check there is no sign of vibration and the trails are sharp. If the trails are too bright, use a smaller aperture, or if too faint, use a wider aperture.

Step 3 Take pictures

Now you can go for it and try a longer exposure of 30 minutes or even an hour. There are, however, two potential problems waiting to trip you up. The first is *noise*. We already looked at this briefly in Chapter 1 and it is the extra signals appearing in your final image, which come from electrical noise rather than the light of the stars. To remove this you need to put the lens cap on the camera straight after taking your image and take another image of exactly the same length of time. This effectively captures an image of the noise so you can then subtract this new "dark frame" image from your star trail image in software like Photoshop, which will remove the noise. The "long exposure noise reduction" setting does this for you, so if your camera has this it is worth turning on.

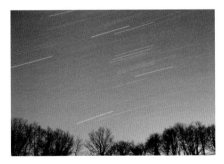 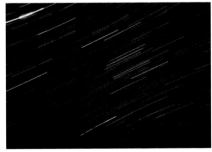

▲ A long exposure of the sky (left) will result in a bright sky caused by light pollution even though it may not be visible to the naked eye, but a much more pleasing result can be gained by stacking loads of short 30-second exposures (right).

▶ *Showing the rotation of the Earth, this image of star trails around Polaris is a combination of 30 individual pictures of 2-minute exposures stacked together. I was lucky and caught a meteor in this shot.*

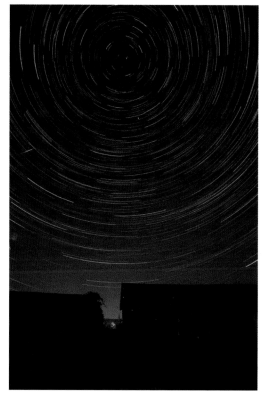

The other thing to look out for with long-exposure shots is *skyglow*. The longer the exposure, the brighter the sky will be. Sometimes the glow of lighting on the horizon can add to the shot but more often it looks unsightly – a way around this is to take lots of short exposures instead. For example, if you want to try to capture star trails for an hour, then try 2-minute exposures one after the other for the duration, to give you 30 individual frames. These can then all be stacked together in Photoshop to produce the hour-long star trails. This gives trail length but removes the effect of the buildup of light pollution. You could even increase the ISO setting to reveal more stars than you could with one single shot.

You can also experiment with your flash when taking star trails. Turning the flash on will mean it fires at the start of the exposure to illuminate your foreground object briefly without affecting the stars in the sky. It is worth trying it first without flash, as you will be surprised how clearly you can see foreground objects in long exposures without it. Pictures of star trails will reveal nicely the colors of the stars and will also show you how stars at different places in the sky move at different speeds. Those near the pole of the sky around Polaris move a lot slower so longer exposures are needed to reveal star trails compared to stars around the celestial equator due south, which move quicker. Knowledge of this is very useful when it comes to trying to capture images of the constellations.

Constellation shots

Probably a little more demanding than shots of star trails are shots of the constellations. With star trails you only need to worry about exposure so the sky is not overexposed, but to capture constellation images requires a little more thought around the focal length of the lens. You will also have learned from star trail photography that the location in the sky you are targeting will determine the speed objects move across the sky, and therefore how long an exposure you can get away with before star trails become noticeable. Stars along

the celestial equator in the south will be moving fastest, and as a very rough gauge you can get away with exposures with a 50 mm lens of about 10 seconds and with a 15 mm lens of about 40 seconds. Shorter-focal-length lenses will allow longer exposures whereas longer-focal-length lenses will be more demanding and require shorter exposures. These times can be increased the nearer to the celestial pole that you are shooting, as stars move slower in that region of the sky.

Set up your camera in the same way as for the star trail pictures, so turn off the flash and automatic focusing, focus on infinity, take a couple of test shots near the pole to get the focus right or use "live view" as we did before, and you are ready to go.

Step 1 Set exposures

Set the exposure at 30 seconds to start with and the ISO to 1600 to maximize sensitivity. Watch out for noise though, as there is more noise when using higher ISO settings. Some of this can be removed by taking a dark frame shot or using the "long exposure noise reduction" setting as we saw in the section on star trails, so make sure you turn this on once you have settled on an exposure. Point the camera at the constellation, which is actually easier said than done as you will not be able to see many stars through the camera's view finder. I find it easier to look through the view finder of the camera and keep my other eye open on the sky as well, so I almost get a superimposed view of the camera's field of view on the sky. You may find after a couple of shots that you need to adjust the direction in which the camera is pointing until you get it lined up nicely. Use a similar aperture to those for star trails, so start at about f/5.6 and try a shot of about 30 seconds or whatever is appropriate for the lens and direction you are pointing. If the stars have trailed you will need a shorter exposure, but you can increase sensitivity by either opening the aperture by one stop or by increasing the ISO setting. If you cannot see enough stars then use a longer exposure or increase the ISO setting or aperture. You will need to play around a little so do not be afraid to experiment.

Step 2 Take pictures

Use the same techniques to take the picture as we did with the star trail images. Lock the mirror up, or use a piece of card and remote control of some sort like an intervalometer to

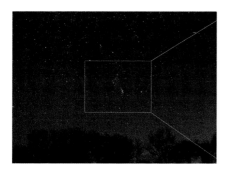 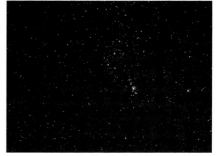

▲ *Different focal-length lenses will capture different amounts of sky. To the left is the region around Orion with a 17 mm lens and to the right with a 55 mm lens.*

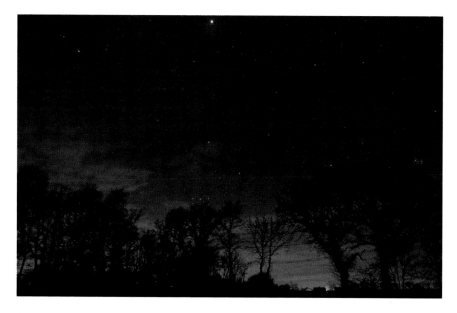

▲ *A higher ISO setting and a shorter exposure are needed to capture images of the constellations like this shot which shows Orion setting behind the trees, with Jupiter at the top.*

reduce camera shake. Do not forget to take a dark frame after your picture, which is more important now than it was for star trails as noise can be more problematic with pinpoint star images. As you will recall, you need to place the lens cap back on the lens and take a picture of the same duration as your star shot, which is then later subtracted through the use of software like Photoshop. Alternatively, use the "long exposure noise reduction" setting as we saw earlier.

Driven camera platforms

One of the great challenges in astrophotography is that the long exposures result in objects seeming to move during the length of the exposure. During normal DSLR photography the exposures need to be limited depending on the focal length of lens being used and on the area of sky being imaged. There is only so much tweaking that can be done to the ISO or aperture setting to maximize the amount of light the camera records, but a great alternative is to use a driven camera platform.

We have already looked at equatorial-style telescope mounts in Chapter 1 and seen how they turn a telescope at the same speed as the rotation of the Earth, but in the opposite direction in order to freeze objects in the eyepiece. Driven camera platforms do exactly the same thing but on a smaller scale. Once set up, they will move the camera slowly across the sky, keeping objects in the same place on the chip of the camera, so no longer do you need

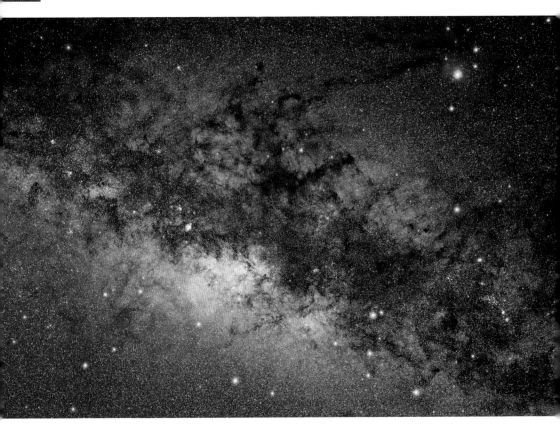

▲ *A driven camera mount allows you to use much longer exposures to capture the real beauty of the Milky Way.*

to worry about exposure times when taking images of stars and constellations. There are a couple of popular camera tracking platforms on the market, but they all generally work in the same way and require a sturdy camera tripod upon which the tracking platform is installed. Some of them have a built-in altitude adjuster to allow for polar alignment, like the iOptron SkyTracker, whereas others, like the AstroTrac, require an extra attachment on the tripod as we saw in Chapter 1.

Once attached to the tripod, both devices require polar alignment and in most cases this is a simple task. You will find a tiny little telescope, called a *polar scope*, which is attached to the tracking platform and is usually detachable. The first step is to identify Polaris, which can be done by locating the two pointer stars at the end of the bowl in the Big Dipper, part of Ursa Major. Now point the tracking platform so that the polar scope is pointing toward Polaris. Check that the latitude adjuster on the camera platform or the three-way head is set to roughly the same as your latitude, and if you are pointing in roughly the right direction you will see Polaris through the polar scope. You should find a switch to turn on the polar scope's illumination so that when you look through it again you will see some illuminated

chapter 2 GETTING IMAGES WITHOUT A TELESCOPE 49

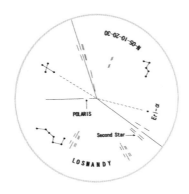

◀ *Polar scopes with illuminated illustrations like this one from the Losmandy G11 mount make polar alignment much easier.*

lines. Look closely at them, as you will notice that some of the lines depict the Big Dipper and the constellation Cassiopeia.

I find the next step is easiest done with both eyes open. As you look through the polar scope with one eye, gauge the orientation of the Big Dipper and Cassiopeia in the sky and slowly rotate the polar scope so that the orientation of the illuminated constellations in the scope matches their position in the sky. This has now positioned the polar scope correctly for polar alignment, so the next task is to adjust the orientation of the tracking platform in both azimuth and altitude to bring Polaris into the gap in the line that is marked "Polaris." There are two other stars that should be reasonably prominent in the field, particularly from a dark site, and these should be between the markers for the second and third stars. You will need to jiggle the rotation of the polar scope, the altitude and the azimuth adjustment to get them aligned. You may notice that the lines for Polaris and the second and third stars have a number of possible positions annotated by years. This is because the positions of the stars change very slightly over time, so just pick the year nearest to the current year for accurate alignment. Take your time with this polar alignment and it should get you pretty well aligned. With this you will be able to take long exposures over any portion of the sky and with focal lengths up to about 500 mm without any real trouble.

It is more essential now to have some form of remote control to activate the shutter so that you do not pick up any vibration in the system when taking pictures. I find that USB control from a laptop is by far the best, as you can change camera settings and activate most camera functions. Exposure times can now be as long as you like, although unless you are working in a very dark location you will still be limited

▶ *With a driven camera mount, much more detail can be seen in the constellations.*

by skyglow. You can avoid this by taking a number of short exposures, perhaps 5 minutes at a time, and then stack them all in Photoshop later. Camera settings for images with a setup like this can be a little more forgiving. Set the ISO to about 400 and the aperture to around f/5.6 and try an exposure of 20 minutes. You will be able to get some stunning shots of the Milky Way and be able to pick up star clusters – the Andromeda Galaxy and some of the wide regions of nebulosity around Orion and Cygnus are now well within your grasp.

▲ *There are many apps available that help you to identify the International Space Station and other satellites.*

Space Station and satellite photography

You might be surprised to learn that you can easily capture the numerous satellites that pass overhead on any given night of the year, as well as the International Space Station (ISS). Even though they orbit at many hundreds of kilometers above the ground, they are easily visible even to the naked eye. If you want to try and spot the ISS for yourself, you can log on to the NASA website where there is a visibility checker for it and many of the satellites. Alternatively, you could download any one of numerous smartphone apps that will get you looking in the right direction.

Photographing the ISS, or indeed any satellite, can be easy if you just want it tracking across the sky. I have seen some stunning images taken of the ISS through a telescope where you can see solar panels and an amazing amount of detail on the structure, but for now we can still capture it with a DSLR on a tripod, and the end result you are after will determine your approach. Either way, you will end up with a trail from the ISS against some pinpoint stars or a trail from the ISS against star trails. Both have their merits and can look stunning, although my preference is the ISS trail against pinpoint stars. To achieve such images we can use the DSLR either on a static tripod for short 30-second exposures before the stars start to trail or with a camera tracking platform to follow the stars over the period of the passage of the ISS. Depending on the orbital characteristics at the time of the pass, it can

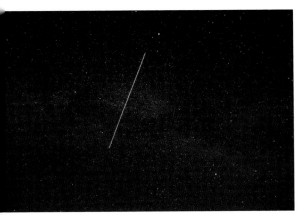

◀ *The International Space Station is a great target for a DSLR mounted on top of a standard tripod. This exposure was 30 seconds.*

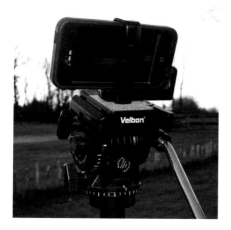

◀ *Special brackets allow smartphones to be attached to a tripod.*

be visible for up to 5 minutes. The trick to capturing the ISS in either case is to look at the details of its pass and find out which direction it will be in the sky at the middle of its passage. This information will be presented as its altitude measured in degrees above the horizon, and azimuth measured in degrees around the horizon from north. Sometimes you will find a chart of the sky with the path of the ISS superimposed, but whichever way it is presented to you, you need to identify roughly where in the sky the center of its passage will be and point the camera in that direction.

It is worth using a wide-angle lens as this will increase your chances of capturing it. If you are working on a static tripod, wait until it comes into view – you may well even be able to see it through the camera's view finder, so wait until it's in your field of view then take a 30-second exposure followed by a couple more to be sure of capturing it. If you are working on a tracking platform, start the exposure 5 minutes before it is due and end it 5 minutes or so afterward to enhance the images of the stars. If you are aiming for star trails then you can start the image whenever you like, but I would not suggest any longer than 30 minutes before it is due and leave the camera open until it has gone past.

However, you do not need a DSLR camera to get simple shots of the ISS, as reasonable results can be gained using a smartphone! There are some great apps like Magic Shutter that allow your phone to take long exposures of up to 60 seconds. You will need to get hold of a mechanism to attach your phone to a standard camera tripod to hold it steady, but these are readily available online or from local photography stores.

As before, you will need to work out roughly where to point to get you in the right direction. Set the exposure to 60 seconds

▶ *Apps can increase the exposure times available on a smartphone, allowing you to capture the International Space Station, as here, but do not expect too much from smartphone images!*

and the self-timer on the app to 5 seconds or more, so that any shake you induce by starting the picture dies down before the exposure starts. Just a few seconds before the ISS is due, start the exposure which will then begin after the self-timer delay has completed. Because of the abilities of modern smartphone cameras, try taking shots in cities or built-up areas if the ISS is going to be particularly bright to add to the composition. My first ever attempt at ISS photography with my smartphone was a real bodge job, as I discovered the app before I got hold of a tripod adapter. Using good old-fashioned ingenuity I set the delay to its maximum of 5 seconds, and when I was ready I started the exposure and very quickly secured the phone to a book with an elastic band and propped the book up at the right angle (very approximately) for the ISS passage. It worked, just, but the stress levels attached with this approach are not to be recommended!

Meteor showers

You may be incredibly lucky and find that on some of your shots of the constellations a long and unexpected streak has appeared. It might be a satellite, of course, but their streaks tend to be fairly consistent in brightness, or it might be an aircraft, but you can usually spot these because of the intermittent dashed lines associated with them as their navigation lights flash on and off. If you have ruled out both of these then you may well have captured a meteor in your picture.

It is possible to see meteors on any night of the year and these random and unexpected events are described as *sporadic*. Throughout the year, though, we are treated to expected meteor events, known as *meteor showers*, and there are about 20 decent ones each year. Meteors are often referred to by their common name of "shooting stars," but in reality they are nothing to do with stars even though their appearance suggests otherwise. Instead, they are chunks of rock, sometimes only a millimeter or so in size, which are plummeting to Earth leaving behind them a trail of ionized gas that we see as the characteristic streak of light.

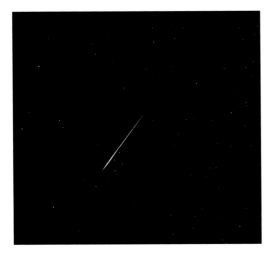

In most cases, meteors will get destroyed high up in the atmosphere, but larger pieces of rock can survive the fiery plunge to Earth, at which point they are known as *meteorites*.

As Earth travels through space we will often pick up random bits of rock, but when we experience a meteor shower something special is happening: the Earth is passing through the orbit of a comet. As it does, it sweeps up some of the debris left behind by the comet, like a great celestial vacuum

◄ *Capturing meteors requires a little bit of luck – you need to be pointing in the right direction at the right time.*

▶ *Longer exposures increase the chance of capturing a meteor and, if lucky, you might get more than one!*

cleaner; all the debris then falls to Earth and we see a meteor shower. Meteors from most showers are visible a couple of weeks before and after their peak, which usually happens around the same day each year. From Earth, we see that all meteors seem to come from one point in the sky, known as the *radiant*, and it is the location of the radiant from which we get the name of the shower, such as the Leonids from Leo, the Geminids from Gemini and the Perseids from Perseus.

Capturing meteors on camera is challenging and, to an extent, very reliant on simple luck, as you must be taking a picture in the right direction at the time a meteor appears in the same patch of sky. My first attempt at getting a new meteor image for this book was during a Perseid meteor shower, which did perform quite nicely – but every time I took a picture a meteor appeared in a different part of the sky! Very frustrating, but fear not, there are things you can do to increase your chances of capturing an image.

You will have a greater chance by covering as large an area of sky as possible. Most DSLR cameras come with a pretty decent zoom lens as standard and these can offer quite a wide-angle field of view. My Canon camera came with an 18–55 mm lens, but the quality was not great so I now use a fixed-focal-length, wide-angle lens for meteor work.

Deciding where to point the camera is probably the most critical decision, and you might think that pointing toward a meteor shower's radiant will yield the best results, but unless you have a very short-focal-length lens you are likely to miss most meteors. Meteors visible near the radiant will usually produce a very short streak and will often be fairly faint, so although it seems to go against common sense, the best place to point your camera is away from the radiant. I generally aim a camera between 40°–60° away from it and usually at least 45° above the horizon. This will give you a band of the sky where you are likely to see the most meteors. From now on, though, it is down to luck whether you have picked the right portion of the patch! Invariably, you will be midway through taking a picture and catch one out of the corner of your eye. Do not be tempted to stop the exposure and then point to that patch of the sky. I find good old Murphy's Law comes into play here – move the camera to where that meteor was and I would bet a lot of money that one will appear where you were just pointing. Welcome to the frustrating world of meteor shower photography!

To increase your chances you should also consider the time of night that you are imaging because the peak of a meteor shower will occur at a specific time, so ideally you need to be up and running around that time. Regardless of the exact moment of peak, the most meteors will be seen in the early hours after midnight. This is because you are on the forward-facing hemisphere of the Earth and, like a car driving through a rain shower, all the impacts happen on the "front." Ideally, the peak of the shower should be in the early hours for your location,

but invariably this is not the case so instead aim to be imaging the morning closest to the peak of the shower. If you are really lucky, the radiant will be nicely placed for you too, giving you the best chances.

Choosing camera settings for meteor photography is a little dependent on the conditions and the result you wish to achieve. Much like capturing satellites and the ISS, you can work on either a static tripod or a camera tracking platform. If the Moon is visible and bright then the glow from it will limit how long you can expose for, as the sky will brighten dramatically. If this is the case for you, then limit exposures to no more than 30 seconds and point well away from the Moon. Try shutting the aperture down a little more than you would ordinarily, say around f/8, and use an ISO setting of around 400 or 800. It is not worth using a tracking platform if the bright Moon is visible, as light from the Moon can limit exposures far greater than the movement of the stars. However, if the Moon is out of the way, then you can afford a higher ISO setting to help capture fainter meteors, but keep the aperture about the same to make sure they are nice and sharp. Experiment with the settings using these as a guide to get the result that suits your taste. Trying a camera tracking platform will allow you to get nice pinpoint star images over longer exposures, so try rattling off some 15-minute exposures with settings around f/5.6 or a couple of stops down from wide open and an ISO of about 400. Sky brightness from light pollution may require you to have a fiddle around with these settings so do not be afraid to experiment.

Photographing aurorae

Aurorae are a great and somewhat forgiving target for astrophotography. The auroral displays are caused by electrically charged particles from the Sun (known as the *solar wind*) that have hurtled through space at speeds in excess of 400 km/sec. On arrival at Earth, they get channeled toward the north and south poles around the planet's magnetic field lines. For this reason, they are more common around the polar regions of the Earth and are less common the nearer you get to the Equator. At latitudes around the UK, displays are visible quite often in the far north but less so on the south coast. The ghostly glowing curtains of

light in the sky are the result of the solar wind causing the gas atoms in our atmosphere to glow, in much the same way as a fluorescent tube gives off light. The intensity or indeed presence of an auroral display varies with the strength of the solar wind, which in turn changes with the activity of the Sun. We know the Sun varies over an 11-year cycle, and at its peak auroral displays are common.

◀ *Sunspot activity is an indicator of the levels of magnetic disturbance on the Sun.*

If you have ever seen an auroral display then you will know that they are great fun to observe. They can go on for hours, quietening down before building up again, or can last for just a short while. From the UK the displays often hug the northern horizon, but the really big displays can cover a good portion of the whole sky. I remember one event many years ago when the sky was illuminated by a strangely eerie, moving and changing but silent, glow of light. The colors that you can see will be determined by the gas that has been excited by the solar wind and by the height in the atmosphere to which the charged particles penetrate. The red glow comes from oxygen molecules at about 300 km altitude, while oxygen at about 90 km produces a yellow-green color. The blue and green colors are produced by nitrogen and oxygen interacting lower down, and the pink colors that are occasionally seen are produced by a slightly different type of nitrogen. There are some great online resources that will show you if a display is likely so wait for those moments before heading out.

If an alert is on then you need to get your camera equipment together. A static tripod is all you need as you will not really benefit from a camera tracking platform because the movement of the aurora will limit your exposure times before star trails are likely to be a problem. Make sure that you have removed all filters from your camera lens as these can cause strange effects on your final image. Now all you need to do is keep an eye out for auroral activity, so to maximize your chances look toward your nearest pole: from the northern hemisphere look toward the north, and from the southern hemisphere look to the south. It is best if you can make sure you have no sources of light pollution in the direction you are looking, otherwise delicate auroral displays may be lost. Be ready to act quickly because they can flare up with little notice. If you cannot see anything, then while you are waiting try taking some shots low near the horizon, because you may be surprised to find a subtle display on the go that is undetectable with your eyes.

Camera settings are a little different for auroral photography. If there is a really bright display that is easily visible to the naked eye then you can try setting the camera to

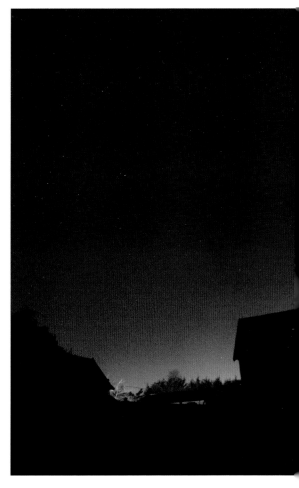

▶ *It is not unusual to see auroral displays from the UK, but they tend to be quite subtle.*

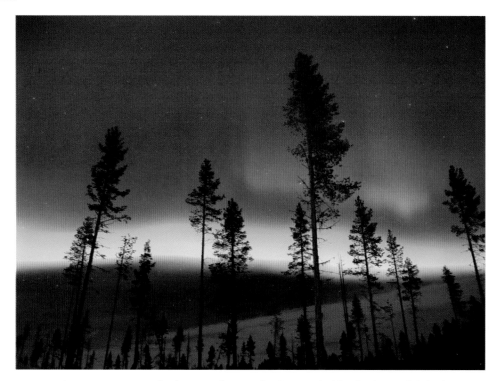

▲ *More impressive displays can be seen further north, like this beautiful display captured by Mia Stålnacke from Sweden.*

"aperture priority" mode. This is often displayed as "A," "Av" or "Ap" on the camera mode dial. With this set, and with a wide-angle lens, you then open the aperture of the camera as wide as possible and take the shot. As usual, a cable release or intervalometer is useful to remove camera shake and you can also use the "mirror lock" function to help. The camera will then automatically expose for the scene, but this technique only works on bright displays. For others you will need to resort to manual mode or "B" – with the aperture set wide open try exposures of around 30 seconds at first. Use a high ISO setting to give as much sensitivity as possible and ensure that "high ISO speed noise reduction" is turned off.

Noctilucent clouds

Capturing the elusive noctilucent clouds can be as challenging as aurorae. Their name gives away their origin as clouds that shine eerily at night, but it is not just their appearance which is mysterious. The clouds are thought to exist high up in the mesosphere at around 80 km, and because of their altitude they are still illuminated by the Sun when those of us down on the ground are entering the darkness of night. As a result, they seem to be strangely illuminated when the sky has darkened after sunset. We are not too sure what causes them

although there are a number of theories. Perhaps the most popular is that the tiny amount of water vapor in the mesosphere (and studies suggest that it is a million times drier than the Sahara Desert) instantly sublimates from vapor to liquid around tiny microscopic dust particles, possibly micrometeoroids from space. For now, though, all we can do is enjoy their enigmatic beauty.

They seem to be visible during late spring around May and June, almost like clockwork, and are seen after sunset over in the northwest. Keep an eye out once the sky has started to darken at this time of year and you might slowly see wispy clouds glowing with a white-blue color. They do seem to change their appearance over time and this can be quite fast. If you spot a display, reach for your camera, tripod and remote control, and see if you can capture their beauty.

Make sure the "long exposure noise reduction" setting is turned off, as you do not want to lose valuable time taking images of the display due to the camera taking its own dark frame, and disable the flash as well. Be sure you note which exposures you are taking so you can take dark frames after the display has finished and subtract them in image processing later. Set the ISO to 400 or 800 and set the aperture as wide as possible, around f/2.8. Try exposures of around 20 seconds if you are using a wide-angle lens, or shorter if you are using something with a longer focal length. It is best to keep the exposures short as the clouds can move around, so you want to try and avoid picking up this motion. Sometimes there are great levels of detail visible in a display, so do not be afraid to try and zoom in even as high as a 200 mm lens, but you will need exposures of about 5 seconds to capture them. You may find you need to increase the ISO to boost sensitivity, and if you do start to use ISO 1600 or more, be sure to turn on the "high ISO speed noise reduction" setting. Noctilucent cloud displays can vary quite significantly in brightness so you may need to play about a little with the settings to capture them at their best.

It is also worth having a play around even if you have secured some good shots already. Try a wide-angle setting with some interesting foreground objects in the frame like a tree or

▼ *Noctilucent clouds only require a DSLR and tripod. This image is a panoramic shot made up from four images, each one at ISO 400, f/4.5, with an exposure of 20 seconds.*

an interesting building and an exposure of about 20 seconds. If your ISO setting is high then you may well pick them up already, but you can always turn on your flash to fire at the start of the exposure to illuminate them nicely, giving the resultant image a strangely surreal effect.

Lunar photography

Probably one of the most frustrating objects to try and capture is the Moon. I have had requests for help from many people over the years who have seen a beautiful moonrise and tried to capture it on camera, only to be disappointed with the tiny white dot resembling our closest astronomical neighbor. There are a couple of reasons why the Moon will look small in pictures: the first is because of the lens you are using. Your eyes are equivalent to a focal-length lens of about 50 mm – but for most cameras you will probably be using a shorter focal length and so it will appear smaller. The other reason is because of something known as the "Moon illusion," which makes the Moon look artificially big when it is near the horizon. The brain takes distance cues from objects on the horizon and makes the assumption that the Moon must be further away than when it is higher up in the sky. As a result of this strange yet false assumption, the brain then works out that if the Moon on the horizon is further away yet appears the same size on the back of your eye, then it must actually be bigger when lower down! This crazy effect of the human brain is known as the "Ponzo illusion." So we "see" the Moon as being bigger than it really is, but a camera with a 50 mm lens will give you a reasonably accurate representation of how it actually looks.

Somehow we need to make it bigger, yet even with modern high-resolution CCD chips and digital zoom capability, many cameras will fail to capture the fine lunar detail that you can see with the eye. I have seen many failed attempts with new high-quality mobile phone cameras, since even these have limitations as digital zoom and lots of megapixels will only help so much. The problem with relying on digital zoom is that it not only increases the size of the Moon but also increases the size of the pixels, so although the Moon gets bigger, the resolution or level of detail in the picture remains the same. However, using longer-focal-length lenses not only increases the image size but also increases the resolution, so you get more information stored on your chip. The solution then is to increase the focal length of lens you are using to produce a bigger image on the chip of your camera.

The Moon measures about half a degree across, but to make sure it is framed nicely it needs to have a further 0.25° of border top and bottom along the short edge of the camera chip, giving a total of 1°. From this

◀ *A small-scale lunar image can be captured with a DSLR and 50 mm lens, but reveals very little of the Moon.*

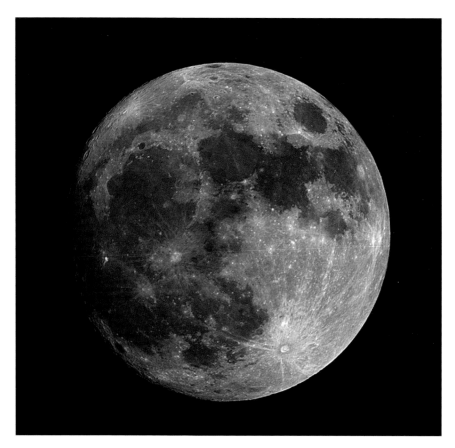

▲ *Attaching a DSLR to a telescope allows much more detail to be recorded. This image of the Moon is a mosaic of nine individual images.*

information, you can work out the ideal focal-length lens to use with your camera. I use a Canon 450D for most of my astrophotography, which has a CCD chip that is 22.2 × 14.8 mm. If I take the shortest of those dimensions (14.8) and multiply it by 57, then divide the answer by 1°, this gives an ideal focal length of 843 mm. That is longer than most camera lenses, so you can either attach it to a small astronomical telescope or use a telephoto camera lens with any of the available teleconverters on the market. The only thing to consider with these is that their use will reduce the quality of the final image and reduce the "speed" of the lens, so if you were using a long-focal-length 300 mm lens which operates at f/5.6, then a 2× teleconverter would produce a 600 mm focal length, but the maximum aperture would be f/8 so exposures will need to be a little longer to compensate.

A telescope is by far the best solution for capturing close-ups of the Moon so we will look at that in Chapter 3. For now, though, let us assume we are using the 300 mm lens with the 2× teleconverter, and to set expectations let us work out just how big the image of the Moon will be. We can do that by simply dividing the focal length by 109, so using a focal

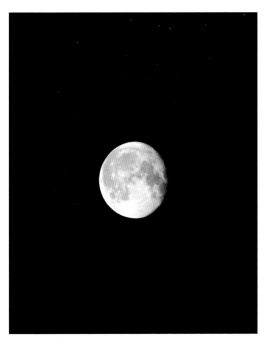

◀ *Longer focal lengths are needed to capture the Moon like in this image, which was taken with a 500 mm lens.*

length of 600 mm and dividing that figure by 109 tells us that the image will be 5.5 mm on the camera chip. Compare that to the size of the chip in my camera, for example, which is 22.2 × 14.8 mm, and you will see that the Moon will fill a little under half of the height of the chip. This is a small image but the digital zoom will allow us to make that a little bigger, with the quality depending on the size of the pixels in your camera and the quality of the lens. If we used the ideal focal length of 843 mm then the image would be 7.7 mm, which although only 2.2 mm larger will give much more detail. As you can see, only a telescope will provide you with an image that fills the camera chip.

Now that we have solved the issue of having a tiny image of the Moon, we can consider the other common problem, which is a bright white blob of light with no detail. The solution to this problem is found in the exposure settings of the camera. It is common for automatic exposure settings to be used when taking pictures and if a camera is pointed at a scene at night that includes the Moon, its relatively small size means the exposure is calculated on the scene, not on the Moon, and to allow the scene to be exposed properly a longer exposure is used, leading to an overexposed image of the Moon. If the exposure was correct for the Moon it would be shorter, but the scene would just be black! If you

Mark's guide to photographing the Moon

Exposure times for the Moon vary not only with focal length and aperture but also with the phase of the Moon. A full Moon is much brighter than a thin crescent so getting it right does require a little practice and experimentation. The guide below will give you a good starting point.

Camera set to ISO 100:

	Full Moon	Gibbous	First/Last quarter	Thin crescent
f/8	1/250	1/125	1/60	1/15
f/11	1/125	1/60	1/30	1/8
f/16	1/60	1/30	1/15	1/4

are trying to capture a scene with the Moon, then you will need two pictures: one exposed for the scene and one exposed for the Moon. The two images can then be added together during processing later.

Assuming that you are trying to capture an image of the Moon on its own, then you will need to set up your camera with telephoto lens and attach it to your tripod. For long-focal-length lenses, you need a very stable tripod because not only are you magnifying the image of the Moon but you are also magnifying any tiny movements of the camera. Set the ISO to 100, which is slower than the settings used until now. There is a level of noise associated with higher ISO settings, and there is enough light from the Moon which means that slower settings can be used for better image quality. It is also worth turning off the "high ISO speed noise reduction" and "long exposure noise reduction" settings as

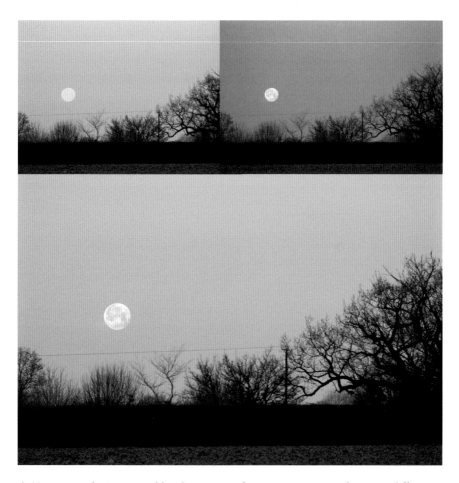

▲ *To capture the Moon and landscape it is often necessary to combine two different shots, one exposed for the landscape (top left) and one exposed for the Moon (top right). These can then be combined in Photoshop for the final result (bottom image).*

◀ Using "live view," which is available on most modern DSLRs, will make focusing on the Moon much easier.

they serve no real purpose in lunar photography. We can afford to use a smaller aperture to get a sharper image because there is plenty of light, so set this at about f/8 or f/11 and use an exposure of about 1/125 or 1/250 second. You will need to experiment with the settings a little as conditions vary from night to night, and sensitivity from camera to camera, but these will get you in the right area.

Line up the Moon in the field of view of the camera and you can then try to focus it automatically. Depending on the size of the Moon in the field of view, you may be able to acquire a sharp focus easily. If this does not work then you will need to switch to a manual focus technique. You can try focusing the lens on infinity, which is depicted on the lens by a sideways "8," and take a shot of the Moon. Using the digital zoom controls, zoom in on the resultant image and check that the focus is right. Do not worry too much about the exposure settings as these can be adjusted once you have got the focus right. You may find that even though you have set the lens to focus at infinity it may still be slightly fuzzy, as some lenses do allow you to focus "beyond" infinity, so this will need further adjustment. An alternative is to switch the rear LCD panel on to "live view" mode, which will give you a real-time view through the camera. You can then digitally zoom in on the Moon and adjust the focus without having to take pictures to check it. This is a little quicker than the previous approach but either manual technique works.

The appearance of the Moon changes throughout the month as its cycle of phases progresses, so a great project is to try and get pictures that capture these changes. But caution will be needed when trying to photograph the thin crescents of the very young or very old Moon because it will lie close to the Sun in the sky.

The changing appearance of the Moon is more apparent during lunar eclipses when the Earth passes between the Sun and the Moon, temporarily blocking sunlight from reaching it. During the partial phases of the eclipse you can use the previous settings to get you close to the right exposure, because it will in essence appear like the Moon at one of its phases, albeit in a slightly different way. You will find that as the eclipse deepens, the bright illuminated portion of the Moon will slowly darken, and as it does, you will need to increase exposure times, ISO settings or aperture to compensate. If possible, increase exposure before trying the other two. During totality you will need to increase the ISO setting and aperture a little

to ensure you can capture the details. You will have to have a bit of an experiment as the brightness of a lunar eclipse is determined by the amount of dust in the atmosphere of the Earth. Some total eclipses can appear a dark brown and require longer exposures, larger aperture and higher ISO settings to record them, whereas others appear deep blood red but brighter, so you can get away with shorter exposures.

Solar photography

Capturing the even more elusive solar eclipse requires a little more preparation and greater caution. The Sun emits a vast amount of energy and it is unsafe to look at it even with the naked eye, as doing so can lead to potentially irreparable damage to your eyes. Pointing any kind of magnifying device, be it binoculars, a telescope or even a long-focal-length lens, is putting your eyes at even more risk. Optical devices like these magnify not only the light but also the heat coming from the Sun. I once put a thermometer at the eyepiece end of a telescope only to find a temperature of around 500°C coming out – you certainly do not want that going into your eye. The magnified light and heat can also cause damage to any imaging equipment you may be using, but there are techniques you can use that are perfectly safe.

The easiest and safest method is to use a full-aperture filter such as Mylar or Baader AstroSolar film. These materials look like thin sheets of aluminum foil and usually come in

▲ *Solar filters on telescopes and camera lenses can be used to safely capture white-light images of the Sun, but always take care that they show no signs of damage* **and ensure any non-filtered optics are covered up**.

▲ *White-light solar images can reveal sunspots, granulation and faculae. Just like images of the Moon, long focal lengths of 500 mm or more are needed to get a good-sized image.*

A4 sheets – a pack of them generally costs no more than about $40. Before use, study them carefully indoors against a light bulb to make sure there are no pinpricks or tears in them. Look very closely and examine the entire sheet, and, if all is OK, then go outside on the next sunny day and give it a try. Place the material close to your eyes and then look toward the Sun – go right ahead as it is perfectly safe. Depending on the material you have bought, you will see either a white or an orange image of the Sun. Look really closely and see if you can spot any dark spots on the surface – these are real features on the visible surface of the Sun and are known rather unimaginatively as *sunspots*. You can use this same material to look at the Sun through a telescope, binoculars or a camera, but when you do, make sure you have fixed it securely to the front end of the instrument (so it cuts down the energy before it enters the optics), so it will not blow off or move while you are looking through it.

To safely fit the filter to a camera lens, you first need to carefully cut out a smaller piece of the material that is large enough to fix across your camera lens. It must then be securely attached, which can be achieved by the use of either a couple of rubber bands (just in case one breaks) or some good strong tape like gaffer tape. As you fix it across the front of the lens, do not worry about getting it too taught as it may rip. A few tiny ripples will not affect the quality of the image as the film is so thin. It is also best to only handle the film around the edges as you work with it.

Which lens you fit it to should be given the same consideration as the lens choice for taking lunar shots, because the two objects are roughly the same size in the sky. Ideally, you should aim for focal lengths of around 600 mm if possible, but if you cannot get this

high with your lenses then get as high as you can using any teleconverters you may have; for example, a 200 mm lens with a 2× teleconverter will give you 400 mm focal length. Once you have the lens attached with a solar filter and the camera attached to a tripod, you can now set the camera up for taking the pictures. If your camera allows it, then it is worth using "live view" rather than looking through the view finder of the camera; this just gives your eyes a little more protection.

In order to get the camera pointing at the Sun without looking at it yourself, there is a really neat trick you can use by looking at the camera's shadow on the ground. Look at what happens to the shadow as you move the camera around – you should notice that it gets a little bigger and then a little smaller. To line up on the Sun you need to get the shadow to look as small as possible, and only then should you be perfectly aligned. Look at the "live view" image on the rear LCD and you should see an image of the Sun, although you may need to scan the sky in that area using tiny movements to locate it. You might also find that the Sun is out of focus even if you have set the lens focus to infinity. Now is the time to adjust the focus of the image before turning your attention to the exposure settings. Depending on the lens you are using, you may need to focus on a very distant object first as some lens focusing rings are at the front of the lens, which is now covered by your solar filter!

Set the camera mode to manual and the ISO setting to 100 or 200. This will give you the highest quality of image. With the Sun this is quite important as the visible surface, which is known as the *photosphere*, has many delicate granular features and using a higher ISO

▲ *Capturing solar eclipses requires adjustment of exposure times as the eclipse progresses.*

▲ *Solar eclipses are beautiful to watch and challenging to capture. Careful use of exposure can reveal stunning detail in the corona of the Sun.*

setting can make them less visible. Initially, try an aperture of about f/11 and exposures of around 1/250 second, but you will need to have a little play around to get the best exposure for your setup. A setup like this will allow you to capture not only sunspots but also delicate surface detail like granulation or faculae.

Taking images of an eclipse of the Sun follow broadly the same approach. For the partial phases you can follow the techniques we have just discussed, but when the moment of totality arrives, then and only then, you can remove the filter from the camera lens and shoot unaided. As the moment of totality approaches, the last remaining portion of the bright solar photosphere will start to disappear fairly rapidly as the Moon moves in. The rugged nature of the limb of the Moon, which is the result of mountains and craters, allows patches of the bright photosphere to shine through, appearing like a string of beads along the limb of the Moon. This effect is known as *Baily's beads* and this is the first moment you can try and capture images of the eclipse without a filter – but it is still **NOT** safe to look directly at the Sun yet. Try an aperture of f/11 (still at ISO 100) and an exposure of about 1/1,000 second to capture the effect.

When the final bead is visible, the beautiful *diamond-ring effect* can be seen, where the photosphere resembles a glittering diamond upon a ring made up of the faint corona of the Sun's outer atmosphere surrounding the silhouette of the Moon. Stick with a similar exposure to capture this, but once the diamond-ring effect has subsided you will need to increase your exposure times. Keep all other settings the same and try increasing exposure

to 1/250 second to capture the brighter prominences or 1/30 second for the inner corona. The fainter outer corona of the Sun is where a lot of detail can be found with longer exposures from around half a second for the brighter portions to as much as 10 seconds for the outer corona itself. Depending on the focal length of the lens you are using, you may find it better to increase the aperture by a couple of stops so you can keep the exposure times down, otherwise you may find the movement of the Sun will cause blurring of the image. You will need to work fast though, and make sure you "bracket" exposures in both time and aperture by selecting settings either side of your intended setting to be sure of getting the right exposure. **Beware:** as soon as you start to see the first hint of the photosphere returning you need to stop looking at the Sun without protection instantly, start shortening exposure times again as we did earlier for the diamond-ring effect and Baily's beads, and return to filtered images for the remaining partial phases.

A great addition to your equipment for solar eclipse or general solar imaging is a pair of "eclipse" glasses. These are usually made of cardboard and use either Mylar or Baader AstroSolar film to give you a hands-free, safe view of the Sun. With these, you can look at the Sun as much as you like during eclipses or on a normal sunny day. My last piece of advice when it comes to solar photography like this is to exercise extreme caution. You only have two eyes and the immense power from the Sun, including the unseen ultraviolet (UV) and infrared (IR) radiation, can cause irreversible damage. Follow my advice, though, and you can secure some beautiful shots of our local star in safety.

Hopefully, by now, you have got the hang of using a conventional DSLR camera to take pictures of the night (and sometimes daytime) sky. The techniques we have used have focused attention on a camera with standard camera lenses and a tripod with or without a camera tracking platform, depending on application. We have looked at how there is a careful balance and compromise between aperture, exposure times and film speed, and how adjusting one will affect the other (for example, shorter exposures mean you need a larger aperture). In reality it is a bit of a juggling act with a little trial and error, but with practice your experience will soon build and you will be producing stunning shots of the night sky.

Now that you have mastered this method of astrophotography, let us move on to Chapter 3, which will introduce you to the wonderful world of webcam imaging to get beautiful high-resolution images of the planets and the Moon through astronomical telescopes.

chapter 3
SOLAR SYSTEM PHOTOGRAPHY

THE PREVIOUS CHAPTER looked at different ways of capturing the night sky using just a camera, which can yield some beautiful results, but after you have mastered those techniques you may yearn to get up close to the planets. To do this, the only real solution is to use a telescope. It is easy to understand why a telescope is needed if you think back to the section where we discussed the focal length of lenses and the capturing of lunar images. You will recall that the longer the focal length, the bigger the image on the chip of the camera. The Moon is already half a degree across but even Jupiter, the largest planet in the Solar System, appears 30 times smaller when at its closest to us. To get a decent image size of Jupiter and the other planets, the longer focal length of a telescope is needed. My telescope operates at a focal length of 3,000 mm and with a 2× Barlow I can get it up to 6,000 mm, but you will never find a camera lens capable of that.

Shooting images through a telescope comes with its own challenges, many of which are really only of importance when you start working on longer exposures for deep-sky objects like galaxies, star clusters and nebulae. Imaging the planets does come with its own set of

▲ *Smartphones can be held to the eyepiece of a telescope to capture close-ups of the Moon and the planets.*

▶ *Special adapters can be bought to hold a smartphone securely and steadily to the eyepiece of a telescope.*

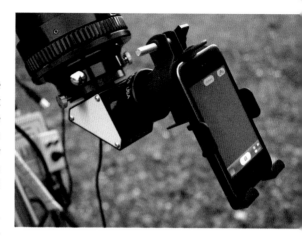

difficulties, but these are easily overcome if you know how. This chapter looks at the techniques for capturing images of the planets, the Moon and the Sun through an astronomical telescope. We start with easy approaches, from using your phone camera all the way through to using webcams and DSLRs to produce high-resolution shots.

The ideal telescope for planetary photography is one with a long focal length for large image scale and large aperture, not for light gathering but to reveal a high level of detail on planetary surfaces. Unless you choose your telescope for planetary work in particular, then the chances are that you will be working with something less than ideal. However, that does not mean you will get rubbish images – far from it. Even with a short-focal-length, small-aperture telescope you can still get some great shots.

An easy way to get started is to use your smartphone and photograph the image that you can see as you look through a telescope eyepiece. This technique is known as *afocal photography*, where the telescope and eyepiece produce an image made up of parallel beams of light and a camera then records the image. This technique is used with normal cameras, and with modern smartphone cameras the approach also works well. The only drawbacks are that it produces a narrow field of view, which means the camera must be perfectly lined up on the center of the field of view otherwise the target may not be visible, and the resultant picture can be quite dark. The dimming of the image is one of the reasons why this technique is not ideal for deep-sky photography. My first attempts at afocal photography of the Moon with my smartphone were done without any gadget to hold the phone in place – I was using my hand. It was tricky and took a lot of patience, but with the telescope drive following the Moon across the sky, all I had to do was watch the phone screen until it was lined up and snap.

As you can see from the image on the facing page, the result was pretty good but this can be improved dramatically by purchasing one of the many attachments that connect a smartphone to a telescope. Usually they provide a mechanism to clamp around the eyepiece and adjust the position of the phone so that its camera aligns to the eyepiece. There are many camera applications that can help you capture the picture, but it is best to choose one that has a timer delay function. This means you can operate the camera but there is a delay before the picture is taken to allow for any vibrations to die down. This is not so essential for this type of photography as the exposures are pretty fast but is still worth doing to get the best results.

One of the secrets of getting great planetary and lunar shots with telescopes is to pick the nights when the weather conditions are right. As we look out into space, we peer through a 100 km thick atmosphere made up of ever-moving gas. The movement of gas is driven mostly by the heating from the Sun, which causes it to rise as it warms and sink as it cools.

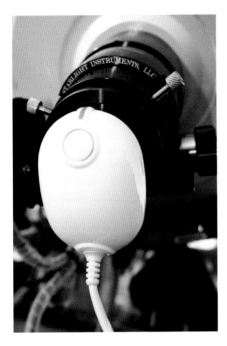

◀ *A webcam attached to a telescope is a great way to capture the planets in close-up.*

Meteorologists talk of the conditions in the atmosphere as being stable or unstable. As astronomers, we can see the effects of this stability or instability in the way it moves around the light from astronomical objects. I am sure you can remember the childhood song "Twinkle Twinkle Little Star," which comes from the fact that stars twinkle in the sky as a result of the movement of gas in the atmosphere. If you look at a magnified image of the Moon or planets you might see this movement as the constant shifting around of the image as the light gets disturbed. The image may come in and out of focus too on some of the worst nights while you watch. This is all the result of an unstable atmosphere and astronomers refer to this as "seeing" – the more unstable the atmosphere is, the worse the seeing.

Bad seeing is not such an issue for visual observers as you can just sit and wait for the moments when the sky settles, but for photography it can be a real problem as you can never tell when the good bits will occur, so you have to keep snapping away. Your chances can improve, though, if you pick a night when the atmosphere is stable, typically associated with a high-pressure system.

Smartphones can achieve some pretty impressive results, but to get superb results a webcam is the ideal camera. As we have just seen, one of the real challenges of high-resolution planetary imaging is the stability of the atmosphere and the necessity to keep shooting individual frames until you get a good one. A webcam is perfect for the job because it takes a movie made up of hundreds, sometimes thousands, of individual frames, and among those will hopefully be moments of wonderful seeing. You can just extract these individual frames or, better still, load the entire video into free software such as RegiStax which can break up all the individual frames, allowing you to get rid of the rubbish ones where the seeing was poor and keep only the best. These are then all combined and stacked to produce one stunning image which can be processed further to enhance fine planetary detail.

Before we look at capturing the movie, it is worth taking a look in a little more detail at getting the webcam and telescope prepared for astronomical imaging. We saw in Chapter 1 how one of the more important factors when choosing a webcam is that its lens is easy to remove. I made the mistake of buying my first webcam without considering this and ended up spending far too long trying to get the lens off and get an adapter attached. It never really worked so I had to buy another webcam that did have a removable lens. This was

a sensible move, I discovered, as it took no more than a few minutes to remove the lens and replace it with an off-the-shelf telescope adapter that simply screwed into the lens thread.

With the telescope adapter in place, it is also worth investing in an infrared blocking filter which then screws into the front of the adapter. There are two reasons for using one of these filters but both will result in sharper, better-quality images. As light from the planets passes through the atmosphere, its path gets moved or refracted in an upward direction toward the zenith, so objects appear very slightly higher than they actually are. The amount of refraction is not only dependent on the altitude of the object but also on the wavelength of light, with shorter wavelengths being refracted more. By refracting shorter wavelengths more than longer wavelengths, the image of a planet actually gets spread across the sky (by a very small amount), appearing as a tiny spectrum in the sky. This is known as the "atmospheric dispersion of light." Using an infrared blocking filter will go some way to removing the blurring due to this effect.

Another more problematic effect for the webcam imager is found in the way the webcam works. Nearly all webcams are effectively one-shot color cameras, which means the pixels on the chip are behind either a red, green or blue filter. A color image is built up by recording the light captured by this matrix of different colored pixels. It turns out that these filters not only let their respective colors through but they also let infrared through. Infrared light is at the opposite end of the spectrum to blue light, so, with its longer wavelength, is refracted less than blue light. This means its "image" in the sky is in a slightly different position to the image formed by blue light, because of atmospheric dispersion. The result is that the image formed in the blue pixels is blurred by the infrared image, as is the green image but by a lesser amount. By using an infrared blocking filter, this blurring effect on the blue and green channels is removed.

It is not just atmospheric effects that can be reduced with an infrared blocking filter, as images taken through some lower-quality telescopes will benefit too. Like the atmosphere, glass also refracts incoming light – indeed, it is this principle that allows a refracting telescope to work. If a refracting telescope has just one piece of glass making up its lens then it will suffer from an effect known as *chromatic aberration*, where different wavelengths of light come to a focus at slightly different points. Looking through a telescope like this will reveal an image that has a colored halo surrounding it, and it would not be possible to get a nice sharp and correctly colored image. By adding more pieces of glass to the lens or by using specialist types of glass these problems are resolved, but telescopes like this are more expensive. The use of infrared blocking filters can help to sharpen up the image on the lower-quality telescopes.

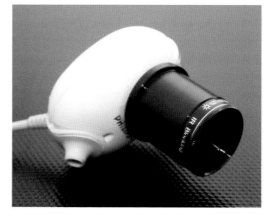

With the webcam adapted and infrared filter attached, the webcam usually slots

▶ *For the best results, use a specially made adapter and infrared blocking filter to remove the blurring effects of the atmosphere.*

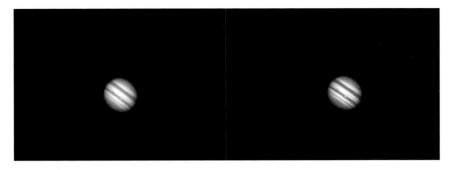

▲ *The sharpening effect of the infrared blocking filter is subtle (left, without filter; right, with filter) but worth it for great results.*

straight into the telescope where you would normally place an eyepiece. For this kind of work, eyepieces are removed – however, there is often a need to increase somehow the magnification produced by your telescope-and-camera combination. Increasing the magnification will make the image larger on the camera chip and the best way to achieve that is to use a Barlow lens. Barlow lenses work by increasing the focal length of a telescope and are generally used visually to increase the magnifying power of eyepieces. The more common Barlow lenses will increase magnification by 2×, so an eyepiece giving you a magnification of 100× would yield a power of 200× when combined. When used with a webcam, a Barlow lens will increase the image size, but before choosing whether to get a 2×, 3× or even 5× Barlow lens, it is worth checking what image size your system will give you.

The table opposite shows the apparent size of all of the major planets in the Solar System, so to see how your telescope-and-webcam system will record them you will need to know your telescope focal length and the chip size of your webcam, both in millimeters. Using my smaller telescope as an example, which has a focal length of 545 mm, and my Philips ToUcam Pro that has a chip size of 3.87 × 2.82 mm, I can work out the size on the chip of any planet. From those figures, the field of view of the camera is calculated by taking one of the chip dimensions, multiplying it by 3,438, and then dividing the answer by the telescope focal length. The calculation now needs to be repeated with the other chip dimension in order to give the area of sky the camera will see, measured in minutes of arc where 60 minutes of arc is equal to 1°. In the case of my system that gives me a field of view of 24 arc minutes by 18 arc minutes. You can now compare the field of view to the planet sizes in the table, which shows the range of their sizes in seconds of arc, where 60 seconds of arc is equal to 1 minute

◀ *It is not just webcams you can use, as other planetary cameras are available, like this iNova PLA-C2. Use a 2× or 3× Barlow lens to boost the image scale.*

of arc. Jupiter is the largest of the planets in our sky, but even at its largest apparent size it is still just under 1 minute of arc. So, with my system's field of view of 24 arc minutes by 18 arc minutes, Jupiter is going to appear very, very small. If I used a Barlow lens, the field of view of my system gets smaller as magnification increases, so even using a 5× Barlow lens means I still only get 5 arc minutes by 3 arc minutes, which would just about give me a decent image scale on Jupiter.

Planet	Apparent size, in seconds of arc
Mercury	4.5" to 13.1"
Venus	9.5" to 66"
Mars	3.4" to 25.1"
Jupiter	29.8" to 50.1"
Saturn	14.9" to 20.7"
Uranus	3.3" to 4"
Neptune	2.1" to 2.3"

As you can see from the calculations above, the telescope I am using with a ToUcam Pro webcam is not ideal for planetary work, as I am struggling to get good image scale. It is interesting to compare it to a longer-focal-length system like my Vixen telescope, with a 3 m, or 3,000 mm, focal length. Even with no Barlow lens I can get a field of view of 4 arc minutes by 3.2 arc minutes, but if I were to use a 3× Barlow lens, the field of view drops to a much more impressive 1.4 arc minutes by 1 arc minute. That would mean Jupiter would just about fill the chip – however, I need to be careful that Jupiter does not drift out of view, so I tend to work with a 2× Barlow lens to get 2.2 arc minutes by 1.6 arc minutes. You can now see how the right Barlow lens makes a big difference to the image scale of the planets.

Another important consideration is the resolution of the system. This is perhaps of more importance in imaging the planets than it is when imaging deep-sky objects, as planets can reveal a lot more fine detail than nebulae and galaxies. We looked at resolution in Chapter 1 when we considered choosing a CCD camera, but it is very relevant with webcams too. You may recall that resolution in imaging terms is determined by telescope focal length and pixel size of the detector. An ideal resolution for imaging planets is around 0.25 arc seconds per pixel, as this will allow you to get the best quality images and the highest level of detail on nights with good seeing. There will be nights of exceptional seeing where a higher resolution would be of benefit, but these nights are few and far between. From the discussions earlier about image size, it is easy to see that my longer-focal-length Vixen telescope is much more suited to planetary work. Ideally, it also needs to provide me with this 0.25 arc seconds per pixel resolution, so what do the figures look like? I can work out the resolution by dividing 206.265 by the focal length (in millimeters) and then multiply the answer by the pixel size (in microns). If I am using the telescope at 6,000 mm focal length by using a 2× Barlow lens and with the pixel size of the ToUcam Pro at 5.6 microns, then I get a resolution of 0.19 arc seconds per pixel. This is a little high for an average night but still perfectly usable; however, it excels on nights of great stability when the seeing is very good.

You can see that it is all a bit of a compromise when it comes to Barlow lenses, focal lengths and webcam chip dimensions. As a general rule, though, an ideal setup is a webcam (due to their usually small-sized pixels) and a telescope with a long focal length. This gives you the high resolution needed to capture fine levels of detail. It is easier to get a longer-focal-length telescope optimized for planetary imaging than it is a shorter-focal-length instrument. However, it is not impossible to do the latter – it just requires the use of eyepiece projection where the

eyepiece of the telescope is kept in place and the webcam (with lens removed) is positioned up close to it. Special adapters are needed for eyepiece projection to hold the camera square against the eyepiece and many of them allow for alteration of the distance between webcam and eyepiece to change the size of the image. Eyepiece projection is covered later on in this chapter (see page 81), so for now let us look at getting the image data from the webcam setup.

Before you insert the webcam and Barlow lens into the eyepiece holder, insert a low-power eyepiece first and center the object you are planning to image. Get it as close to center as possible before switching to a higher powered eyepiece, or eyepiece and Barlow lens, and check that the planet is still as central as possible. If you have an eyepiece with a set of cross-hairs in them to mark the center of the field of view, then this will help to be sure the planet is perfectly centered. If your telescope has them, it is best to use the slow-motion controls to center it, as it will take tiny movements, far too small for your hand alone to achieve. With it centered, and hopefully if you have a good polar alignment it will stay there, very carefully remove the eyepiece and insert the webcam and Barlow if you are using one. This needs to be done very carefully to ensure you do not move the telescope.

Make sure the webcam is connected to your computer and open up the webcam capture software that was supplied, or use SharpCap, which is my preferred software. It should now show you the view that the webcam can see through the telescope, but there is the chance that you might not see anything yet, in which case do not worry – it is quite likely that you have knocked the telescope when removing the eyepiece and replacing it with the webcam. This is the first thing to check, so replace the webcam with an eyepiece and double-check that it is definitely centered. If it still looks centered then try a higher magnification, as it may not be perfectly centered with a higher magnification. Remember that the webcam chip is very small and you need to get the planet to hit the chip, so this has to be accurate.

If you are definitely centered then try adjusting the "gain," which is the webcam equivalent to increasing the ISO in a DSLR. There are subtle differences between the two terms, but for our purposes increasing the gain simply increases the sensitivity of the webcam, allowing it to show you a brighter image. If the image is not visible, increase the gain to at least 75% and the image should pop into view.

There is one other reason why you may not see anything: your focus might be way off. It is unlikely to be so far out that you cannot even see a fuzzy image of the planet, though, particularly if you focused with a high-powered eyepiece, which should get it close to focus

The Earth's atmosphere and "seeing"

The conditions in the atmosphere have a big impact on the quality of astronomical images. Of particular interest to the astrophotographer is its stability, which we refer to as the "seeing." It is quantified by the Antoniadi scale where 1 is classed as excellent and 5 is very poor. When looking at objects through a telescope, the nights of poor seeing are revealed by the image jumping around, with fine detail being lost, whereas those beautifully still nights allow you to see the finest detail. This affects astrophotography because targets that are jumping around will result in blurred images.

▶ *One frame from a video taken of Jupiter using the webcam proprietary capture software.*

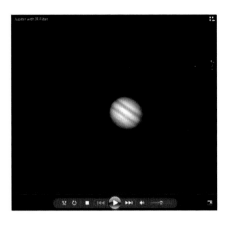

for a webcam. Try adjusting the focus and watch the output to see if it improves. It is usually one of these three reasons why an image cannot be seen, although you may also want to take a glance at the sky to make sure it has not clouded up. This may sound like a flippant suggestion, but you would be surprised how once you get tapping away on your computer you can often forget to look at the sky! I was once imaging some deep-sky objects in my observatory and noticed that the image was slowly getting worse and worse. I spent ages fiddling with settings only to glance up to see the Sun was rising! There is a lesson in that for us all.

Once you have a centered but fuzzy image on your computer display, you will need to adjust the focus slowly to get it nice and sharp. This is relatively easy with a webcam because you are getting live feedback in the software. It is best to adjust the focus slowly and gently because you can very easily be too heavy handed, only to watch your beautifully centered image disappear off the screen as you nudge the telescope. A good approach is to tweak the focus a little and then take your hand off the telescope, let it settle down, and then check the image to see if it is sharp – if it is, rejoice, but if it is not then tweak it a little more. You will find it difficult to see if it is sharp if you are touching the telescope, because the tiny movements of the telescope and therefore the image will mean the image will become artificially blurred as it bounces around from your touch. As you focus, the image will be getting either bigger or smaller – if it is getting smaller, then you are heading the right way so keep going. But if it is getting bigger then you are going the wrong way, so stop and turn the focuser in the other direction. An electric focuser makes this job significantly easier so use that if you have one.

With a centered and sharp image, it is now time to adjust the settings on the webcam to get the right exposure. The first thing to do is disable any auto exposure function that your software may have, which will give you full control of the exposure settings. Amongst these, there are only three that are important to adjust for planetary imaging. The first is already familiar to you, which is shutter speed – the faster the shutter speed, then the more likely you are to capture sharp images that are not blurred by movement of the atmosphere. That said, it is a compromise because a higher shutter speed generally means you will need a higher gain, the second setting, and that comes with a lower-quality image. I tend to stick to shutter speeds of around 1/33 of a second and the gain at no more than 50%. These settings do depend on the planet that you are imaging, but start with these and do not be afraid to experiment to get the best image. If you have to adjust too much then try to keep the gain as low as possible and adjust the shutter speed to compensate.

The third and final setting to check is the frame rate. As its name suggests, this is the number of frames taken per second and is directly related to image quality. A lower frame

◀ *Getting the settings right in the webcam software can take a little experimentation but use the settings in the text below as a guide.*

rate will result in a higher-quality image than a higher frame rate. There is a benefit to a higher frame rate, though, as you get more frames that you can then stack, but it is more important to consider the atmospheric conditions than how many frames you can get. I usually stick to 5 frames per second when the conditions are very stable and the image is not bubbling around too much, or 10 frames per second if it is a little unstable. There are other settings in most webcam software such as gamma, brightness and saturation, but I tend to leave all of these at their default and control the camera as we have just seen. Now for the exciting bit – capturing the movie!

In order to capture the movie, first you need to decide how long it should be. In theory, the longer the movie then the more individual frames there are, so therefore more that can be stacked and the sharper the final image! Alas, it is not quite as simple as that because the planets rotate, so take a movie that is too long and by the time the last frame is taken the features will have moved, blurring the final stacked image. I tend to limit my movie captures to a maximum of 3 minutes to be sure no blurring takes place, and even a 3-minute movie captured at 5 frames per second will give me 900 frames. Many of them will not be used because of moments of turbulent seeing, but there should be enough good ones. Do not be tempted to increase the time of the movie capture – instead, try to increase the frame rate to 10 frames per second. This will give 1,800 frames over 3 minutes and that is enough for anyone.

Before you start the capture you will need to specify a location for the file and its format, which will usually be in the form of an AVI file – once this is done you can start the capture. As the video comes in, keep an eye on it so that any movement of the planet toward the edge of the field of view can be corrected. Only worry about movement if the planet is about to disappear out of view – any other movement can be corrected in the processing of the image later. An electronic hand controller is ideal to nudge the telescope gently if the image drifts toward the edge of the chip, and it is a good idea to hold the hand controller so that it matches the movement in the video output. If the image starts to drift to the left then your instinct is to push the right button to bring it back, but if the image is inverted you will have to hit the left button instead. Hold the hand controller upside down if necessary or in whichever direction you need so that it feels intuitive. Keep the planet visible and wait for it to complete. You have now achieved your first capture.

The next step is to load the AVI file into software like RegiStax, which is available free on the Internet, align the individual frames and stack them all together. The process is of course a little more time-consuming than that, so start by opening up RegiStax and click on the select button at the top left of the screen to load your video file. I will use RegiStax Version 6 in this explanation as it is the latest version and will soon become the most commonly used software for the task.

▶ *RegiStax is a piece of free software available for download from the Internet which converts your webcam video into a high-quality image.*

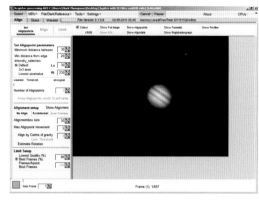

1. On opening RegiStax, the first thing to do is load the video you have just shot. Once it has loaded, you will be presented with the first frame and a set of options down the left-hand side. The first step is to set alignment points that will be used to move the planet effectively to the same position on every frame so that they can be stacked in a later step. Locate the "minimum distance between" option and set it to around 10 for Mars and Saturn, which appear smallest in the sky; Jupiter should be set to 15, and the largest objects like the Moon or Sun to 40. The larger objects mean you can have a greater gap between alignment points; using a lower "minimum distance between" setting will give you more alignment points, which in the case of large objects will be too many. There need to be sufficient points and of sufficient separation to get the best alignment. Keep the alignment distance at around the values above and do not be tempted to set it too low, otherwise you will have too many alignment points and the processing will take a lot longer but the image will not look any better. Leave the "minimum distance from edge" setting at its default.

2. You can now select "set alignpoints" and the screen will change as alignment points are superimposed over the image. You can add extra alignment points if you wish by simply clicking on the point with your mouse, or you can remove unwanted points by right-clicking on them. If you do add your own, make sure they are within the disk of the planet and not too close to the edge. I find that RegiStax does a fine job selecting them so I tend to leave well alone.

3. Near the top of the screen you will see nine tick boxes, some of which will be grayed out. Ensure that "color" and "show aligndata" are selected. This latter option allows you to look a little closer at the alignment data.

4. Now click on "align," which should have a green line under it. The alignment points will now change to look like yellow flies

▶ *Setting the right number of alignment points is an important step in processing and stacking the video.*

that have been squashed! The yellow marks represent the movement of the alignment point on all of the other frames, with the red circle showing whether the movement is uniform or deviating strongly as a result of bad seeing. Larger circles represent an alignment point that has been badly affected by the seeing conditions so these should be deselected by right-clicking, otherwise they will affect the alignment process and result in a poorer quality final image.

5. RegiStax is pretty good at choosing a sensible number of frames to stack based on the alignment information and quality of the images, but I always take a scan through a few of the frames at this point by adjusting the slider at the bottom of the screen. Just below the slider is information that shows the current frame number and then the number of selected frames out of the total number of frames. Choose a few random frames and look at the alignment data. You will see how the alignment points on the current frame move with respect to the original frame you were working from when selecting the points. If the green lines are longer over parts of the image then this is a tell-tale sign of poor seeing affecting the quality of parts of the image, so it would be worth reducing the number of frames being used. Look again at the numerical information just above the slider and at the second number, which tells you how many frames are selected. To the left of the frame you will see a section titled "limit setup" – select "best frames" and choose a number a little lower than the pre-selected RegiStax number of frames. If it was 59 then perhaps choose 50. You will need to experiment a little with this value.

6. Now click on the "limit" button, which will take you to the stacking page. There are a few settings on this page but I leave them at their defaults. Click on "stack" and all of the frames selected will now be stacked one on top of the other. This may take some time depending on the number of frames, the number of alignment points and the power of your computer.

7. You will be presented with your stacked image and this will look a little better than the original, but before doing anything else it is a good idea to save the image, which can be done by selecting "save image."

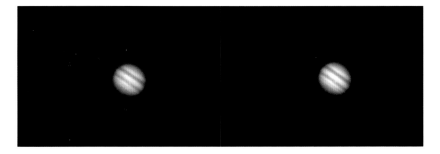

▲ *A single frame from the original video (left) compared with the individual frames stacked before any further processing (right).*

▶ *The final processed image, having adjusted the wavelet settings.*

8. Click on the "wavelet" tab and this is where the real magic happens. To the left of the image is the option to select a "wavelet filter" and I change it from "default" to "Gaussian." Below this is an area where you can specify a value for "denoise" and "sharpen" for each of six layers, and getting the right value requires a little trial and error. An easier way to manipulate the value is to use the sliders, and as you adjust them to the right you will see more detail emerge out of the image. But be warned – going too far can make the image appear to be noisy and look overprocessed. There is a sweet point on all layers between underprocessing and overprocessing, so set the values to those in the image above to get you in the right area and experiment for the best results.

And that's it – you have successfully captured and processed your first high-resolution planetary image! If you want to take an image of the Moon then the principles and techniques are the same. You will find that in most cases it will be far too large for the field of view of the webcam-and-telescope combination that you are using, so you only get a portion of its disk. Some wonderfully detailed images of the Moon can be built up if you complete one image using the above alignment and stacking techniques, and then take another movie right next to the first area. By doing this you can make a beautiful mosaic of the entire lunar surface, but this does take care to ensure you cover the entire disk and do not miss bits out. Depending on the focal length of your telescope this may require a fair few movies to be shot to cover the entire lunar disk so be prepared for a lot of work.

If you would like to capture an image of the Sun then the same mosaic technique can be employed to cover the whole area. There are additional considerations when imaging the Sun, however, and we touched on these in Chapter 2 when we looked at ways to take white-light images of the Sun with a standard DSLR. The same precautions should apply here, even more so as a telescope magnifies the light and energy from the Sun many, many times, making it even more powerful and dangerous. Mylar or Baader AstroSolar film should be used as a filter over the open end of the telescope tube to cut down all of the harmful radiation before it enters the focusing and magnifying components of the telescope.

If you are using a telescope with an aperture larger than about 75 mm then it is a good idea to make up a special mask to cut down the amount of light that enters the telescope. You can do this by cutting a cardboard disk the same size as the outside diameter of your telescope tube, and off to one side cut a smaller hole about 75 mm in diameter. On the inside of this hole securely fasten some Mylar or Baader AstroSolar film with plenty of tape to be sure it is not going to fall off. Do not pull it too tight, and use a piece of film larger than the hole so that you can handle it without touching it where light will pass through. Be sure to

◄ *Eyepiece projection tubes allow a camera to be securely fitted to an eyepiece for a larger image scale.*

inspect it very carefully before and after fitting to make sure there are no tiny pinpricks letting light through. With the film securely attached, take a strip of card about 50 mm in width and long enough to wrap around the open end of the tube of your telescope. Now, using tape, secure the strip of card to the disk so that it fits snugly over the end of the tube. Use a couple of pieces of tape to secure it into place so that a gust of wind cannot blow it off midway through use. Telescopes smaller than about 75 mm can just have the whole aperture covered with the solar filter with no need to make up a mask. Remember not to pull the film too tight when fixing otherwise you risk it becoming ripped – a few ripples in the film will do no harm to the image. With the filter securely in place, you can now safely point your telescope at the Sun secure in the knowledge that no damage will occur, either to you or to your webcam.

Lining up a telescope on the Sun without actually looking at it can be a tricky business, but there is a really neat way you can do it safely. First off, make sure that your finder telescope is preferably removed or has both its covers on, as even these small telescopes can pack quite a punch with the full blast from the Sun. If you just have a cover for the eyepiece part of the finder scope and you cannot remove it from the telescope, then cover up the front end with card or paper so that light cannot pass through it! All you need to do to line up your telescope on the Sun is to look at the shadow it casts on the ground. When the tube is pointing directly at the Sun, it will appear at its smallest! Try it and you will see what I mean. It may take a little jiggling to get it lined up, but with filter in place, you can use your eyepieces in the main telescope to look safely at the Sun to get it centered. Make sure it is centered, or if you are trying to capture an image of a sunspot region that you center it in a high-powered eyepiece to be sure of getting it on the chip of your webcam. With the webcam lined up on the Sun, you can follow the techniques described earlier in this chapter to capture and then process the image.

There is no doubt that webcams are the perfect choice for planetary imaging, but it is possible to use DSLR cameras as an alternative. However, their larger chip size makes them less than ideal when compared to a webcam, whose smaller chip is great for getting small objects like the planets to fill the frame. While the image may look big it does not mean that the resolution will necessarily be great, so the level of visible detail may be under par. As we saw earlier, the atmospheric conditions through which you are working are one of the other important factors in getting good planetary images. Poor seeing means the image will bubble and boil, so by capturing lots of pictures in very quick succession you maximize your chances

of getting a few good ones. Unlike the webcam which shoots video at up to 60 frames per second, a DSLR is not as good at this task, shooting perhaps only 2 to 3 frames per second.

If you still fancy a go with the DSLR then it is still possible, but a slightly different approach is required. The issue of image scale is solved by using a technique that we touched on earlier, by magnifying the image from the telescope through an eyepiece. As you will see in Chapter 4, we do not tend to use eyepieces for deep-sky imaging with a DSLR or CCD, but this technique called *eyepiece projection* will nicely increase a small image scale. It works by leaving the eyepiece in the telescope and attaching the camera body without the lens. The distance between the eyepiece and the camera will determine how much bigger the resultant planetary image will be. There are special adapters that assist by coupling the camera and the eyepiece so that both are held securely together, and they usually take the form of two tubes with one allowed to slide inside the other. The eyepiece slips inside the tube so that it sticks out of one end and is then secured with a tiny thumbscrew. The camera is then screwed on to the other end, with the eyepiece-and-camera combination then inserted into the telescope in the usual fashion. The distance between the camera and eyepiece can be adjusted to produce a smaller or larger image as required. This all comes at a price though, as increasing the focal length of the telescope, which is the outcome of the eyepiece projection technique, means a fainter image results and longer exposures will be required.

There is a simple formula for working out how much more magnification can be gained using eyepiece projection than you would get without using an eyepiece and just using the main telescope optics. There are a couple of numbers needed before you can work it out: the focal length of the eyepiece, and the distance between the eyepiece and the CCD chip of the camera. My wide-field telescope is probably a good example to use, as I struggle to get a decent-sized planetary image without eyepiece projection. It has a focal length of 545 mm and an aperture of 80 mm, and for eyepiece projection I use an eyepiece with a focal length of 16 mm. I've already mentioned that you need a way to hold the camera to the eyepiece and extension tubes are made for this very task. The set I use is made up of two 50 mm tubes that slide one inside the other, and using them at their full extension gives a distance from eyepiece to CCD of 100 mm. The calculation is quite simple: take the distance between the CCD and the

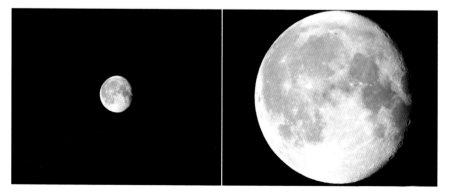

▲ *Imaging the Moon with just a DSLR and telescope can still give a relatively small image (left), but using eyepiece projection increases the image scale greatly (right).*

eyepiece and subtract the focal length of the eyepiece. Take the answer and then divide this by the focal length of the eyepiece (again), and that will give you a value of magnification compared to simple use of the telescope optics. Using my numbers I get a value of 5.25× greater.

This value is of interest, but to get a real understanding of the size of image it would be very useful to know also the new effective focal length of the telescope and eyepiece. This is an even easier calculation than the one above as you take the previous answer, in my case 5.25, and multiply that by the focal length of the telescope. Working on a 545 mm focal-length refractor and with the 100 mm distance between a 16 mm eyepiece and the camera chip means I now get 2,861 mm, or 2.8 m! As you can see, using eyepiece projection means it is now possible to get much better image size on a wide-field telescope. Using eyepiece projection on long-focal-length telescopes is not a good idea, however. On my larger telescope with a 3 m focal length and with the same eyepiece and extension tubes, I would get an effective focal length of 559 m, which is over half a kilometer and that is pretty impractical, as I am sure you can imagine!

It is not just about the size of the image on the chip, though, as there should be some consideration given to the resolution of the system. We looked at this earlier in the chapter when considering webcams, but it is useful to review it here. For most average nights, a resolution of about 0.25 arc seconds per pixel is sufficient and there is a great little formula for working out the ideal focal length for that. All you need to do is take the pixel size of your CCD camera and multiply by 825, as this will give you the ideal focal length. My Canon 450D has a pixel size of 5.2 microns, so multiplying that by 825 gives me an ideal focal length (for resolution purposes) of 4,290 mm. If I can aim for a focal length of about that with eyepiece projection, then that should give me perfect resolution. As you saw with my earlier example, a 16 mm eyepiece was only giving me a focal length of 2.8 m, so with that configuration I would not be getting optimum resolution. I could either try a shorter-focal-length eyepiece or try increasing the distance between eyepiece and camera chip. Ultimately, of course, it is down to the images that I am getting and not the numbers, but getting them right will mean you are getting the most out of your equipment.

If you are going to use your DSLR for lunar or solar imaging then you do not need to go down the route of eyepiece projection, because the objects have a much larger size in the sky and more magnification is not necessarily required. On the other hand, if you are trying to get close-ups of certain features on the Moon or Sun then you may want to boost your magnification with eyepiece projection – but for general shots, just connect the camera to the telescope without an eyepiece.

◄ *Attaching a camera (without its lens) to a telescope without an eyepiece effectively turns your telescope into a big zoom lens!*

▶ *Images of the Sun captured using a DSLR and telescope with suitable solar filters easily reveal features like sunspots.*

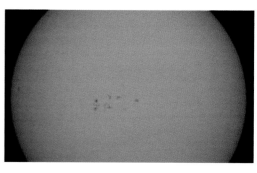

Aside from the negatives of using DSLRs for planetary work as we saw earlier, they do have one advantage: they already have an infrared blocking filter in place. We looked at the removal of the infrared filter earlier (see page 15) and this is essential for capturing the nebulosity in star-forming regions, but, unfortunately, to get sharp planetary images the filter needs to stay in place. Because the infrared filters are not easy to remove and require specialist skills and tools, you might think that you need to make a decision on deep-sky or planetary imaging and stick to it. Fortunately, there is a happy solution and that is to get the filter removed so your DSLR can give you good deep-sky images, but then to buy an infrared blocking filter which fits across the adapter that holds the camera in the telescope. This is very likely to be the same adapter you could use with a webcam, so it can double up there too. With this approach you can still do both, but do be aware that if you have removed your infrared filter from your camera then it will make your daytime pictures look a little strangely colored. This can be resolved by having a fiddle with the color balance settings, but that is for another book. This is about astrophotography so let us look at getting pictures with a DSLR now that it is connected.

Getting solar, lunar or planetary images through a telescope with a DSLR requires similar techniques. Of course, solar does require the use of special solar filters as we covered earlier when discussing the use of webcams, so look back to page 79 for more information. Getting the images focused is easy enough, as you can turn on the "live view" function and watch the rear LCD on the camera until your focus is sharp. The objects are generally all bright enough to be seen through "live view," and as you adjust the focus, take your hand off the telescope to give any vibrations a chance to settle down before you examine the image for focus. Take your time with this, as the atmosphere will be bubbling around even on the better-than-average nights, making it look out of focus when in reality you may be there. The use of a Bahtinov mask can greatly increase the ease with which you can get good focus. Place it over the open end of the telescope and line up on a bright star to achieve good focus before slewing the telescope back to the planet.

With the image focused it is now time to start getting images. The use of a cable release, or more ideally a computer attached via USB to the camera, will give you more control without disturbing the telescope. If you do not have either, then you can use the self-timer on the camera – set it to the longest duration to give the longest pause between you touching the camera and the picture being taken. Set the "mirror lock" up too, as this will help to alleviate any vibration that you impart on the telescope. Many cameras now allow you to shoot video in the AVI format like webcams, although the resolution of this tends to be lower than you would get with a still image. Even so, the benefits of shooting video far outweigh shooting still images, so if you can, then do this for anything between 10 and 30 seconds. You can then load the video into RegiStax and process as described on page 77.

However, if you do not have video capability on your camera you will need to shoot at least 50 individual images to capture moments of greatest stability. Exposure times will vary depending on your focal length and the object you are photographing, but should not be longer than 1 second. You might find that your camera exposures are not fast enough and your images are too bright, so try using a neutral density filter to cut down the amount of light entering the system. The individual frames can then be loaded into RegiStax and processed in just the same way as we did with a video.

Getting pictures of large comets can be achieved easily with a DSLR on a tripod and an appropriate focal length to frame the comet nicely. If you have a driven camera mount then you can use long exposures, but if you are using a standard tripod then you will need to limit exposures to keep trailing to a minimum. For smaller comets and asteroids you will need to attach a DSLR or CCD to a driven telescope with a focal length of at least 500 mm. Exposures should be no longer than 5 minutes because comets and asteroids tend to move at a different speed to the background stars. Shorter exposures will result in less trailing of the object, but do not forget you can always stack multiple images together. If you do that then make sure you use the comet to align the images rather than the stars.

I do have one final tip about imaging Solar System objects that is of relevance to all astronomical imaging. If conditions allow, it is worth waiting until objects are nicely positioned in the sky, as high as possible. I have mentioned seeing conditions on many occasions, which is the result of incoming starlight being knocked and bumped around by the turbulent atmosphere. The optimum position for objects to be imaged or even observed visually is when they are at their highest in the sky, generally due south for northern hemisphere observers. This means their light is coming through the least amount of atmosphere and so will suffer less disturbance, and you will get better, sharper images. This is not always possible, though. For example, in December 2013 I was in the process of grabbing images of Comet ISON as it neared the Sun, but it rose only a few hours before the Sun – by the time it was high in the south, the Sun had risen, so it was a battle with the onset of twilight. There are many compromises in astrophotography, as you may now start to appreciate.

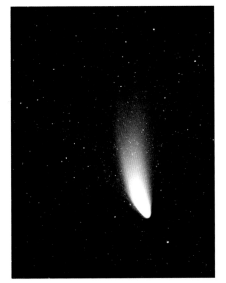

Imaging objects in the Solar System is probably the least demanding of telescopic astronomical photography, but as you have seen there is still much to consider. The key thing is to wait until the weather conditions are right, get your equipment set up properly and you are halfway there. Exposure times and other camera configurations vary depending on makes, models, focal length of telescope and even the object being imaged, so do not be afraid to experiment and you will not be disappointed.

◀ *Comet Hale–Bopp photographed using a DSLR attached to a standard camera tripod, revealing the beauty of its blue gas tail and white dust tail.*

MARK'S PHOTOGRAPHIC SOLAR SYSTEM TOUR

Sun

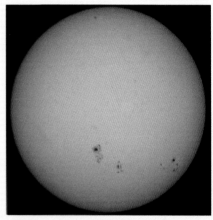

Maximum apparent magnitude: −26
Maximum apparent size: 32.7 arc minutes

Capturing images of the Sun is one of the more challenging aspects of astronomical imaging for no other reason than the dangers involved. The Sun kicks out immense amounts of energy – without proper precautions, the magnified solar radiation can not only destroy an unprotected CCD chip but, worse, it can also blind the unwary astronomer. The use of proper full-aperture filters (either white light or the more expensive hydrogen-alpha version) can reduce the light to a safe level, allowing you to capture images safely. Focal lengths in excess of 500 mm are needed (depending on the camera chip) to give a good image scale.

Moon

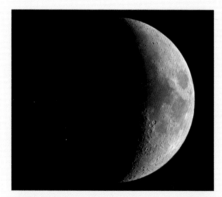

Maximum apparent magnitude: −12.7
Maximum apparent size: 34.1 arc minutes

We see the Moon because it reflects sunlight, so its appearance changes as the Earth and Moon move in relation to the Sun. This is why we see the phases of the Moon and, as a result, the amount of light reaching us varies. When taking pictures of the Moon, exposure times vary significantly depending on its phase. It appears almost identical in size to the Sun so to avoid disappointments when imaging the Moon make sure you use a focal length of at least 500 mm. For close-up shots of the lunar surface, try removing the camera lens and attach it to a telescope with a Barlow lens.

Mercury

Maximum apparent magnitude: −2.4
Maximum apparent size: 13.1 arc seconds

Mercury is an elusive planet to spot due to its proximity to the Sun. The best times

to try and detect the innermost planet is when it is at its furthest point from the Sun in the sky: these are known as greatest eastern and western elongation. Like the Moon, Mercury displays phases and to capture images of this requires telescopic observation. But be very, very cautious when using a telescope to find Mercury, as the Sun is never far from it in the sky. It is good practice to wait until the Sun has set before trying to home in on it. A webcam and Barlow lens attached to your telescope will be needed to get a good picture.

Venus

Maximum apparent magnitude: −4.9

Maximum apparent size: 66 arc seconds

Venus is much larger in the sky than Mercury with a maximum apparent size of just over 1 arc minute (66 arc seconds). For this reason, it is much easier to get a good image scale when compared to the likes of Mercury, Uranus and Neptune. It is worth experimenting with filters when imaging Venus because they can enhance some of the detail in the clouds of the planet. See if you can capture the "Ashen Light," which is a subtle glow of light on the night hemisphere of the planet.

Mars

Maximum apparent magnitude: −2.9

Maximum apparent size: 25.1 arc seconds

Compared to Mercury and Venus, there is a wealth of detail to be captured on the surface of Mars, not least of which are the white polar ice caps or the dark rocky outcrops that cover the planet, such as Syrtis Major. To get the best images it is worth waiting for moments of great stability in 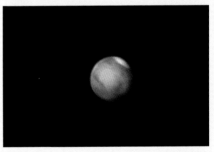 our atmosphere, which are often seen in the early hours of the morning. The size of Mars in the sky varies significantly but it is at its best every two years as our two planets become closest to each other.

Jupiter

Maximum apparent magnitude: −2.9 *Maximum apparent size:* 50.1 arc seconds

Along with Saturn, Jupiter is one of the most popular planets to image because of its large apparent size and wealth of detail. Good atmospheric seeing will reveal great levels of detail

in the planet's many belts and zones, as in this image by Damian Peach. Webcams and telescopes with Barlow lenses will get nice large image scale, but some lovely shots can be taken by using the webcam without a Barlow lens to pick out the Galilean moons as they orbit the planet. For shots like these, DSLRs can be used through a telescope too.

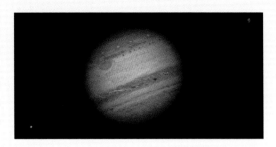

Saturn

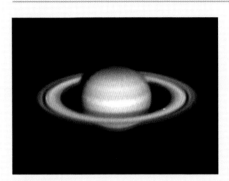

Maximum apparent magnitude: −0.5
Maximum apparent size: 20.7 arc seconds

One of the great challenges in imaging Saturn is capturing the rings in their full glory. The rings are made up of millions of pieces of ice all in orbit around the planet, but there are gaps which are within easy reach. Large-aperture telescopes are of benefit here as their greater resolution will show finer levels of detail, so a large scope with long focal length (boosted by a Barlow lens if necessary) will work well. There are also subtle belts and zones on the disk of the planet that can require a little work with processing to bring out the detail.

Uranus and Neptune

Maximum apparent magnitude: 5.3 (Uranus); 7.8 (Neptune)
Maximum apparent size: 4 arc seconds (Uranus);
2.3 arc seconds (Neptune)

Unless you have an instrument like the Hubble Space Telescope at your disposal, you will not be capturing any detail on the disks of the two outermost planets! What you can get a picture of, though, are the moons, as in this image of Uranus by Ed Grafton. Uranus and Neptune both have a family of moons in orbit around them, but I tend to favor a CCD camera rather than a webcam, whose exposures can be a little too fast to capture them. If you have a mono CCD camera, you can still get the color of the planet by using a set of RGB filters and combine the images later on.

chapter 4
DEEP-SKY IMAGES

SO FAR WE HAVE LOOKED at various ways to capture images of the stars using a standard DSLR camera and how telescopes can be used to magnify the view to get high-resolution shots of the planets, the Moon and the Sun. The challenges up to now have been more to do with getting image scales and exposure right, but to capture the true beauty of deep space we also need to consider a more accurate tracking platform to keep the telescope and camera pointing in exactly the same direction for a number of minutes.

In order to get good-quality deep-sky images, not only is the CCD camera and its configuration important but the balance of the telescope on the mount and an accurate polar alignment is also essential. If you have been a telescope owner for some time then you may already be aware of the need to balance them. It not only makes them easier to use but it also minimizes wear and tear on the motor drives and gearboxes, since a perfectly balanced telescope will take minimal effort from the motors to reposition it, whereas a poorly balanced telescope can require significant effort. Because of this, poorly balanced telescopes continue to be among the most common causes of guiding problems so it is very much worthwhile – essential, in fact – to get the balance right.

Balancing a telescope

Fork mounts are common among certain brands of telescopes and in the majority of cases they are not provided with the ability for balance to be adjusted. Instead, they are usually balanced in the factory, which is fine for visual work as the addition of an eyepiece will not significantly affect it. However, once you start attaching field flatteners, filter wheels, cameras and guide scopes you will soon find that the telescope becomes unbalanced. The only way to correct this is with the addition of extra counterweight systems that bolt to the side of the telescope tube.

Balancing an equatorial fork mount is pretty straightforward: start by pointing the telescope straight up and slacken off the brakes so that it will move freely (but do not let go of it while doing this as it may quickly drop if the balance is off, risking striking the base of the fork). With all the equipment attached, see which way it tends to move. If the top of the tube is too heavy (the same side of the tube that is uppermost when it is pointing at the horizon), then attach a counterweight to the bottom of the tube to balance it out. If the reverse is true, then add weights to the top or remove some weights from the bottom. With it balanced while vertical, you now need to repeat the process with the telescope horizontal, as though pointing at something on the horizon. If it is too heavy at the eyepiece end, then slide the weights that you have attached toward the front end of the tube. If, on the other hand, it is too heavy at the front end of the tube, slide the weights further back toward the eyepiece

end. Once you have it correctly balanced, you should be able to loosen off the brakes on both axes, push the telescope to any position with minimal effort and it will just stay there.

Balancing a German equatorial system is a little easier and does not usually require extra weights. As you look at the mount, you will see that one of the axes has the telescope at one end of the bar and some counterweights at the other. Turn the telescope so that this bar is horizontal and point the telescope at the horizon. Making sure all of your accessories are attached, loosen off the brakes, keep hold of the telescope at all times, and twist up and down – the counterweights will stay in the same place but will spin if you are moving the telescope in the right way. If it is too heavy at the eyepiece end, then the whole telescope will need to be slid a little further backward (away from the eyepiece end) in its cradle. If it is too heavy at the back end, then slide it back toward the eyepiece end. Be very careful when sliding the tube forward and backward in its mount – it is good practice to turn the telescope so it is above the mounting plate before adjusting, thus minimizing the chances of it dropping off! However, if you cannot move it far enough to get a good balance, you will need to look at additional balance weights. With it balanced about the declination axis first, you can now check the balance on the right ascension axis – return the telescope to the same horizontal position and this time lift it so that the telescope goes up and the counterweights go down. Continue to test around this axis and if the telescope side is too heavy, then move the counterweights further along the pole. But if the counterweights are too heavy, move them closer toward the telescope. Now you should be able to move the telescope to any position and let go – the telescope should stay just where you left it and show no signs of slowly wandering off because of poor balance.

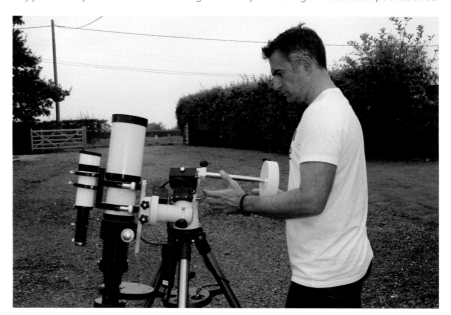

▲ *Correctly balancing a telescope mount is vitally important. Mounts like this modern version of a German equatorial mount are balanced in both axes by first placing the declination axis horizontal.*

Polar alignment

We saw in Chapter 1 how an altazimuth telescope with motors attached to both axes can follow an object across the sky, but how the image will slowly rotate as the object arches across the sky. Using an equatorial mount with one axis of rotation aligned with the rotational axis of the Earth means only one axis needs to be driven to make the telescope mimic the rotation of the object. For this to work at its most efficient, an equatorial mount needs to be accurately aligned to the north (or south, depending on the hemisphere of the Earth in which you live) celestial pole in a process known as *polar alignment*.

There are two steps in polar alignment: *rough* polar alignment, which is fine for visual work, but to get great astronomical pictures we need to go further and achieve a *precise* polar alignment. Before starting, be sure that your finder telescope is aligned to the main telescope by lining the two up on a distant object during the day. It is easier if you do this by pointing the main telescope at an object, perhaps a TV mast on a distant building, before adjusting the pointing of the finder scope to center the same object. Trying to do this at night will only lead to more stress as objects in the sky move, so by the time you have fiddled with the finder scope and got it lined up you may well find that the main instrument is no longer pointing at it.

With finder scope aligned, the next step is to achieve a rough polar alignment, which will set the mount so that its polar axis is approximately parallel to the axis of the Earth. This is generally enough for visual work but it is also a necessary step to make the precise-polar-alignment phase easier to achieve. The first step is to adjust the angle of the whole mount so that it is the same as your latitude – for that, equatorial mounts have a latitude scale. I live in the UK and my latitude is about 52°, so I would set the latitude to be 52. This is usually done by loosening a nut of some description to allow you to gently adjust the angle before tightening it again, although some mounts have a big adjusting screw that when you turn it, the mount's angle is adjusted. If yours does require you to loosen a nut before adjusting, then I wholeheartedly recommend doing this without the telescope in place, otherwise you risk the whole lot crashing down.

With your latitude set, you then have to get the polar axis pointing north – if you do not know where that is from your observing site, then use a compass or smartphone to identify north, and point the polar axis in that direction. Be careful when holding a compass near some metallic mounts as this can affect their accuracy. An alternative solution is to note the direction of the setting Sun, and north is roughly 90° to the right – although this approach is very

◄ *The latitude scale on an equatorial mount is used to set the polar axis of the mount at approximately the right angle for polar alignment.*

> **The celestial pole**
> Polaris is used by observers in the northern hemisphere to polar align equatorial telescopes. There is nothing special about Polaris except for its location, which happens to lie in the same direction that the Earth's axis of rotation points: the celestial pole. The position of the celestial pole moves slowly over time as the Earth wobbles on its axis, so that by 14,000 AD Vega will become the northern Pole Star.

approximate as the Sun sets anything from southwest to northwest depending on the time of year. It is a good idea to take a quick look at the mount to make sure it seems about right, so check that its polar axis is pointing about the same angle above the horizon as your latitude. Mine points just over halfway between the horizon and overhead, which is fine for 52° latitude, and I know roughly where north is so can make sure this too is correct.

Now identify your telescope's declination axis, which is the one with degrees marked all the way around it from 0 to 90. Rotate the telescope about this axis until it is at 90°, so it should now be pointing along the polar axis. Do not worry if you cannot find any degree markings – just turn the telescope so that it is pointing along the polar axis. Take a look through your finder scope, and if you have been accurate enough you should be able to see Polaris through it. Your telescope should be reasonably well set up now to make rough polar alignment easy. If you were to turn your telescope drive on, then you would probably find that objects will stay in the field of view of low-powered eyepieces for a few minutes, but if you were to increase the magnification you might find that they soon drift out of view. Imagine your tiny CCD chip with an object sitting nicely in the center – you can now understand why precise polar alignment is necessary since the object will soon drift off the chip.

The next step in polar alignment involves aligning on Polaris (the Pole Star), which is easy to find by following the two pointer stars in the bowl of the Big Dipper, part of the constellation Ursa Major. Now move the entire telescope mount, telescope and all, so that the tube is pointing toward Polaris – this should not need moving much if you pointed it due north using a compass. If you have set up the mount as described above, then Polaris should be visible in the field of view of the finder telescope. Now you just need to make minor adjustments to the mount by adjusting its left–right position and the angle of the polar axis to center Polaris. Assuming your finder telescope is aligned well, you should now see Polaris in the field of view of a low-power eyepiece in the main telescope. Now make further tiny adjustments to the mount, as before, to center it in the field of view of the main telescope eyepiece. It is worth adding that the adjustments to make on your mount during polar alignment are not around the axes but on the positioning of the mount. You will find adjustments on your mount that will twist the whole thing around, thus affecting where the mount points in azimuth, and with the altitude adjustment we looked at earlier you can move it to exactly where you want. Your telescope is now roughly polar aligned and will be fine for visual observing, but this book is about astrophotography, so assuming you are using your telescope for imaging, then you will need to move on to precise polar alignment.

◀ *Illuminated reticule eyepieces like the one pictured have a tiny bulb and battery attachment to illuminate the inside of the eyepiece. They are essential for accurate drift alignment.*

To make accurate polar alignment easier, some telescopes have polar scopes that are fitted inside the polar axis of the telescope. (If your mount does not have a polar scope, you can skip to the end of this paragraph.) Looking through a polar scope having completed the steps just outlined will present you with a slightly magnified image of the sky through which the stars are visible. You will also be able to see some lines gently illuminated by a red light. These lines act as a guide to getting a slightly more accurate alignment. In most polar scopes, the illuminated lines in the field of view represent the constellations Cassiopeia, Ursa Minor and Ursa Major. The polar scope needs to be rotated so the constellation lines represent the orientation of the constellations in the sky. The easiest way to achieve this is by keeping both eyes open as you look through the polar scope and adjust it. This has now set up the polar scope correctly for the current time, so all that is needed is to adjust the pointing of the mount, as above, until Polaris sits between the reference lines for it. The process of rough polar alignment does not take into account the fact that Polaris is slightly offset from the north celestial pole, but the polar scope does, so it actually aligns your mount to the pole, rather than Polaris. This will give you a more accurate level of polar alignment, but the next and final steps are necessary for very accurate polar alignment.

This last step relies on watching the drift of stars through the eyepiece and slowly fine-tuning your polar alignment until all drift is eliminated. You will need an extra piece of equipment to perform this task: a medium-powered illuminated reticule eyepiece. This is an eyepiece that has either a cross etched into the lens or thin wires forming a cross – mine is 12.5 mm focal length and gives a magnification on my Vixen telescope of 250✕. The crosses inside are illuminated by a faint bulb fitted in the side of the eyepiece. They can be bought from most astronomical suppliers and are essential to the task.

Start by identifying a star that is roughly due south, or preferably a little to the left of due south, and within 5° declination from the celestial equator (the celestial equator is the extension on to the sky of our own Equator and can be seen on any star chart). Center this star in the field of view of the telescope so that it lies on the illuminated cross. Now, using the slow-motion controls of the telescope, move it east and west in right ascension and rotate the illuminated eyepiece so that the star moves slowly back and forth along one axis of the cross. Center the star and, with the motor running, observe how the star moves, ignoring any left–right movement, just looking at up-and-down drift. It may take some time for any movement to be detectable, depending on how accurate your polar alignment is.

- If it moves down, the polar axis of the telescope is too far to the west (to the left of Polaris).
- If it moves up, the polar axis of the telescope is too far to the east (to the right of Polaris).

Using the mount's azimuth adjustments, make appropriate changes to correct. Now recenter the star and perform the same step again. You may find that it takes quite a few iterations of this process if you are quite a long way off, so stick with it and eventually there will be zero drift up or down for a good 5 minutes or more. It is best to leave the motor running for a few minutes and check to see where the star seems to be drifting rather than instantly responding to any movement.

Next, it is time to work on the other axis, so find a star near the eastern horizon – ideally it should be about 20° above the horizon and fairly close to the celestial equator. Center it on the cross like before and align the cross so that east–west movement takes the star along one axis of the cross. Now monitor the star with the motor still running.

- If it drifts down, the polar axis of the telescope is too low.
- If it drifts up, the polar axis of the telescope is too high.

If you do not have a good eastern horizon, a star on the western horizon will work fine, but the notes above regarding the adjustments required will need to be swapped.

Make adjustments to the elevation of the polar axis as appropriate, recenter the star and check the drift again. Once drift is eliminated, go back and check with the star due south – when that has been rechecked, your telescope will be accurately polar aligned and objects will stay in the center of the eyepiece or, more importantly, your camera. I have managed to get my system polar aligned so there is no movement of the star at 250× magnification for a good 10 minutes. Depending on the quality of your telescope, you might detect some "wandering" along the east–west line, but this is probably due to error in the drive and will be corrected by guiding systems that we will discuss later. Some telescopes have "periodic error correction" systems that allow you to "train" your telescope to know what tracking errors are expected. In my old Meade LX200 you simply had to watch the star for a period of 8 minutes (which is how long it took for the gear inside the drive to rotate once) and correct it if it moved. The system then recorded your commands and constantly played them back, giving much more accurate tracking. Telescopes on the market nowadays have a few different ways of tackling periodic error, so it is best to check in your manual for how this should be completed.

It really is worth taking the time to nail accurate polar alignment, and while it may take you an hour or two the first time, with some practice you will achieve alignment with quite surprising accuracy and speed. If you want to increase the accuracy further, then you can insert a Barlow lens, which doubles or triples the magnification of the eyepiece so that any further drift will be noticeable and can be eliminated. Fortunately, with modern guiding technologies you do not need to go mad with polar alignment. The steps described above will be more than sufficient.

> **To achieve accurate polar alignment, follow these key steps:**
>
> - Set mount to rough position (set latitude scale to your own latitude and point mount due north).
> - Point telescope at declination of 90° and adjust mount to center Polaris.
> - Perform drift alignment on star due south.
> - Perform drift alignment on star on eastern or western horizon.
> - Repeat last two steps to achieve accurate polar alignment.

I highly recommend the use of a Go To telescope mount, as we looked at in Chapter 1 (see page 19). The equatorial versions of these telescopes require polar alignment, as above, but also another step of *star alignment*. This simply means that you need to select a couple of bright and easily identifiable stars from a list on the telescope handset and then point the telescope manually at them through a high-power eyepiece, or indeed centered in the CCD frame. With this done and with accurate entries of latitude, longitude, date and time, the telescope will know exactly where it is and, crucially, where all objects are in the sky. With this set up accurately, you should not need to look through the eyepiece again and can readily move the telescope from one object to the next, happy in the knowledge that your targets will appear in the camera's field of view. If you do not do this accurately, though, you will more than likely need to remove the camera and replace it with a low-power eyepiece to center the object, before reattaching the camera. Doing this may seem like a small inconvenience, but as we will see later in this chapter, it will also mean more supporting images or calibration frames will be needed.

Connecting camera to telescope

With your equatorial mount accurately polar aligned, your telescope is now set up for deep-sky imaging and that is where the fun really begins! Connecting your camera to the telescope may sound like a simple task but I recall the time when I tried to attach my first CCD to a telescope. I took the CCD out of its box and unwrapped it, only to be confronted with a screw-thread attachment and no adapter to plug straight into the eyepiece holder. It seems I had learned a valuable lesson about connectors and adapters. I had no idea what I needed and it took me a long time to get the two hooked up, so I had to watch clear nights come and go with the CCD safely packed in its box – a very frustrating experience!

When you get your first CCD camera, make sure you know exactly what the connection is – it will probably be a screw thread but you will need to know what size it is. You will also need to know how you are going to connect it to your telescope, and for most beginners' cameras a simple 31 mm (1.25-inch) adapter will allow your camera to slot straight into the eyepiece holder. If you are going to be using a focal reducer or a color filter wheel, then you will need to be sure how you are going to connect the camera to the accessory, which will generally just be a converter that adapts one screw thread to the other. The accessory will then need some kind of adapter to connect to the telescope. This all sounds horribly complicated and it can be frustrating when you have purchased your kit only to

▲ *Most astronomical CCD cameras will have a screw thread where telescopes or other accessories can be attached, such as filter wheels or focal reducers.*

find you cannot connect them together. My setup when used on the larger telescope has a CCD camera that has a connector to allow it to connect to the filter wheel, followed by another adapter on the filter wheel which connects it to the focal reducer, before a final adapter that connects the focal reducer to the eyepiece holder of the telescope. Three adapters are needed and none were supplied as standard, so make sure you check on what you will need in order to connect the items together. Do not forget that if you are using a separate guide scope and guide camera, you will need to make sure that you have adapters for the two of them as well.

Setting up guide cameras

Before looking at setting up guide cameras, this is perhaps a good opportunity to consider briefly the options for guiding systems. Earlier in the book, we saw that there are no telescope drive systems on the market that can accurately and unaided track objects perfectly across the sky. From inadequate polar alignment through to mechanical imperfections in the drive systems, objects

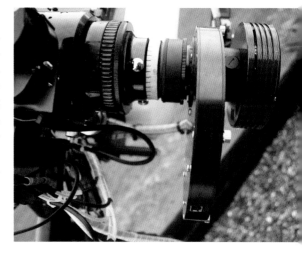

▶ *The author's imaging configuration with (from left) telescope, focal reducer, filter wheel and CCD camera.*

will wander in the field of view of the camera, giving you a blurred image. However, this can all be rectified by carefully monitoring the image and moving the telescope mount to counteract it.

There are two options when it comes to monitoring or *guiding*, to use its correct term: either pick off a little bit of the light coming through the main telescope to provide what is known as an off-axis system, or attach a second smaller telescope on the side, known as the guide scope, through which guiding is performed. It is typical these days for a second guide camera to be used to provide the guiding correction information to the mount, so there is, unfortunately, extra expense when it comes to deep-sky imaging. The two different guiding systems have pros and cons. It is sometimes a little tricky to find a "guide star" in the off-axis system because only a tiny portion of the total amount of light from the telescope is used. However, modern guide cameras are pretty sensitive so this is not always a major issue. One of the downsides, though, is that it reduces the amount of light on offer to the main imaging camera; again, this is not a big problem but worth consideration. My preference is to use a guide scope attached to the main telescope, although some would argue that there can be a tiny amount of movement or flexure between the two of them, so while guiding is accurate for the guide scope, it can be a little off for the main instrument. This flexure is the result of movement in the rings that hold the guiding telescope in relation to the main instrument, though modern materials mean that this is slowly being eradicated. Long focal lengths will be most likely to notice the problem, but with good-quality mounting systems I have certainly never found it to be a problem, and I often image at 3 m focal length.

Whether you guide through an off-axis system or through a guide scope, you will need to attach the guide camera into its appropriate eyepiece holder. Now you could just stuff it in at any orientation, but you will get better guiding results if you make sure the CCD is roughly aligned to the right ascension axis of the telescope. The best way to achieve this is to look at the CCD chip and ensure that, when you insert the camera, the chip sits square in the eyepiece holder – this will mean that one of its sides will run along what is effectively the bottom of the field of view. By doing this, you will get much more accurate guiding corrections. Most guide cameras come with some kind of guiding output that plugs straight into the telescope drive system and a USB cable to the PC, so that you can control the camera. With the guide camera attached to the telescope and the cables plugged into their respective sockets, you are ready to get things turned on and start imaging.

◀ *Guide scope (80 mm refractor) and guide camera (QHY5-II) attached to the top of the author's telescope.*

Camera cooling technology

Many of the good-quality CCD cameras on the market come with some form of cooling system that reduces the temperature of the CCD chip. This is done to reduce the level of noise generated by the electrical signals inside the camera. The noise is seen in a captured image as a speckled effect, which for images of stars is rather unwanted. It can be removed through the use of dark frames, which we looked at when we considered taking DSLR images of the sky (see page 44). The principle for dark frames and a CCD is the same: an image of the noise is taken and then subtracted from the image with the object during processing later on. In practice, a dark frame can be reused for

▶ *Software like Maxim DL allows the operating temperature of the CCD camera to be controlled.*

different images if the temperature of the CCD and length of exposure are kept identical. This is only achievable if you have a CCD camera with "set-point cooling" (see page 32), which allows you to specify the temperature that you wish to operate at. Other cooling systems cool to a specified number of degrees below ambient air temperature, which of course can be different from one night to the next or indeed during the course of a single night. Set-point cooling is by far the best system as it allows you to get the camera to the same temperature repeatedly. So while it is possible to remove the majority of the noise by subtracting dark frames, it is far better to get rid of the noise at source first.

Setting up the cooling should be your first task – turn the imaging camera and guide camera on, connect to them with your control software, and on the imaging camera turn on the cooling and specify the temperature. Choosing what temperature to cool to for ground-based amateur imaging has been the subject of many a discussion and you might think that the colder you can get it the better. In practice, there are a number of other less desirable effects that come into play with going too low, so for the best compromise it is worth aiming for around −15°C, if you can get it.

Getting focused

It may take quite some minutes for your camera to cool down to the required temperature, so while it is doing that you will need to slew your telescope to a rich star-field to get both cameras focused. I tend to aim at a bright region of the Milky Way that is nice and high – if you pick an area of sky that is too low, then the turbulent effects of the atmosphere may make it difficult for you to get an accurate focus. If your telescope is accurately aligned and has the Go To functionality, you could just select a moderately bright star. On the other hand, if you

do not have that control then remove the camera and place a low-powered eyepiece in the eyepiece holder. Center the star, switch to a high-powered eyepiece and make sure it is in the center of the field of view – the task is easier if you have eyepieces with cross-hairs etched into them. Then, with the star finally centered, carefully remove the eyepiece and replace it with the camera. The next thing to do is to take a sample image with the control software of perhaps a couple of seconds and examine the result. Chances are the star will appear as a big blob. If the star is a very large blob, turn the focus control (or operate the electric focusing motors) quite a bit, perhaps half a turn, and see if the star image gets smaller or larger. When it starts to get smaller you are going the right way, so continue to make adjustments, making them finer as the star image gets smaller. You will find the star gets brighter as it pulls into focus, so shorten the exposures as you continue. If you see bright lines coming out of the star then your exposure is much too high, so it will need to be reduced. You may find that you get to a stage in focusing where you cannot shorten the exposure significantly and so will need to move to a fainter star. This process will need repeating with the guide camera too.

A great aid to focusing is the Bahtinov mask, which fits over the open end of the telescope. We looked at these in Chapter 1 (see page 36), and for about $50 they make focusing a lot easier. It is worth reviewing their use for telescopes here as you need to make sure you use one that is manufactured for your size of telescope and place it over the open end of the tube. Taking an image of a bright star will reveal three so-called diffraction spikes, each slicing the star through the middle. Two will form an "X" and you will notice that, as you adjust the focus, the central spike will move toward or away from the center of the other two. You have achieved perfect focus when the middle spike is exactly in the center of the other two spikes. This approach is quick and easy and can get you to perfect focus manually.

I mentioned motorized focusers earlier too (see page 35), which can either be controlled manually at the push of a button or, better still, you can hook them up to software (like that provided in the Maxim suite of software) to focus automatically for you. All you need to do is point the telescope at a moderately bright star and tell it to focus. You will hear the motors gently whirring as the software hunts for the right direction in which to turn the motor to get focus, and it will slowly home in on a perfect focus for you. If you do not have a computerized system like this then I would wholeheartedly recommend getting a Bahtinov mask to ease the task. Even when using the mask, I would highly recommend investing in a motorized (not necessarily automated) focusing system so

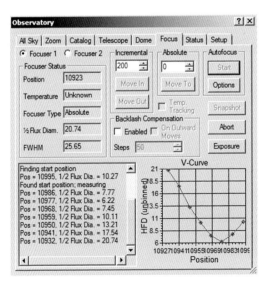

◀ *Computer software and an appropriate motorized focuser mean focusing can be achieved at the touch of a button.*

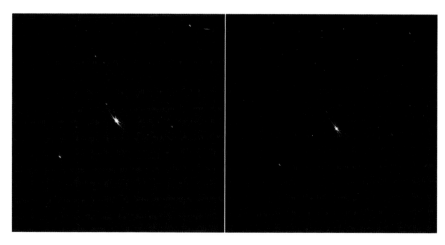

▲ *The Bahtinov mask introduces diffraction spikes into an image which can be used to find perfect focus. When the central line is off-center (left), the image is out of focus – but when it is exactly between the two outer lines, focus has been achieved.*

that you do not have to touch the telescope as you adjust focus. You will be surprised how much the object jumps around as you adjust focus, or worse still, you risk knocking the object out of the field of view of the camera entirely, which means having to remove it, replace with eyepiece, refocus, center and put the camera back in, before starting again – something to be avoided.

It is worth mentioning at this point that focusing on some telescopes can be particularly challenging and troublesome. Many telescopes like refractors or reflectors adjust focus by moving the tube within which the eyepiece or camera sits, and this works perfectly well. Others, typically the catadioptric type, adjust focus by moving the main mirror up and down the telescope tube. The effect of doing this is that the image you look at could slowly move around the field of view as focus is adjusted; now, this is not particularly a problem for visual work as the field of view is large enough to accommodate this, but it can be quite a problem when imaging. The much smaller field of view can often result in the image of the star that you are trying to focus disappearing entirely as the focus is adjusted. The only thing that can be done is to stop, locate a new star to focus on and recommence, but a much better solution is to remove the

▶ *Rear-cell focusers should be added to some telescopes to eradicate focusing problems caused by the mirror movement.*

problem by adding a new focus mechanism. Most catadioptric telescopes have a "mirror lock" which allows you to fix the position of the mirror, and by adding a new focuser on the rear end of the telescope which adjusts focus by moving the eyepiece and *not* the mirror, the problem goes away. You will of course need to find a focuser that fits your particular model of telescope as the thread attachments on the rear do vary from one to the next.

Setting up the guide camera

Some CCD cameras have two chips inside, one for imaging and another for guiding. These tend to be at the upper end of the market and quite pricey so it is unlikely that you will be starting with one of these. Instead, you are more likely to be using a separate guide camera attached to either a guide scope or an off-axis guider. Place the guide camera in to the guide scope or off-axis guider so it is not at an angle. You can check this easily when it is dark; once the stars are visible, get it focused using the same approach as the main camera above. Once you have it nicely focused on a bright star, switch the telescope slew (movement) speed to a low setting and set the camera to take continuous images of 1 second. Most camera-control software allows you to run a focusing routine that simply takes a 1-second image and displays it before taking another automatically and displaying that. This allows you to see any changes from image to image, so although it is great for focusing it can also be used to line up the guide camera. With the focus routine running, I find it easiest to slowly move the telescope in right ascension during the exposures so that star trails can be seen. You should aim for having the star trails move horizontally across the image, so if they are not, then adjust the orientation of the camera in the eyepiece holder and try again. This does not need to be accurate but it does mean the guide camera has far less work to do when guiding than if the camera was not aligned. With the main camera and guide camera focused and aligned it is time to start taking pictures, but the first pictures are called calibration frames and are not yet the exciting images of deep space.

Image calibration

Because of the nature of the images taken in astrophotography, there are a number of things that need to be "done" to the raw image to get the best possible final result. This process is known as *image calibration*, which essentially involves taking a picture of some of the unwanted effects of the optics and electronics, and subtracting them from the final image. We have already looked briefly at *dark frames* to remove so-called dark current but will cover this again in more detail a little later. There are two other supporting images that need to be taken so we shall look at each of them now.

The first and easiest is the *bias frame*, although in most cases if you have taken a dark frame then the bias information will already be accounted for. As you progress through CCD imaging, you may at some point need to use separate bias frames. Bias information is generated from within the CCD and is the result of a tiny amount of pre-charge in each pixel. In

▶ *The calibration routine moves the telescope by a small amount in both axes and records how far stars move across the CCD chip. This allows the software to know how much to move the telescope in order to make corrections during guiding. This image of the Orion Nebula was taken while the calibration routine was taking place.*

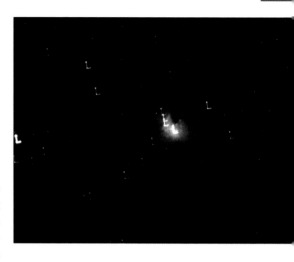

its simplest sense, the pre-charge readies the pixels for detecting light, so if kept in the dark completely, then the pixels will still generate a subtle variation in brightness across the chip (this is different to the dark current we have already briefly mentioned). It can be visualized as a gentle mottled effect and although on initial investigation it is not detectable, once you start to process the image the effect can become a problem and your lovely black sky can end up with a rather ugly blotchy look to it.

As we work through this book, we will consider taking dark frames at the same temperature and exposure length as the raw image, but there are techniques where dark frames are produced at different exposures and temperatures. In cases like these, you will also need to use bias frames so it is useful to know how they are taken. The best way to get a bias frame is to take an image that has an exposure of zero seconds. Unfortunately, not all CCD cameras will allow this as some have a minimum exposure time, so set the exposure to as fast as possible and ensure the camera is protected from as much light as possible. This will record the subtle variations in the chip caused by the bias information, giving you a bias frame that can be subtracted – but as we have seen, with the simplest techniques, these are already accounted for so do not worry about producing them for now.

Another more important calibration image is known as the *flat field*. The flat field calibration is used to correct the variation in sensitivity across the array of pixels on the chip. This variation in sensitivity comes from a genuine variation in sensitivity to light of each pixel, but also comes from an uneven illumination of the chip from dust and other contaminants on the detector or on the lens or mirror. In order to take a flat field it is necessary to find some way of evenly illuminating the CCD, which can be achieved by shooting the clear twilight sky before the stars are visible. An alternative but more fiddly arrangement used by a friend of mine is to use a white light box placed over the aperture of the telescope; others will use a piece of evenly illuminated white card held nice and steady at a distance from the telescope. I tend to use the dusk sky before the Sun has finally set for my flat fields, as I have always found this solution to be easiest and most convenient, although care must be taken for the sky to be featureless with no clouds or stars appearing. Pointing the telescope just to the east of the zenith (the point overhead) usually works best in my opinion. The only drawback to this approach is that if you need to reshoot your flat fields during the night, then you will have to wait until the brightening of the dawn sky.

Struggling to tell your flat fields from your dark frames?

Check out this simple reminder:
- The **bias frame** is a zero-second exposure that records only the noise from the electronics.
- The **dark frame** is taken with the telescope cover on, at the same temperature and exposure at which you are imaging, in order to capture noise buildup in the image sensor.
- The **flat field** is an exposure of just a few fractions of a second to capture the variation of sensitivity across the field of view of the CCD.

◀ *This image shows an enhanced bias frame from my Atik 314L+ CCD camera. Removal of this and other sources of noise is key to getting good astronomical pictures.*

◀ *A dark frame doesn't often look like much but it is an image of the noise being generated inside the CCD camera at the same temperature and exposure as your intended subs.*

◀ *Flat fields like this one capture the varying sensitivity across the CCD field, including any variation caused by contaminants or dust.*

Flat fields must also be taken with the camera at the same temperature as the image file or data file and with the camera at exactly the same orientation in the telescope. This is important as the flat field is used to remove the effects of pieces of dust on the optics, so if the camera is at a different orientation, the dust "signal" will be removed from the wrong part of the image. You also need to ensure that you are using the same filters that are used in the data file and that all other optical components are the same, which means you also need to have the telescope focused, as any contaminants on the optics will change shape as focus is adjusted. To be sure that the flat frames are a good representation of the sensitivity of your optical system, it is good practice to take them before starting an imaging run on every night that you are observing. Some people suggest that you can do them once a week or even less

▶ *Maxim DL allows you to examine the pixel value of your flat field to ensure you are getting the exposure just right.*

frequently, but in my opinion it is time well spent while the sky is getting dark.

Perhaps the only challenge of taking flat fields is working out what exposure to use. When considering the light-collecting ability of a pixel, we talk of its "full well capacity," which in the case of my Atik 314L+ camera is 17,500 electrons. In taking flat fields we need to aim for the pixels to be at a value that is around 35% of the full well capacity, so for my system I need to aim for a pixel value of about 6,125 electrons. This only needs to be approximate, so with camera cooled and pointing at the sky, optics all set for the night, you can now take a 1-second exposure and open up the image in your imaging software. I use Maxim DL as this is, in my opinion, the best tool on the market. With the image opened I can inspect the value of the pixels and see if they are near the target value. If the average value is close then you can proceed to take more flat fields, but if it is too far away (perhaps outside the range 30–40%) you should wait for the sky to darken if too bright, or slightly increase exposure time if too dark.

When you have achieved the appropriate pixel value, you will need to take at least nine more flat fields as ten is a minimum for good-quality images. This can actually be a fairly laborious job as you need flat fields for each filter if you are doing tri-color imaging (more on that later but essentially it means taking an image through four different filters). If I am imaging an object that will take quite a lot of work to drag out much detail, then I will often use up to 50 flat fields per filter, which equates to 200 flat fields in all. With your ten flat fields saved, you will then use software like Maxim DL to average them all together and then divide them out of the raw data image. These terms of "average" and "divide" may sound strange, but image processing is just like mathematics! The amount of light a pixel receives is translated to a number which can then be manipulated mathematically. In practice, it is much easier than it sounds as most software has features to do it all for you. This is all covered in more detail in Chapter 5.

The final calibration file to be captured is the dark frame, which we have already looked at. You will recall that the dark frame captures the "noise" within your CCD system and to record it accurately you must have the camera at the same temperature that you are imaging at and also at the same exposure. Because a dark frame only captures noise and not dust or other optical defects it is not necessary to take dark frames every night. I have a library of dark frames that I have built up for quite a range of exposures at a given temperature that I can use. You don't even need to worry about having a dark frame for specific filters as this only records noise in the CCD itself, not defects or contaminants in the optical components. It is worth replacing the dark frames every month or so as the noise signature of your CCD will change over time and you will need to capture that in your library.

We looked at using dark frames during DSLR photography, but for this it was a quick and simple task of setting the "long exposure noise reduction" feature on. I am afraid it is a little more complicated in a CCD, though easier than the flat frames we've just discussed.

In order to correct for the dark current, an image must be taken of the same length of exposure and at the same temperature as the actual image, but with the cover over the telescope so no light hits the CCD. I tend to aim for collecting 20 frames at each exposure and temperature setting that I work with and then combine them all together to produce one master dark frame for that specific camera configuration. Remember that using this technique means you do not actually have to worry about collecting bias frames too, as this dark frame approach takes care of removing the bias information as well.

There is another approach to subtracting the dark current, but it is a little more complicated and requires the additional step of taking bias frames and combining them with the image frame and also the dark frames. The result is what are known as *scalable dark frames* and their real benefit is that you do not need multiple sets of master dark frames for each different exposure – you can use the same dark frame for different exposures. The process involves taking approximately ten dark frames about five times longer than your expected exposures, and then subtracting the bias information using the bias frame. The resultant dark frames (minus bias) are then averaged together to produce the master dark frame at that temperature. They can then be used in processing steps to be applied to raw image data, which can correct for the different exposure times. However, this technique, while useful to know about, is best left for now as it is a fairly involved process.

All of these calibration files may seem a little confusing so we will go over them again later, and in the next chapter will look at how they are applied to image files. For now, remember to grab some flat fields before the start of every imaging run and make sure that, after you have them, you do not rotate the camera in the eyepiece holder or adjust any other optical components, otherwise you will need to take fresh flat fields. If you do have to adjust, then you could always take fresh flat fields around dawn once the sky has started to brighten again. As for the dark frames, you can build these up over time as it is not essential to take them at the time of imaging – we will look at what you do with them in practice in Chapter 5.

▼ *The Lagoon Nebula is a stellar nursery 4,100 light years away. By ensuring the correct application of the calibration images, a truly stunning picture is the result.*

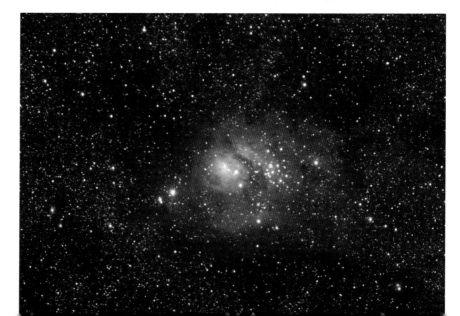

MARK'S TOP TEN DEEP-SKY TARGETS

1. Orion Nebula

Type: Nebula *Apparent dimensions:* 65' × 60'
Apparent magnitude: 4

The Orion Nebula is one of the most popular targets for amateur astronomers, and its brightness and apparent size make it a great target for newcomers to astrophotography. Wide-field telescopes and a large chip mean the entire region can be captured in one frame without the need for creating a mosaic from multiple images.

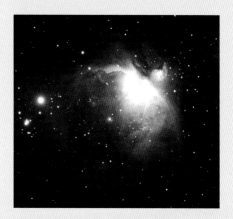

2. Andromeda Galaxy

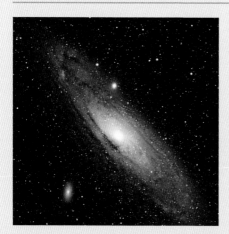

Type: Galaxy *Apparent dimensions:* 190' × 60'
Apparent magnitude: 3.4

Even though the Andromeda Galaxy is bright with a magnitude of 3.4, it provides a challenge to the imager. The difference in brightness between the core and the outer regions means very careful use of exposure times and image processing using curves are needed to bring out the subtle details across the galaxy. To capture the whole galaxy, including its fainter outer regions, mosaics will more than likely need to be built up from multiple images.

3. Dumbbell Nebula

Type: Planetary nebula *Apparent dimensions:* 8' × 6'
Apparent magnitude: 7.5

Planetary nebulae like the Dumbbell Nebula can often require a little more focal length to get a nice image scale, so if you have a wide-field telescope then a Barlow lens may be required to boost the magnification. These are also great objects to have an experiment with narrowband filters to reveal detail that was otherwise hidden.

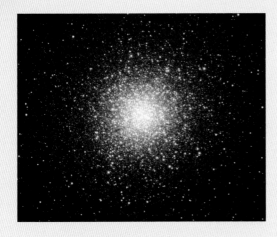

4. M13

Type: Globular cluster *Apparent dimensions:* 20' × 20' *Apparent magnitude:* 5.8

Globular clusters like M13 are great targets that require little post-processing work. The crucial thing with globular clusters is the exposure time. Too long and detail in the core will be lost, but too short and the fainter outer stars may not be picked up. Stacking shorter exposures together will help to retain core detail yet reveal the fainter outer stars.

5. NGC 891

Type: Galaxy *Apparent dimensions:* 14' × 3' *Apparent magnitude:* 10.8

Galaxies come in all shapes and sizes but this beautiful example of an edge-on spiral galaxy in Andromeda is one of my favorite targets. Most galaxies benefit from a longer focal length and this one is no exception. Making good use of the orientation of the camera in the telescope means you can get the longer axis of the galaxy diagonally across the field of view. This is a bit of a challenge for the newcomer but well worth the hard work.

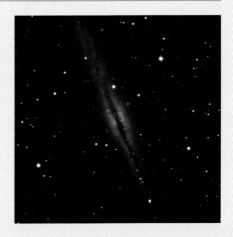

6. M81 and M82

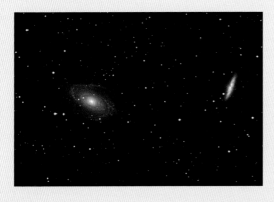

Type: Galaxies *Apparent dimensions:* 60' × 30' *Apparent magnitudes:* 6.9 and 8.4

Wide-field telescopes can be great for capturing groups of galaxies like this shot of M81 and M82 in Ursa Major. Using computerized telescopes is great for centering single objects, but if you are aiming for a group of objects then you will need to identify the coordinates (right ascension and declination) of the center of your intended image and direct the telescope to that point.

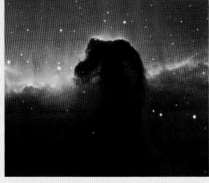

7. Horsehead Nebula

Type: Dark nebula *Apparent dimensions:* 8′ × 6′
Apparent magnitude: 6.8

The Horsehead Nebula, an elusive object for visual observers, is much easier to detect with imaging equipment. The dark cloud resembling a horse's head is silhouetted against the red light from the brighter emission nebula behind. The region around the nebula is aglow with nebulosity so wide-field telescopes and longer-focal-length instruments reveal different but very pleasing results.

8. Pleiades Cluster

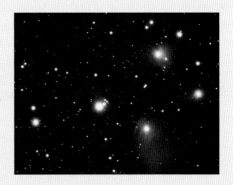

Type: Open cluster *Apparent dimensions:* 110′ × 110′
Apparent magnitude: 1.6

The Pleiades Cluster covers a large area of sky (just under 2°), so large chips can help to capture as much of it as possible. The sensitivity of CCD cameras means that the stars of the cluster can be captured as well as the nebulosity surrounding them. The nebulosity appears blue in images as it reflects light from the stars.

9. Sombrero Galaxy

Type: Galaxy *Apparent dimensions:* 9′ × 4′
Apparent magnitude: 8.9

Another great example of an edge-on spiral galaxy is the Sombrero Galaxy (M104). Longer-focal-length telescopes are needed to get good image scale and, due to the contrast between the dark dust lane and the brighter bulge of the galaxy, a little work is needed to process the image, with particular attention to manipulating the curves. This image of the Sombrero Galaxy was captured by Nick Hart using a 250 mm reflecting telescope from Newport, South Wales.

10. Eagle Nebula

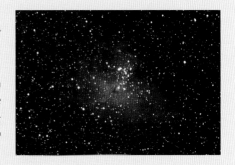

Type: Nebula *Apparent dimensions:* 7′ × 7′
Apparent magnitude: 6

The Eagle Nebula (M16) is a fine example of an emission nebula appearing red in images. The hydrogen emissions from the cloud and its brightness mean it is also a really good object on which to practise your narrowband imaging.

Image composition

With a focused camera and the object centered on the chip, plus supporting frames all captured where necessary, now comes the exciting bit – taking the picture! Lining up the telescope on your target object can be a little bit of a challenge, but this is where a computerized Go To telescope mount is essential to makes things easier. With an accurately setup Go To mount (which means accurate polar alignment, star alignment and accurate entries of latitude, longitude and time), selecting an object from the telescope's database will bring it within the field of view of the camera. If you do not have one of these Go To mounts and are reliant on finding objects yourself, then it would be worth investing in a flip-mirror eyepiece holder. As their name suggests, they slot into the eyepiece holder of a telescope and incorporate a mirror at a 45° angle to the incoming light path that can be flipped up and out of the way. They are usually set up so that a CCD receives the incoming starlight if the mirror is flipped up, but with the mirror down, the light gets diverted out of a different tube and into an eyepiece. This allows you to switch between eyepiece and CCD without removing the camera. If you do not have a Go To mount then this extra gadget is well worth investing in.

You may find that the object is slightly off-center in the field of view and if this is the case then slowly move it to the center using the telescope's electronic slow-motion controls. If you do own a Go To telescope mount then it is a good idea to align the telescope on the object once it is centered on the chip, as this will add a greater level of accuracy to your alignment model – for the few clicks it takes on the keypad of your telescope this is well worth doing.

Deciding exactly what to image may sound like a simple thought process: "I think I will photograph the Andromeda Galaxy tonight – that always looks pretty." Certainly, it helps to know first whether your chosen target is visible but try and pick objects that are nice and high, because if they are lower down their light will be passing through much more atmosphere and so will be more disturbed. This could result in the image jumping around much more and will affect the quality of your final shot. The best position is when objects are high in the south, though this may not always fit with your availability or may coincide with a weather front heading your way.

Another more important consideration when choosing an object is the field of view of your camera-and-telescope combination. We have already looked at this in some detail in Chapter 1 when considering choosing CCD cameras. If it turns out that the Andromeda Galaxy is larger than your field of view then the two options are to use a focal reducer to

> **Composing an image**
> Planetarium software can be very helpful in helping you to compose your shots. By entering your pre-calculated field of view of the camera, or by entering the camera and telescope details for the software to do it for you, you can immediately see where you need to point the telescope in order to get the best composition. With many of the more advanced pieces of planetarium software you can even command the telescope to slew to exactly that position.

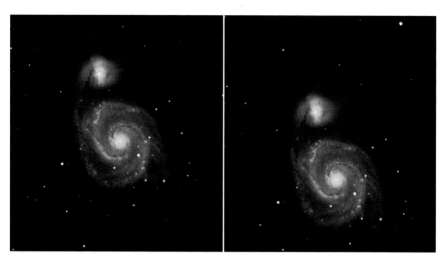

▲ *The result of good image composition or framing (left) of an image of M51 compared to poor composition (right).*

shorten the focal length of your telescope and give you a larger field of view, or to take a number of shots to produce a mosaic. The latter option is worth steering clear of for now as it can have its own challenges, so, as a newcomer, find objects that will fit within the field of view of your system.

You will need to think a little about the composition of the image as well, and while I am not suggesting rotating the camera in the holder (which will mean you need to take more flat fields), you can tweak the position of the telescope to allow for the visibility of the whole object. A great example of this is the Orion Nebula. Centering the brightest portion of the nebula will mean the southern aspect of it is likely to be clipped along the edge of the CCD frame, whereas placing its brightest regions to the top of the frame will mean the whole nebula will be captured. Take a few test exposures to check that you are in the right area before getting your teeth into the actual images (or subs, as they are sometimes called) that you are going to use. For fainter objects that require longer exposures to reveal the detail, you can judge composition with shorter exposures by looking at the position of the brighter stars in the field of view. Waiting for objects to rise higher in the sky is a great opportunity to fiddle around with composition and focusing, so make sure you use the time wisely.

There will be occasions when you will need to rotate the camera, perhaps to get the long thin axis of a galaxy across the diagonal axis of the chip, so remember that you will need new flat fields for this. Of course, if you have planned thoroughly, then you will already have worked out the approximate angle of your camera and got it roughly correct before taking the flat fields. Planetarium software can help to work out the orientation of a camera, so check that yours will display fields of view and make use of the feature.

To maximize the quality of the image data, you will need to take a number of subs and stack them together. If you are using a mono camera with color filters, you will need to take a number of subs through each of the different color filters, so do not be surprised

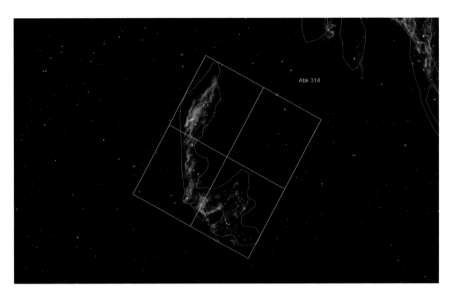

▲ *Software like "TheSky" can even help to establish the correct camera angle to achieve the best orientation of the object.*

to find that you run out of time in one night. It is not always practical to leave the CCD set up in the telescope, but there is a great way of making sure you put it back in almost the same position the next time you come to image. A friend of mine showed me this really neat, albeit cheap, solution! Identify where the CCD camera can rotate against the eyepiece holder of the telescope and measure the circumference. Take some masking tape and cut a piece as long as the circumference of the tube. Divide it up equally into about 15 sections and mark them clearly with a black pen and number the marks. Now stick the tape carefully around the tube at the very end where the CCD adapter meets it and then coat it in clear varnish (nail varnish works well) to protect it from the damp of the cold night air. All that is left to do is to paint a thin white line to act as a marker on the CCD where it is flush against the masking tape, so that you have a reference point. Now, whenever you take an image you can make a note of its orientation in the eyepiece holder and replace it in the same position should you wish to get it back in roughly the same place.

◀ *The author uses a very simple system for establishing camera angle with a piece of masking tape and angles marked off at regular intervals against which the camera is rotated.*

Taking the pictures

Now that you have all the calibration files, with the cameras focused and running at the right temperature, and the image composed, it is time to start gathering data. If you are planning on taking exposures of longer than 30 seconds, which is more than likely, then you will need to get the guiding running. For a well-polar-aligned telescope and a relatively short focal length of less than 1 m, the drive is probably sufficiently good to provide accurate enough tracking, but for longer exposures you will need to get the guide camera set up first.

The first thing to do is decide what exposure to set the guide camera to. If you have a lower-quality mount then you might find the drive needs correcting a little more than a better-quality mount, so in order to achieve the more rapid adjustments a shorter exposure would be preferable. Alternatively, if the atmospheric conditions are turbulent and the seeing is poor, then a shorter exposure could cause the guide camera to start chasing the star around the sky as it bobs around. Getting the exposure just right will mean a little trial and error, and you will certainly need to tweak it to account for the conditions. I set my guide exposure to be anything from 5 to 10 seconds, which works well for my setup and typical weather conditions.

An exposure of the required length is then taken with the guide camera, and depending on the software used, you can either choose a star to guide on yourself or the software will pick one. Do not pick a star that is too bright as I find that most guiders work better on fainter stars, so stick to those that are around 5th–7th magnitude. At this point, select the "calibrate" command if you are using Maxim DL to get the software to work out how many turns of the drive motor are needed to move the star a certain amount in the sky. You will hear the motors whirr as it moves by a tiny amount, and from images taken the software will calculate how much it has made the star move. Once calibration has been completed, you now just need to select the "track" command and the software will continuously take exposures that you have defined, and will control the mount to keep the star in exactly the same place. You will then be shown the images as they appear; in addition, most software will show you a small graph that reveals the amount of guiding corrections that the software is making. With this running, you can be sure that the object will stay perfectly still on your main CCD chip for the duration of your exposure.

You may find that you run into problems with guiding. As you watch the guiding corrections, a sudden spike might indicate a bit of dirt in the gears of your guiding system. If this has happened, try running the motors of the telescope back and forth at their highest speed, as this should dislodge any dirt that has got into them. If this does not work then it is a case of taking the drive system apart, but that is not for the faint-hearted, so it would be worth getting along to your local

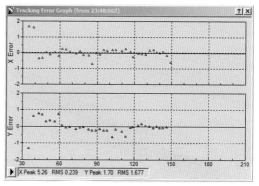

▶ *The guiding information window gives regular information about the guiding corrections that are needed.*

▲ *More data means a stronger signal! Here we see one 30-second sub of M51 (left) compared to five 30-second subs all stacked together (right).*

astronomy society where there are likely to be some more experienced astronomers who would be happy to help. You may find that lots of fairly big guiding corrections are being made, which could be a sign that the seeing is too turbulent for the exposure you are using, so try a slightly longer exposure. If the images you are taking with your main camera are showing stars that look more like blobs, it could be that there is a little flexure or bending between the guide scope and the main scope, so look into ways of making the guide scope attachments a little more rigid. Take a look at the Appendix on page 156 for solutions to other guiding problems.

With the guiding running, it is now time to start the exposure of the main camera – and this is where it gets really interesting! If you have a one-shot color camera, or are working in black and white with a mono camera, then things are reasonably simple. In the old days of astrophotography with film, it was necessary to take a single long exposure that was able to record enough detail of the object you were imaging. But with the advent of digital imaging you can now easily simulate a longer exposure shot by taking a number of shorter exposure images and combining them all using software. If you are not using a guide camera to make guiding corrections then now would be a good time to test out the accuracy of your polar alignment. You can do this by starting off with a short 30-second exposure and see if the stars are trailing. If they are not, then try a 45-second exposure, followed by a 1-minute exposure, and keep going until you see the stars beginning to trail. You can then use this value as a guide to your exposure and take multiple images, which are combined to produce the final image. You will need to experiment with the number of individual subs required, but start off with three and see what the results are like. Later on, in Chapter 5, we will look at the technique of combining the images, known as *median combining* – this will need an odd number of subs, so try three, five, seven or more. In theory, there is no limit to how many subs you should take and I have seen some incredible pictures that have been produced from subs totaling many hours! The limit is really only your patience. One of the main benefits

How true is "true color"?

Combining color subs (including narrowband) can have a big impact on the look of the final image. To get a true color representation it is obvious that you need to use the red image in the red channel, the green in the green and the blue in the blue, but do not be afraid to experiment. To get a close approximation to true color for narrowband, use H-alpha as red, O III as green and S II as blue or you can try using the Hubble palette which assigns S II to red, H-alpha to green and O III to the blue channel.

in combining subs like this is that it will increase the signal-to-noise ratio (SNR). As its name suggests, the SNR is the difference between the amount of noise in the picture and the amount of image information, so by combining images the SNR is increased and the object will be clearer in the final processed picture.

Getting a number of subs of the same exposure is pretty easy with camera-control software because most of them have a feature that allows you to run a sequence of subs, which simply takes the pictures and saves them all for you. If you are running long exposures or taking lots of subs, then this is an ideal opportunity to sit back, relax and enjoy a cuppa! It is always worth taking a few more subs than you intend to use as you might find that the wind buffets the telescope during the odd exposure or perhaps a satellite or aircraft zips through the field of view. Pick the best and then combine them all together using processing software, which we will look at in Chapter 5.

The technique of taking a number of subs and then combining them is a great way of getting lots out of your mono camera, and you can use the same technique in one-shot color cameras too. We touched briefly on one-shot color cameras when choosing CCDs (see page 33), and, if you recall, they are a great choice for getting color images if you do not have much time to devote to processing. There are limitations with the one-shot color cameras, though, such as a reduction in resolution and sensitivity, but modern cameras can still produce some pretty impressive results. But if you have time and want the best results, then the ultimate solution is to start tri-color imaging. This technique involves using a mono

▲ *NGC 7000 taken through a set of LRGB filters (left) compared to a narrowband image using H-alpha, O III and S II filters (right).*

▲ *These red (left), green (center) and blue (right) subs of NGC 7000 clearly show that the nebula emits more light in the red spectrum than in the blue or green.*

camera to give you the best resolution possible (having calculated the best camera for your telescope, as we did in Chapter 1), but with the beauty of full-color images. This is achieved by taking mono subs through different color filters and then combining them later using processing. The results are very impressive but patience is needed to get the end result.

An important point here is that RGB images are supposed to offer a reasonably good color balance. This is not the same as being representative of the view seen by the human eye. The eye is actually a pretty poor detector for astronomical purposes and has its peak sensitivity when dark adapted in the green part of the spectrum. That is why deep-sky objects look bluey-green when looked at through a telescope, and I for one would rather produce gloriously colored images that are balanced well instead of images representative of the view that I can see anytime.

One of the advantages of tri-color imaging is that you do not have to restrict yourself to using the standard red, green and blue filters to produce red, green and blue subs. An extra layer can be added by taking a luminance sub, which boosts the level of detail that can be seen. The filters work by blocking some wavelengths of light while allowing others through – in the case of a red filter, for example, it will let red light through but block all other wavelengths. So by taking a mono image through a red filter, all the camera is doing is recording the red light from the object. By repeating this process through a blue and green filter, a full-color image can be produced.

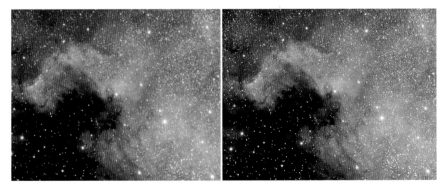

▲ *An RGB combined image (left) compared to an LRGB with the luminance channel adding the fine level of detail (right).*

Standard RGB tri-color imaging can be used on all deep-sky objects but there is another set of filters, called *narrowband*, which can be used to greatly enhance the detail seen in emission nebulae. These narrowband filters use hydrogen-alpha (H-alpha), oxygen-III (O III) and sulfur-II (S II) instead of the standard red, green and blue, and you can get some really amazing results. Other narrowband filters like hydrogen-beta (H-beta) and nitrogen-II (N II) are also available and these can reveal a lot of otherwise hidden detail. Narrowband filters are different to RGB filters in that they block out more light than the standard ones and only allow through a narrow band of light, hence their name. The name of the filter (for example, hydrogen-alpha) comes from the chemical element that is responsible for emitting that specific wavelength of light – by using narrowband filters not only will you record more detail but, because they block out more wavelengths of light, they can also be used to great advantage in light-polluted skies.

The emission nebulae that narrowband filters are so great at imaging are visible only because the energy from nearby stars is exciting atoms within the cloud and causing them to glow or emit their own light, in just the same way that a neon tube glows. The chief difference between using RGB filters and a narrowband set is that the image produced by RGB tries to emulate what the eye might see, should it be capable of detecting color on such faint objects. Narrowband filters, on the other hand, do not try to simulate this and instead produce what is often called a false-color image, but in doing so they provide a much higher level of detail.

We will leave narrowband imaging for now and concentrate on RGB first. A simple RGB image can be achieved by taking a single exposure through each of the red, green and blue filters, giving you three black-and-white pictures. This point is important as many people

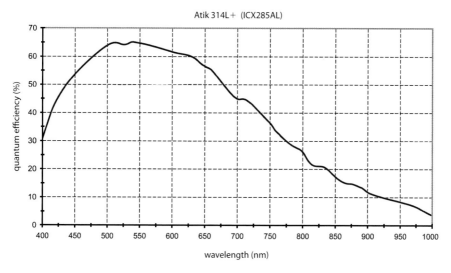

▲ *The quantum efficiency graph of the Sony ICX285AL chip which is used inside the Atik 314L+ camera shows it is more sensitive at a wavelength of around 530 nanometers, which is in the green part of the spectrum.*

expect to see a red image, a blue image and a green image, but the color only appears once the images are combined in image processing later. The mono pictures are then loaded into software like Maxim DL or Photoshop and are assigned to the appropriate red, green or blue channel of the new, combined color image. This process is simple and essentially involves telling the software that you wish to use Image 1 for the red channel, Image 2 for the green channel and Image 3 for the blue channel, and will give reasonably good full-color images. A modification to this approach is to follow the same technique as we used during mono imaging, where a number of subs were taken to reduce the signal-to-noise ratio. If we aim for perhaps five subs at the required exposure per color filter, then that will result in a total of 15 subs. When it comes to processing, the five red subs are combined to produce the master red; this is repeated with the green and blue subs, before the three master subs are combined to produce the color image. As you can see, this starts to become time-consuming – for example, if you are working at exposures of 1 minute, then instead of a total exposure time of 3 minutes it ends up being an exposure time of 15 minutes. If you are exposing for longer with a guided system of perhaps 5-minute subs, then this equates to 75 minutes of imaging time – over an hour! The results will be worth it, though.

It is appropriate here to mention file naming briefly, because if you end up with 15 files (or many more) it is very easy to get confused over which is which. There is no real naming convention that everyone uses, so just make sure you decide on a naming system and stick to it. This will avoid you making mistakes when you start to process the subs and combine them all together.

One of the drawbacks of this approach with red, green and blue filters is that quite a lot of information is lost. Take a look through a telescope filter with an eyepiece in place and you will see that the image is quite dark when compared to a normal unfiltered view. With filters in place, less light reaches the CCD so the level of detail in the final combined color image is reduced. The solution is to use a straight mono unfiltered image to boost the level of detail, producing what is known as an LRGB image, where L stands for "luminance." A great way of understanding how this works is to think how black-and-white photographs

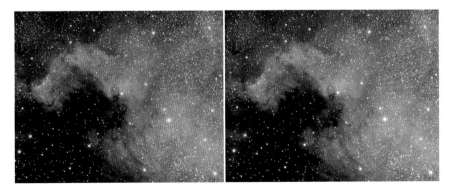

▲ *LRGB images can be processed without consideration of the sensitivity of the CCD chip but the result will be poorly color balanced (left). To get a true color representation of NGC 7000, the color channels were adjusted to compensate (right).*

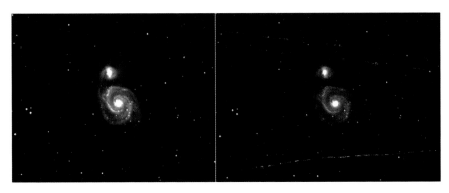

▲ *The luminance image (left) of M51 is at full resolution with 1 × 1 binning, but the resolution of the red image to the right is much less at 3 × 3 binning.*

were colored before the days of color photography. The black-and-white picture provided the detail and the color, applied over the top, turned it into a color picture. In CCD terms, the mono luminance sub is high resolution with all the detail and the color is applied from the red, green and blue subs. Clear or luminance filters are used to get the luminance data, and while some of them may look like a clear piece of glass they will often block a little of the infrared signal that can cause the image to blur. Others block nothing and truly are clear filters, but they should still be used as leaving them out may mean you will need to adjust the focus very slightly. Most people buy a set of LRGB filters that are sold as parfocal, which means that as long as the filter wheel is well built you will not need to adjust the focus when swapping between filters.

Interestingly, because the red, green and blue filters are denser than the luminance or clear filter, a lot less light gets passed through. The sensitivity of the CCD chip should also be taken into account, and as the graph for my camera shows (see page 115), sensitivity varies across the visible spectrum. This should all be taken into account when thinking about exposure times; however, the simplest method is to take exposures of the same length through each of the color filters. If you are interested in working out the correct exposure times then you need to take a look at a quantum efficiency (QE) graph for your particular camera. If the graph is not supplied when your camera arrives, then you will have to search online for it. In many cases, it is easier to find the graph relevant to your camera by searching for the chip rather than the camera. My Atik 314L+ uses a Sony ICX285AL chip, so a quick search online reveals the quantum efficiency graph.

The majority of red filters generally transmit in the regions around 680 nm, with green filters around 530 nm and blue filters at about 470 nm. If you look at those wavelengths on the graph on page 115 then you can see that it is most sensitive in the green part of the spectrum with a quantum efficiency of 65%; blue is next with a QE of 60%, followed by red which is least sensitive at 50%.

It is easy to see that equal exposure times for all filters would give roughly the same information for blue and green exposures, but 10% less information would be captured with the red filter. To adjust for this in my imaging, I tend to make red exposures 1.15 times longer

than the green exposures, and if I wanted to be very accurate then I would also make the blue exposures 1.05 times longer. It is worth noting here that to achieve almost perfect color balance you should not only take into account the sensitivity of the CCD chip, but also the density of the filters and the distorting effect of the atmosphere. The only way of doing this is to point the telescope at a moderately bright white star near the zenith, and take it slightly out of focus. Finding a star of the G2 class means it is the right color, and one like Xi Ursa Majoris is just the right brightness at magnitude 4.9. With this star centered in the camera, take equal-length exposures through each filter that are long enough to register a brightness of no more than 50,000 ADU in each filter. This value is found by choosing the "information tool" in Maxim DL and selecting the star with the mouse – this will bring up a window with its brightness, which is usually referenced as its ADU (analog/digital unit) value.

You will end up with three values – for example, I get red at 22,000, green at 25,000 and blue at 23,000. From these values, we need to do a few sums to work out the correction factor for each filter. The calculation is simply 1 divided by (star brightness value divided by maximum star brightness value). As an example we can look at the red filter for my setup – the calculation becomes:

$$1 \div (22{,}000 \div 25{,}000)$$

which gives me 1.13 for the red filter. Plugging in the values for blue I get 1.08 and, of course, for green a value of 1.00, so these are the figures that I use to work out exposure times for proper color balance with my specific set of filters and camera. If an exposure with the green filter is 5 minutes, then the red filter exposure will be 5 minutes 36 seconds, with the blue filter 5 minutes 24 seconds. Some people go to the extent of applying a further correction factor due to atmospheric effects, which is dependent on the altitude of the star, but I have never found this to make a significant difference. An alternative approach to adjusting the exposure times at the telescope is to keep the exposure times the same for all filters and then adjust how they are processed when combining them in software, and we will take a look at this in Chapter 5.

Whether you have worked out the correct exposure times for different filters or are just sticking to equal exposures, it is still a good idea to expose the red, green and blue channels for longer than the luminance channel so that they produce the same level of information. In principle, the red, green and blue images should be three times as long as the luminance channel, but this can make your total imaging time skyrocket. For example, if you are taking 5-minute subs and taking 5 minutes for each channel, then the luminance data will take 25 minutes and the color channels a whopping 75 minutes!

Fortunately, there is a way to reduce this imaging time by lowering the resolution of the three color images. This can be done in a process that is known as *binning*, which is achieved by telling your CCD camera to combine the signal from four (2 × 2 binning) pixels and consider them as one. By doing this, the resolution of the image is decreased but this comes with an increase in sensitivity of about four times. Having binned the image (which is controlled when the exposure is set up in the camera-control software), the exposure times for color channels will be about the same as the luminance channel

▷ *Making sure the color balance is correct is key to getting an accurate representation of the object's true color, like this image of the Trifid Nebula over 5,000 light years away.*

and will record the same amount of data. It is more common, however, to use 3 × 3 binning, which combines the signal from nine pixels thus increasing the sensitivity even more, leading to exposure times for the color channels of about a third of the luminance channel. So using the example above, which had a total imaging time of 100 minutes, we can now reduce the time taken at the telescope to just 50 minutes. The only extra task that needs to be done is during processing, where the color images will need to be resized to match the size of the luminance image, but the lower resolution that this technique yields (and the color subs will look horrible when you look at them individually) is not an issue because the detail is provided by the luminance channel, which is still at full resolution.

This might all sound horribly complicated, but with the sequencing feature available in many pieces of camera-control software it is pretty easy. Assuming you have invested in computerized filter wheels, which I believe are essential, then you simply input your chosen exposures, number of subs and which filter is used and the computer runs the whole lot for you.

Earlier, we looked at the narrowband imaging technique to get a finer level of detail recorded in the color channels (see page 115). In order to produce a narrowband picture, subs are taken through each of three (although it is possible to use more) filters and then assigned to either the red, green or blue channel during processing. In reality it is not too important which sub is applied to which channel as all narrowband images are effectively false color anyway. Unlike LRGB imaging, there is no luminance channel used in narrowband work, so keep the exposure times the same for each filter, take a number of exposures to improve the signal-to-noise ratio, and then median combine in processing software to produce master subs before applying to the channels. This technique is even used by the Hubble Space Telescope and other professional observatories to enhance different details. Although it does not really matter which filter is applied to which channel, I do tend to apply filters to channels depending on what types of object I am imaging; for example, the light from planetary nebulae comes mostly from excited oxygen atoms so I use hydrogen-alpha in the red channel and O III in both the blue and green channels. Emission nebulae, on the other hand, like the majority of the Orion Nebula, are glowing from light emitted from hydrogen atoms, so I will use hydrogen-alpha for the red channel, O III for the green and then hydrogen-beta for the blue channel. Try experimenting a little as there is no right or wrong way of doing this, unlike LRGB which tries to simulate real color.

▲ *Narrowband imaging of some objects like the Dumbbell Nebula (right) can reveal detail that might not have been seen in an LRGB image (left).*

Exposure times for narrowband subs tend to be much longer because of the lesser amounts of light being allowed through the filters. It is fairly typical for exposures to be about ten times longer with narrowband filters, so if you were taking pictures of 5 minutes' exposure with LRGB then you can expect to be taking one exposure lasting 50 minutes! You will still need to median combine a number of subs into one master, so taking five subs each of 50 minutes means you will be imaging for 250 minutes for just one filter and a total of 750 minutes (or 12.5 hours) for a full set of subs. Don't forget to include the usual dark frames and flat fields as we discussed at the start of this chapter and you can see that it is not unusual to be working on one image over a number of nights.

There is one potential pitfall with narrowband work but it is only relevant if you are using a guide camera with an off-axis guide unit or if your camera has two chips. Either of these two approaches means the guide camera is very likely to be imaging through the narrowband filter too, so finding a guide star can be much harder. Many people opt for using a separate guide camera and guide scope so the challenge of finding a faint guide star through the narrowband filters is removed.

As you can see, tri-color imaging takes a lot of time and a lot of patience but the results can be incredible. One-shot color cameras can give you great and fast results but while it is possible to dabble in narrowband imaging with one of these cameras, it is really not ideal. In my opinion, the flexibility and the high level of sensitivity offered by a mono camera and

Narrowband filters

By using a variety of combinations of narrowband filters (H-alpha, H-beta, O III and S II), different detail will be revealed so it is worth experimenting. But remember: because the filters let less light through, exposure times will be much greater (you should expect around ten times longer).

a set of filters far outweigh the benefits of speed that one-shot color cameras offer. While one-shot color CCD cameras remain the least popular option, using DSLRs seems to be gaining in popularity a little.

It is appropriate to mention briefly the drawbacks of using DSLRs for deep-sky imaging. The main issues are noise and the infrared blocking filter. Many of the astronomical CCD cameras have some form of cooling as we looked at earlier (see page 97) and by cooling them you can minimize the effects of noise, but this is not an option with DSLRs so you must make sure you take dark frames to remove the effect. The infrared blocking filter is not so easy to resolve but its impact is great when it comes to trying to image the red emission nebulae. Most CCD chips, including those used in DSLR cameras, are sensitive in the infrared part of the spectrum and certainly a good proportion of the light coming from emission nebulae is in the infrared. The presence of the blocking filter means that there will be a significant impact on the amount of light to which the CCD is exposed, so ideally for imaging nebulae the infrared blocking filter should be removed. This is a specialist job and certainly not one that you would want to attack yourself if you are unfamiliar with the workings of a camera. It is probably best, therefore, to get a DSLR just for use in astronomical imaging because it is not practical to keep removing and replacing the filter. Using a modified DSLR will give you a funny color balance for normal daytime shots but this is avoidable by messing around with the white balance settings. The infrared blocking filter is less of an issue for galaxy or stellar shots, however, so these can be captured without its removal.

Capturing the shots with a DSLR is best by setting the ISO to about 800. I find this setting offers a good sensitivity, not too strong for stars and just about manageable for deep-sky objects. Higher ISOs are possible but they tend to lose the color in the brighter stars so I usually stick with the lower 800 setting. The aperture setting is now no longer available as we are using a telescope in place of the lens, but the same principles for focusing and framing that we discussed earlier can be used. The automatic focusing option is not always possible with DSLRs because it relies on computer analysis of the image followed by automatically executing a change to the focus, and not all cameras have the software drivers for the advanced camera-control software that offers this feature. Instead

▲ *A cooled CCD image of NGC 7000 (left) compared to a 10-minute exposure from a DSLR which was not cooled (right).*

it will be a manual job using either the reliable Bahtinov mask or the less reliable human eye. With the camera focused and the object nicely composed in the field of view, you should take a number of exposures around 10 minutes each. The exposure will be limited for a DSLR not just by the tracking ability of the mount (if unguided) but also by the thermal noise building up in the uncooled camera. Exposures of much more than 10 minutes tend to start suffering with thermal noise buildup, which is too much to eradicate with dark frames. Take as many subs as you feel appropriate but try starting with about five to see what the result is like. A total exposure time of 50 minutes should be sufficient for most objects but you can always do more for fainter targets.

Object too big? Make a mosaic

If the image is too big for your camera-and-focal-length combination then do not worry – you don't need to buy a shorter-focal-length telescope or a CCD with a larger chip. Both these options are a bit costly so instead you should try shooting a mosaic. We are all familiar with mosaics from our school days when we made them out of ripped-up pieces of magazines to produce a new picture. Astronomical mosaics require a little more planning to get right so that is where the process should start. The easiest way to plan for mosaic work is to use software that allows you to set up an indicator that shows the field of view of your camera. I use TheSky 6.0 Professional but most planetarium software allows you to do this

▲ *This image of the North America Nebula was too large to fit on to one image so it is a mosaic of four individual images that were captured, calibrated, processed and then combined.*

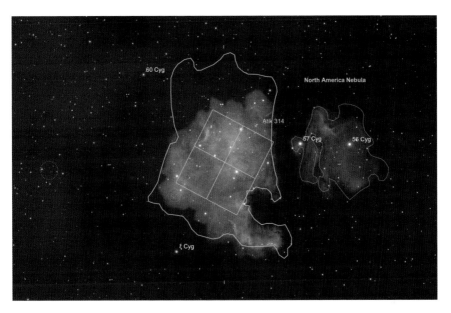

▲ *A simulated CCD field of view of the North America Nebula which shows that the object is too large to be captured in one frame of camera and telescope without using mosaics.*

these days. By selecting either the type of camera or using the custom function to enter the dimensions of the chip, the software will calculate how much of the sky this will cover with your particular telescope focal length.

With this representation of your field of view you can now plan where to take the images and even what rotation your camera should be at to best capture the object. While planning the position of your frames, make sure you overlap each one by a good amount so that you can reconstruct the mosaic later in your image-processing software. Take care when producing mosaics with very short-focal-length telescopes. These give you a very wide view of the night sky and because the sky is to all intents curved, transferring that on to a flat CCD chip will lead to distortions. At longer focal lengths this distortion is not noticeable, but at shorter focal lengths you may find there are issues with getting the frames to line up when you process them. To minimize this, stick to the longest-focal-length system you have that allows you to capture the image with as few mosaic tiles as possible.

That pretty much covers all the basics of getting deep-sky images through a telescope. Whether you have a CCD or a DSLR, capturing the raw image is only half of the battle. After an imaging run, you will now have lots of frames that need pulling together into the final image. Once you have got your end result all processed and looking lovely, it is quite fascinating to compare it to one of your raw image files. The difference will be amazing, particularly if you are tri-color imaging or using narrowband filters. Either way, you are now halfway through producing your beautiful prized picture. The next chapter will now lead you carefully through the field of image processing.

chapter 5
ASTRONOMICAL IMAGE PROCESSING

COMPOSING AND TAKING pictures of family, friends or scenery is usually enough to capture the moment, but when it comes to astrophotography things are a little different. Capturing the raw image is only a small part of producing the final picture, while a surprising amount of time can be taken up with image processing. Regardless of whether you are working with a webcam video, mono or color CCD, or even a DSLR, you will invariably need to perform some tasks at the computer to enhance the image you have just captured. These can be simply adjusting the contrast or brightness levels all the way through to complex mathematical manipulation of the image.

As we have already seen, a digital chip is an array of pixels or light-sensitive devices which produce an electrical charge that is representative of the amount of light they received, with more light producing a higher charge. Digital images are therefore essentially represented in a computer by a grid of numbers from the charge in the individual pixels, with the number equivalent to the brightness of the portion of the sky that the individual pixel was imaging. This may sound a little confusing but the principle can be simplified if we imagine a pixel that can only detect two levels of brightness: dark and light (compared to modern digital chips which can record thousands of different brightness levels). In the computer, that pixel will either have a value of 1 if it has detected light or 0 if no light is detected. Now imagine thousands of these pixels arranged in the grid that will produce a matrix of 1s and 0s when trying to record a full image. This is in effect all that an image is composed of inside a computer, although of course the range of numbers will be much larger due to the greater sensitivity to different light levels.

Having captured the raw image or images, the act of image processing is all about manipulating the numbers that represent the brightness detected by each pixel. The primary purpose of image processing is to enhance the detail visible in an image, but it can be used to correct some minor levels of defects found in images too. What it cannot do is perform magic and turn a rubbish picture into a brilliant one, so your raw images still need to be of good quality. For example, if

◀ *A raw luminance sub of M51, with binning set at 1 × 1 to give maximum resolution. There will be a number of defects in this uncalibrated image that now need to be corrected.*

your image has not been guided properly and there are trails, then there is no amount of image-processing wizardry that can get rid of this. Spend time at the telescope when the sky is clear and get the best possible image to give yourself the best chance of getting the most out of your shots. I know people that rush through capturing images only to spend time processing later to try and turn them into something beautiful. I tend to spend my nights concentrating on capturing the images and only think about processing during the day or when it is cloudy and I cannot use the telescope. At the start of this process you will more than likely have dozens of frames from raw-image files of different colors, flat fields, dark frames and so on – all to produce one image. As we work through this chapter, we can follow how the final image evolves as we look at an example of processing one of my images of the Orion Nebula.

There are three main pieces of software that I use for my image processing: RegiStax for manipulation of webcam footage on planetary objects, Maxim DL for deep-sky image processing, and Photoshop for more general processing techniques of both. We have already looked at using RegiStax to process a webcam video and transform it from a video into a stunning planetary image in Chapter 3. Taking the image from RegiStax, it can then be further enhanced in Photoshop, and likewise with deep-sky images. Maxim DL is great for a number of techniques, but combining with Photoshop will open up a powerful set of processing tools to you.

Calibration

The first task to be done with deep-sky images that have been captured is to calibrate them and this means to apply the dark frames, flat fields and, if appropriate, the bias frames. We have already had a brief look at this when considering capturing them, so the first and easiest task is to remove the dark current by subtracting the information captured in the dark frame. As you will recall, a dark frame is an exposure with the telescope covered up and of the same duration as the raw-image file and at the same camera temperature. Load up your image file into your processing software (such as Maxim DL) and take a close look. You will see a very subtle speckled effect in the blackness of the sky – this is mostly from the dark current and is what we will now remove. Select the "dark subtract" function from the processing software and then select the file which is the appropriate dark frame – this can be a recent dark frame or one from your library if you

▶ *The dark current has been removed from the luminance sub by subtracting the dark frame. This will yield varying degrees of improvement depending on the dark current in your camera.*

have built one up. And that's it! You have just removed the dark current, and taking a closer look at the resultant image will reveal that the subtle speckled effect has now gone. You may be able to detect a little variation in background blackness but this can only be removed by increasing the amount of signal information. Longer exposures will achieve that, of course, but this means guiding needs to remain accurate for longer and the effects of light pollution may start to impact the final image. It is better instead to take more frames and stack them as we saw in Chapter 4 to increase the signal-to-noise ratio. It is important that the dark frame image size is the same as the raw-image size so that the dark current pattern matches exactly, so do not try and fiddle with the dark frame or raw image until you have completed image calibration.

I touched on scalable dark frames in the previous chapter and it is the use of these that means we should consider taking bias frames too. Having captured the ten or so frames about five times longer than your expected exposure, you also need to capture bias frames. A bias frame records the charge applied to a CCD chip so that the pixels are primed to collect light and is of zero seconds' exposure time. The bias frame must be subtracted from each of the ten dark frames in turn and the resultant file saved. You then need to head back into the "process" menu where you can stack the files together and select "median combine" to combine all ten of the new dark frames. This gives you the master scalable dark frame, which you can then apply to your different-length exposures.

As before, you can build up a library of these master scalable dark frames for each of the temperatures at which you operate your CCD, since the noise from the dark current is dependent on operating temperature. With your new scalable dark frame you can use this in the same way as a normal dark frame to calibrate your raw data images. Most pieces of astronomical image-processing software are clever because you simply need to ensure that the software is told of the exposure duration and temperature of the different frames and the software will be able to scale them for you automatically. The scalable dark frames work well too if you have, for whatever reason, not got an accurately matched dark frame for your image. Choose the scalable dark frame which best matches your raw image and use that. You will need to subtract a bias frame from each image file first before then subtracting the scalable darks, but that will mean you now have a partially calibrated image file.

The final task in calibration is to remove the varied sensitivity across the CCD chip and the effects of dust and contaminants. Chapter 4 looked at how to capture these flat fields, and while some consider that the short exposures result in negligible dark current, the noise from bias is enough to warrant this extra step. Subtracting dark frames from flat fields will not only remove

◀ *The next step is correcting the sensitivity across the image by applying the flat field.*

> **A final word about calibration!**
> Make sure that you calibrate *before* you start to align or process the images in any other way. Calibration should be the first thing that you do to your raw image files as any movement or adjustment of the signal in any way will mean calibration will fail and the results will be far from perfect. If you are producing a mono image, you will just need to calibrate once or as many times as you have subs. But if you are using LRGB or perhaps narrowband imaging, then you must calibrate the raw images first before bringing the individual colors together for alignment and stacking. As you can see, this can take a little time – but patience is important if you want to get the best out of your images. Calibration is only necessary for CCD images or DSLR images – you do not need to perform any calibration on webcam images or footage as the exposure times are short enough that you do not have to worry about dark frames; from experience, trying to apply flat fields is pretty challenging and frustrating with little benefit.

the almost negligible dark current but also the rather more impacting bias. The improvements will be minimal so do not expect an amazing transformation, but time spent here will give you a brilliantly calibrated data image from which you can perform other processing tasks. As with dark frames for the data image, the dark frames for flat fields must match in terms of exposure time and CCD operating temperature, and are then subtracted from the flat fields to give you a calibrated flat field which can be applied to your data image in the calibration function of your software.

Maxim DL makes image calibration easy. From the "set calibration" command you can specify the master dark frame (and bias frame if you are using scalable dark frames) and flat field files too. The software will interrogate the individual image files and pull out the exposure, temperature and other items and display them. You then need to specify which file is which and select "OK" for the software to do the rest. There are other configuration items available but you can leave these for basic calibration. The information pulled from the files allows Maxim DL to work out any scaling that is needed, particularly for the scalable darks. There is a calibration wizard too if you are unsure of the settings, so that is a good place to get some further help.

Now that you have calibrated data files, we can move on to the more simple tasks of adjusting the image to display better on your computer screen by "stretching" its histogram.

Linear scaling of the histogram

Many computer screens only display 256 shades of gray whereas nearly all CCD cameras will capture at least 4,096 shades, though many will record up to 65,536 shades. Computers will automatically try and display a picture at its best, but this usually results in the blacks becoming too bright and the bright whites, such as stars and bright regions of galaxies and nebulosity, becoming completely washed out. By stretching the histogram or scaling the

◀ *The "screen stretch" function in Maxim DL is great for revealing previously hidden detail in the image.*

image, much more detail will be displayed. (A histogram is a graph that shows the brightness of pixels against the number of pixels at that brightness.)

Start by opening the calibrated image in your image-processing software and find the "screen stretch" or "histogram stretch" function. You will then be presented with a histogram of your image. All of the good image-processing software I have used usually show the histogram in broadly the same way with tiny markers to the lower left and the lower right, representing the blacks and the whites in the image. Anything to the left of the left-hand marker will be displayed as pure black with a pixel value of zero and anything to the right of the right-hand marker will be white. The markers can be dragged to new positions to adjust which pixel value is taken to be pure black and which is pure white. The same information is displayed numerically in the values in the minimum and maximum boxes just below the histogram. You can adjust the "black point" and the "white point" by entering different values in the boxes. The background sky should be black but the presence of light pollution will cause the background to have a pixel value greater than zero, so to get a proper black sky you can adjust the slider on the left toward the right until the sky looks black, which should be at the start of the information in the histogram. You will now see that the value in the "minimum" box has increased.

Adjusting the left slider has taken account of the background sky so that it actually looks black; we now need to do something similar to the right slider and adjust it so that the bright white regions are not completely washed out. To recover the information in the brighter regions, the white marker needs to be adjusted further to the right, which again can either be done by dragging the marker or by adjusting the number in the maximum box. This will result in an increased value for the "white point," bringing out more detail in those regions.

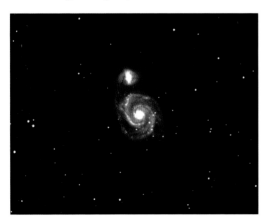

If you look at the histogram, you will see that there are still some pixel values above the maximum that you have just set so you may think it worth adjusting the right slider

◀ *Extra detail is revealed after applying a simple screen stretch to the image of M51, although more can still be done.*

even further to include those, but caution is needed here. Most of the information in the histogram is toward the black end and this includes the majority of the information from the fainter regions of the nebulosity. The few pixels that are much brighter are from just a few bright stars. By stretching the histogram further the really important detail in the faint nebulosity will be spread over a smaller range of the computer's available display capabilities (256 shades of gray) and it is better to lose a little of the bright information in order to preserve the fainter portion.

Log scaling of the histogram

The approach we have just used is good but not great – it can leave some of the fainter information hidden in the black background, although there will be good structure and detail in the brighter portions. A better option is to use log scaling, which actually alters the image data rather than just how it is being displayed as the previous method does. Log scaling will reveal detail nicely in both bright and fainter portions of the image while retaining a black sky. Scaling functions, including the linear method we've just looked at, are accessed from the "process" menu in Maxim DL and then selecting "stretch." With the "stretch" window open, select "log" in the permanent stretch area and then select "max pixel" in the "input range." Leave the "output range"

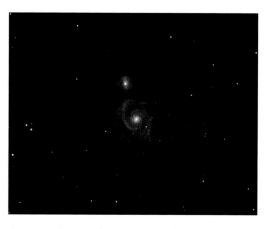

▲ Log scaling makes more use of the available data, bringing out even more information than a simple linear or screen stretch.

as "unlimited" and select "OK." You will be surprised at the difference and can then return to the linear scaling method to darken the sky further or enhance the detail a little more.

Adjusting curves

Once you are happy that you have brought out as much detail as possible by stretching the image, the next thing to do is to enhance specific areas by adjusting the "curves." The curves process is essentially the same as the stretch functions, but instead of applying the same adjustment to the whole image, it allows you to set a new brightness level based on the original brightness level – or, in other words, you can adjust the really bright bits or the fainter bits independently of each other, making it a really powerful tool.

In Maxim DL you can access the curves function from the "process" menu; once selected, it will launch a window that shows a big black square with a white line in it to the left and

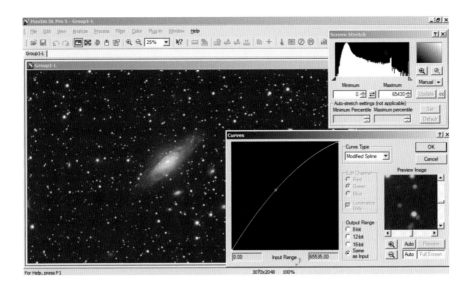

▲ *Adjusting curves after performing linear stretches of an image is a great way to bring out detail in different parts of the image.*

a small preview of your image to the right. Between the two will be some functions that allow you to enhance the image further. The graph has no values along its axes but all that you need to know is that the original brightness value is represented along the horizontal axis and the new value is represented by the vertical axis. The first thing to do, though, is to reset the curves values to their default, which is easiest to do by right-clicking in the black box and selecting "curves" followed by "reset." This will set the white line back to its default, which will display as a straight diagonal line running from lower left to upper right. It is also a good idea to check that the "curve type" selection box is set to "modified spline."

With the graph in its initial state as a straight line, nothing has yet been changed in the image as the original and final values are the same, so what needs to be done now is to adjust the values. If you are dealing with a color image then the "edit channel" box will be accessible so that you can adjust the individual color levels, or you can select "luminance only" to adjust the overall luminance values of the image. Whether it is color or mono, to adjust the curve click somewhere along its length (the middle is a good place to start) and then simply drag it to a new point either up or down. A square will appear at that point on the graph and the line will adjust to pass through that point. If you selected a point roughly along the middle of the graph and moved it upward, then the pixels with an original brightness that was roughly in the middle of the range will now have become brighter. If you moved it down, then they would have become fainter but usually the purpose is to boost the value rather than reduce it.

You can create as many adjustment points as you like along the graph but I tend to work with no more than about six, unless a lot of work is required on an image when I may use as many as ten. If you need to remove a point then you can just right-click and select

"delete point." Just how the graph responds to the different adjustment points is specified in the "curve type" box that we looked at earlier. If you select "piecewise linear," it simply joins up the points with straight lines, whereas the "spline" option joins up the points using a smooth curve. The "modified spline" is the one I use most often – it does the same as the "spline type" but also adds new points on its own to smooth out the curve.

Set the "output range" radio button to "16-bit" and choose the "auto" tick button next to "full screen" – this will show you how the adjustments will look on the full image in the background. If you need to adjust further, then go back to the curves dialog box which should still be visible and make more adjustments, but if all is looking good then select "OK" on the curves box to apply the changes.

Now go back to the stretching function that we used in the previous section and apply a linear screen stretch to make sure the entire brightness range is being used. Head back into the curves dialog box and adjust a little more following the screen stretch, and then (yes, again!) apply another linear stretch and another curves adjustment. You may end up doing this a few times to bring out more data from the image but once you are happy with it and have applied the last curve by selecting "OK," then open up the curves dialog box one last time, right-click and select "reset curve," and make very minor adjustments to the curve to bring out any remaining detail before selecting "OK." Dealing with curves is a bit of a repetitive process and it will take three or four cycles of adjusting the stretches and the curves until you are done.

Combining images

In the previous chapter we looked at the concept of stacking images to reduce noise. It is probably more accurate to refer to this as enhancing or increasing the signal from the object rather than reducing noise, although this is the effect we are after. Unlike the signal from the object, most of the noise in an image is random with the exception of the noise generated by the camera itself, which can largely be removed by the calibration techniques we looked at earlier. The remaining random noise can be greatly reduced through combining images – the more subs that are combined, the greater the result although there will come a point where adding more subs will have little further impact. It works because the image data is consistent from one sub to the next while the noise is random and never the same from one to the next. By combining two images, the signal data is mathematically doubled while the noise is

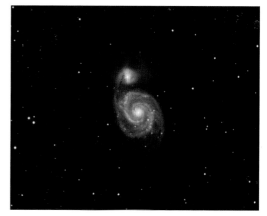

▶ *Stacking five subs of M51 increases the signal-to-noise ratio, effectively making the image data stand out more.*

only enhanced by around 40–50%. In the example on page 131, there was a significant amount of noise visible in the original image which was seen as a speckled effect across the entire image, but by combining five individual subs the noise was reduced and the object enhanced.

Combining a number of images is easily done in Maxim DL or other good-quality astronomical image-processing software, which for the most part completes the task automatically. To access the combine commands in Maxim, select the "process" menu followed by "stack." This process will be familiar from the webcam work we did earlier to stack the individual frames from a webcam video (see page 77). The stack window will appear and from here you can select the files you are going to combine; you then have the option of sorting through them to weed out the rubbish ones where seeing has affected the quality before you select the "alignment" tab, which is done automatically. The software will take care of shunting around the images to align the stars in the field of view and any rotation that is required.

You will recall that I described camera rotation marks in Chapter 4, which enabled you to put the camera back in the correct position for shooting the same object over a number of nights. The ability of software to rotate images to align them should not detract from your efforts to try and get rotational alignment roughly correct, so the software has less work to do. Choose to automatically align the images and then, in the "combine" tab, choose "median" as the "combine method." Now the exciting bit – choose "go," for the images to be aligned and combined to see the result.

Processing filters

Now that you have a nicely combined and noise-reduced image you can apply some additional image-processing functions to make it even better.

If your image still looks a little "speckly," you can try applying a *low pass filter*. Any object that you have imaged will result in the value of pixels varying gradually from one to the next. Rarely will there be an object that will cause significant differences from one pixel to the next unless there is still some level of noise present. The low pass filter looks at the value of every pixel, compares it to the value of the neighboring pixels, and any which stand out significantly will be noise and have their value adjusted to bring them more in line with their neighbor. The effect is that your image will be smoothed after applying this filter. Depending on the software that you are using, it may also be referred to as a *blurring filter*.

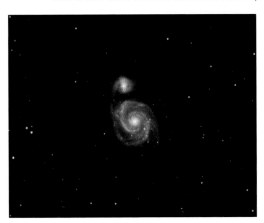

◀ *Filters like the low pass and high pass are great at further enhancing the image, but use them subtly.*

▶ *A further tweak to M51 using an unsharp mask brings out more detail that was previously hidden.*

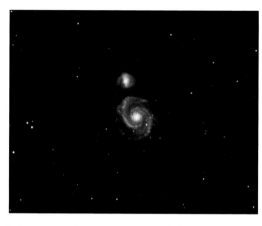

You may find that your image could do with a little sharpening to bring out finer detail and to do that there is a filter that works in an opposite way to the low pass filter, which is known as the *high pass filter*. Use this function with caution, though, as too much sharpening can make the image look overprocessed. The sharpening ability of the high pass filter will not correct for badly focused images, so make sure you get the images as sharp as you can and then use this function for tweaking to bring out a little more detail.

A slightly different yet more powerful version of the high pass filter is the *unsharp mask*. The unsharp mask works conceptually by first creating another more blurred copy of the original image by performing a low pass filter. The new, blurred image is then subtracted from the original to reveal a finer level of detail. This is a much more powerful tool than just the low and high pass filters themselves, since the strength of the unsharp mask, which is created from the initial low pass filtering, and the strength that is applied to the original can both be varied, having a greater or lesser impact on the final result. Applying a much stronger low pass filter will result in a more blurred filter image, which is then subtracted to remove more of the large-scale features that are perhaps a little too bright, thus masking detail. This can be particularly useful in images of nebulosity or to help enhance the regions around the outer edges of the core of a galaxy. Alternatively, a weaker low pass filter will result in a less blurred filter image that will work to enhance and sharpen finer details.

It is interesting now to compare one of the raw image data subs against the fully processed final black-and-white result (see the images below). As you can see, the difference that image processing makes is significant.

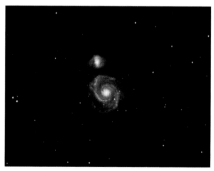

▲ *Comparison between the original image (left) and the fully processed image with low pass and high pass filters and an unsharp mask (right).*

Combining color images

If you are taking on the challenge of tri-color imaging then you will have at least three black-and-white images that need to be aligned and combined. You will recall from earlier in the chapter that calibration techniques were used to remove dark current and degradation due to large dust particles, and to adjust for a different level of sensitivity across the chip. Following this, the calibrated images for each color channel were combined to increase the signal-to-noise ratio. Having done all this and been diligent not to have messed around with the image scale or the orientation of the image, it is now time to take your individual mono pictures and combine them. Remember that if you are using red, green and blue images to get a color image then you will have one image per color channel. You may even have a fourth image with luminance information.

The process for combining these individual files is largely the same from one piece of software to the next. As with the mono images, I will describe the process with Maxim DL but it will not vary so significantly from other pieces of software that you would not be able to work it out from this description. We will look first at just combining the red, green and blue images without the luminance information. The first thing that you need to do is to load the individual files (note that it is a good idea to have named the files in a way

▲ *The four subs making up a color image with (a) full-resolution luminance at binning 1 × 1 and the color images all at lower resolution with 3 × 3 binning – red (b), green (c) and blue (d).*

▶ *The four images are combined during processing, using the functions of Maxim DL.*

that clearly identifies which color channel they represent so as to avoid any confusion during processing). Remember that you will not see any color yet – you will need to wait until the images are combined before color almost magically appears. It is interesting to look at the differences between the individual images as you can sometimes see quite significant variations between them. Images of galaxies tend to show only a little change between the red, green and blue images, but those of nebulae such as the Orion Nebula will show greater differences between them. This is because some objects emit significantly more light in certain wavelengths.

With the images loaded, the next step is to select the "combine" menu and then "color combine," which will load the control panel to set up the color combine. At the top of the window, you will see the option to select what type of color combine you wish to perform. For a basic RGB color combine you need to ensure the RGB option is selected, but, as you can see, there is also the option to choose LRGB and a number of other different types. The rest are best left for now, as even narrowband images can be combined using the RGB option. With this option selected, you will need to select the images to be applied to each of the three color channels.

You can make things easier for yourself here when you set up your color filter wheel and configure your camera-control software to use it. You need to ensure that the software knows which filter is in which slot of the filter wheel in order to configure the software properly. You will need to do this anyway so that you can pick and choose which filter you wish to use, but make sure you label them as red, green and blue from the start. When you take your images, the format of the file saved is known as a FITS file, which stands for "flexible image transport system." These files will store a lot of information about the setup used for taking the picture, including any filter that was used. Maxim DL interrogates the files that are open at the time the "color combine" window opens to see which filters were used. It will try to assign images correctly to the right color channel from the FITS information it finds, but you can correct any assignments that are wrong. However, if you find Maxim is constantly getting the images in the wrong slots then make sure you put R, G or B (or L for luminance) at the end of the filename before loading them. Maxim will check the last letter of the filename as well to work out which color channel it should be applied to.

Take a look at the preview window now in the lower right of the "color combine" window. If the "auto preview" option is selected (which I recommend you leave turned on) then you will see a color image of some sort, but do not be worried if it looks like a multi-colored mush because the images still need to be aligned.

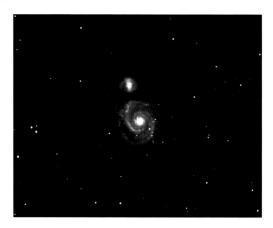

◀ *A simple RGB combined image with the luminance channel left out.*

In order to align the images, the "align" button must be selected. This causes an align dialog box to launch and from here the images can be perfectly positioned with respect to each other. During RGB alignment, the red image is usually automatically selected as the reference image against which the other images are aligned. With the align dialog box open you can select an alignment mode and for this I recommend either "auto – star matching" or "overlay." The first of these options will take the images and recognize matching patterns of stars across them before aligning them by nudging the images around, scaling the images and even rotating them as appropriate. The "overlay" option gives you full manual control to move and scale the images, and helps by overlaying them in different colors to make it easier. There is one further option that requires a little more work but is probably the most efficient of the modes: "astrometry." This mode takes information from the FITS file header that tells the software exactly which part of the sky the image shows. All of the images must be run through an additional piece of software first, called "pinpoint astrometry," which determines the exact field of view from the stars. With this information added to the file header, the "astrometry" mode will appropriately align the images to gain an accurate alignment. Generally, I stick to the "auto – star matching" mode and then use "overlay" for any finishing touches.

The area under the alignment mode selection is for manual alignment – this mode requires you to manually select the same star in all of your images. If you choose this option (which can either be to manually select one star or two stars) then make sure you select the "auto next" box. This will automatically present you with the next image as soon as you select the star in the image, which saves you time in selecting each individual file and indeed minimizes the risk of missing one. The next area at the bottom is home to the "overlay" controls, which is my preferred method of manually moving around the image by

> **Getting the best from your imaging run**
> Gathering data for astronomical images can take quite some time, particularly if narrowband images are being worked upon. It is perfectly OK to capture data on different nights – just be sure to take all the necessary supporting dark frames and flat fields to calibrate the new images. Make sure you use the same optical system too, even though you might have a different telescope that has the same focal length and aperture – you may find there are subtle variations in field flatness which will make performing alignment difficult.

selecting the arrows appropriately to nudge the images to a perfect alignment. Selecting "OK" at the bottom of the dialog box will activate the alignments and return you to the "color combine" dialog box.

On returning back to the "color combine" box, you should now be presented with a much nicer preview that is starting to resemble your final result. The last step is to set the values in the table at the bottom of the window. If this is a simple RGB image then the only slots available to be filled in are "red input/red output," "green input/green output" and "blue input/blue output." These allow you to alter the color balance of the image by adjusting the strength of the color applied based on the original exposure times. If your three images all had the same exposure then you need to enter 1 in each of the slots, but if your blue image, for example, was half the length of time as the red and green then blue should be set to 2 and the red and green values set to 1. Do not be afraid to experiment with these settings until you get a satisfactory result. You will recall the discussion about exposure times in Chapter 4 (see page 112) so this is where you can enter your adjustment factors.

Combining LRGB

This should be sufficient to combine the red, green and blue images and present you with a full-color reproduction of the object under study. We looked earlier at ways that you could utilize a fourth image to record luminance information and you will recall that we discussed how to capture this extra image through a clear filter. The concept is simple: a full-resolution luminance image provides the fine level of detail in the final image, and because there is no color filter to reduce sensitivity, the full sensitivity of the chip is used. The color frames can then, if so desired, be binned to reduce their resolution and also their exposure times, giving us a full-resolution luminance image and three lower-resolution color images. These can then be combined in a process much the same as the one we've just looked at.

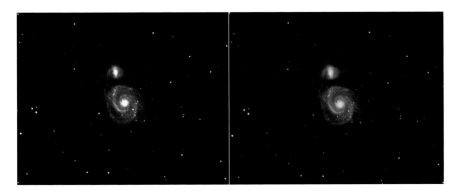

▲ *Comparison between RGB (left) and the same image with the luminance channel providing the higher resolution data (right).*

To combine LRGB images the first thing you will need to do is to resize the color images (if you have binned them 2 × 2, then they will be half the size of the full-resolution luminance file). This is done by opening the three color images and then selecting "process," followed by "resize." From the dialog box that you are presented with, select the "no constraint" option before typing in new numbers for the image dimensions. If you have binned 2 × 2 then simply double the image size, or if 3 × 3 binning then multiply the image size by three. Selecting "OK" will then present you with a resized image, but it will look horribly pixelated. No need to panic, though – the beauty of LRGB imaging is that the color files just provide the color information; the fine level of detail is provided by the higher resolution luminance file. You should now have three resized and pixelated color images for the red, green and blue channels. Now open up the luminance file and select "combine," followed by "color combine."

Instead of selecting the RGB color combine mode, choose LRGB which will give you another file selection box to choose the luminance file. Now repeat the steps we looked at earlier to align and then combine the four images. I sometimes find that Maxim seems to struggle with image alignment, particularly if I have binned the color images 3 × 3, so instead I tend to use the manual two-star alignment method so that I have to choose two stars on each of the color frames.

Narrowband processing

We looked earlier at the use of narrowband filters, which are a great alternative to using red, green and blue filters. When combining narrowband images the technique is identical to combining RGB images, but with one crucial difference that you should bear in mind. Narrowband images make no attempt at re-creating what the human eye can see so these images are considered to be false-color. Usually just three narrowband images are combined and in doing so they are assigned to either the red channel, the green or the blue during processing. They are then processed in the same ways that we looked at earlier.

Perhaps the most common method is for H-alpha to become the red channel, O III to become the green and S II the blue channel. Do not be afraid to experiment with the way that you assign these colors, though. Even NASA tends to use a different assignment to take advantage of the sensitivity of the camera being used and so may assign S II to the red channel, H-alpha to the green and O III to the blue channel. My camera is most sensitive in the green so I tend to use the H-alpha image as the green channel when imaging emission nebulae, as that allows me to exploit the sensitivity of the camera. The real beauty of narrowband imagery is that there is no right or wrong way of doing it, so get creative!

Processing one-shot color images

Surprisingly, the majority of one-shot color cameras require images to be processed (with the exception of the DSLR-style cameras). We looked at these earlier and saw how the CCD is covered in an array of color filters known as the Bayer matrix (see page 33). The image that

CCD filters

The graph shows the amount of light being passed through a red, green and blue filter, but look closely to see the thin lines buried inside those chunks of color. These lines represent the light being passed through the narrowband filters. As you can see, a lot less light is passed through narrowband filters and that is why exposure times need to be so much longer.

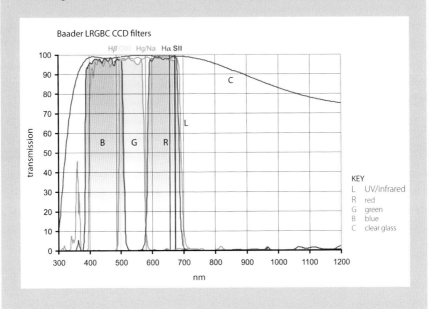

comes out of a one-shot color camera is still mono but will look somewhat speckly in comparison to a normal mono image from a mono camera. This speckled effect is not the result of noise, although of course there will be noise present but that can be dealt with in just the same way that we looked at earlier in the chapter. Instead, this speckled effect is the result of the presence of the color filters covering the pixels, where each pixel is seeing either red, green or blue light depending on the filter in front of it. To remove the speckling effect and to turn the picture into a color one, the "color conversion" or "debayer" process must be completed. These are the terms used in Maxim DL but other software will have similar terms. This process is done automatically in most DSLR cameras but needs to be manually performed in astronomical one-shot color cameras.

Load the image into your processing software and complete all your calibration tasks first – dark frames and flat fields – and once this is all done you can start adding color. Thankfully, the software usually knows how to "colorize" most camera models so you just need to select the model of your camera and the software will do the rest. However, you may find that the result is pretty garish, because while the software knows how to colorize the image, individual cameras may require a little tweaking. This can now be done

in the "convert color" section, which allows you to adjust the alignment of the color channels until you get a good result.

A word about the flat fielding which in many cases will annoyingly strip out the color information in the image. This happens because a flat field should assume a perfectly uniform field, but of course with the Bayer matrix in the way there will be color tints across the field, so applying a flat field will remove this. When you are registering your calibration files in Maxim, there is an option to select "boxcar filter" when specifying the flat field. This will ensure color information is retained through the calibration process. Once you have completed this debayering procedure, you can then look at stacking multiple images to improve the signal-to-noise ratio and other processing techniques that we have already discussed.

Advanced processing techniques

Having completed all your calibrations, aligned, stacked and done everything that you think you could possibly ever need to do to your image, there are a couple of other more advanced processes that will eek out a little more information – although, be warned, these should ideally be done after calibration and before any other processes. There are two particular techniques that I want to look at: the "digital development process" and "deconvolution." Both of these have very different benefits to your beautiful new image, and while you may think it cannot get any better, a little more time spent processing your picture will get the very best you can out of it.

The "digital development process" or DDP (also known as the "digital development filter") was developed to re-create the responsiveness of film in a CCD-produced image.

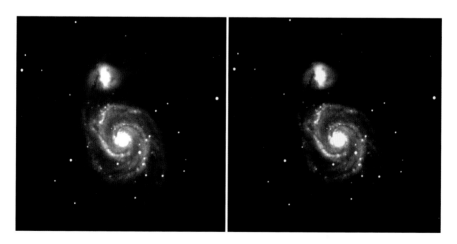

▲ *Image of M51 before the application of the DDP filter (left) and after (right). Notice how the darker regions of the image are more enhanced but the lighter regions are barely affected.*

▶ *Selection box positioned over the darker area of the image for Maxim DL to determine the best DDP settings.*

Stubbornly, it has taken me many years to accept that the CCD is much more capable than film and, ironically, here we are, now using techniques that allow us to mimic film response in a digital image! Unlike a CCD, which is equally responsive to all levels of light from black to white, a photographic film tends to be more sensitive in the darker levels around dark grays. This characteristic means that it was always easier to tweak and enhance the darker regions in a photographic picture without completely blowing out the brighter regions. The DDP allows us to do this with digital images and it is most useful when working on images with a large range of brightness across the entire image – galaxies are a great example of this.

It should be noted at this stage that the DDP should be done before combining color images or stacking in any other way. If you are using one-shot color then it should be done after you have completed the debayering process to add the color.

With the image open that you wish to apply the DDP filter to, run the mouse pointer over the darkest areas of the background to see what their values are – the darkest part will have the lowest number. With this number in mind, you now need to select "filter," followed by "digital development," and you will be presented with the DDP dialog box. It will look familiar from the filters we looked at earlier, but this time take a look at the bottom of the box and you will see a DDP section with an "auto" tickbox underneath "background"; uncheck this to see the value that has been applied. It should be similar to the value that you found earlier by running the mouse over the background. If it isn't, then adjust it – I always find it overestimates this value by anything from 100 to 200, which results in too much processing and a loss of information in the final image. Alternatively, choose the "mouse" option and select a dark part of the sky for Maxim to enter the value for you in the "background" box. Just next to the "background" box is the "mid-level" section, and for this I tend to leave it at automatic.

Just above the DDP parameters section is the "FFT hardness" section. By applying DDP there tends to be an overall softening of the image, so the FFT section allows you to sharpen up the image to compensate. I usually ignore the pre-programed "mild," "medium" and "hard" settings and use the "custom" option with a "cutoff" setting of around 80%. Have a play with this figure, though, to get a result that you are happy with. The final setting is the "filter type" and for that I tend to find the "FFT – low-pass" option works the best, although this is very much a subjective thing so try each of them to find the one that you prefer. However, be cautious with overprocessing, otherwise the final image will look unnatural. Once you have chosen which "filter type" you wish to use, select "OK" and the filter will be applied to the image. You will be amazed at the difference.

"Deconvolution" is perhaps the most powerful of the two processes that we consider here, and when used in conjunction with DDP can transform an image. The technique was first used in angst by NASA on the troubled Hubble Space Telescope. Even after its corrective optics were installed, the images still required further sharpening so the deconvolution technique, which was first used by radio astronomers, was employed. It remains a very useful tool among astronomers who use the Hubble Space Telescope as well as being popular with amateur imagers. No matter how much effort you put into focusing to make sure you get the sharpest possible images, deconvolution will be able to get them a little sharper. I tend to find that images taken through longer focal lengths which have a smaller pixel scale respond better to this process (in other words, are less sharp) than those taken with shorter-focal-length, wide-field scopes which are more forgiving in getting a good focus.

As with DDP, it is best if you run deconvolution after you have calibrated the images but before you have color combined them. This is particularly the case if you are producing an LRGB image, in which case you should try to apply DDP and deconvolution to the luminance channel only before color combining to get the best results.

The process works by determining something called the "point-spread function" (PSF), which is essentially how much the image of a star has spread across a number of pixels. Having analyzed it, the process tries to tighten up on the spread, making the image sharper and revealing a little more detail. The image you are working on is probably still open from having used DDP, but if it is not, then open up the image you wish to process and select "filter" followed by "deconvolve." The first thing that needs to be done is to identify the level of background noise. To do this, you will see a "noise extraction tools" section at the bottom of the window: choose "auto-extract" for the noise levels to be automatically populated. This will ensure that the background level of noise is not amplified when the deconvolution process runs.

Now select the "PSF model" tab and select "Gaussian" as the function type. This is the option to choose if you are removing a blur that has been caused by atmospheric seeing. (In the case of the Hubble Space Telescope, the "exponential" option is usually chosen as it removes blur induced by the optical system instead.) Now click on "select from image" to the right and find a star in your image that is not completely burned out but is of average brightness. Once you click on the star, an information window will appear showing you the brightness value of the pixel – this should be no higher than about 60,000, and from this star Maxim DL will calculate the PSF. The calculated PSF will appear in the "PSF radius" box, which I find is always too high. Experience has shown me not to bother even running it at this value, otherwise the stars will end up looking horribly overprocessed with dark rings around the brighter ones. I usually reduce the calculated PSF by at least 50%, sometimes a little more.

We are now nearing the end of this final piece of processing so select the "deconvolve" tab. This opens up the final settings and from here choose the "Lucy–Richardson" method of deconvolution, which will take the known PSF and apply it across the entire image. It is always worth applying the process to a small portion of the image first, as it can take quite some time to deconvolve a large image. You can do this by choosing a subframe of the larger frame in the "operate on" section. There are a range of values that you can select from a dropdown box but I tend to stick with a subframe of 512×512. This can then be dragged around the screen to choose the most interesting part of the frame to process. It is no use

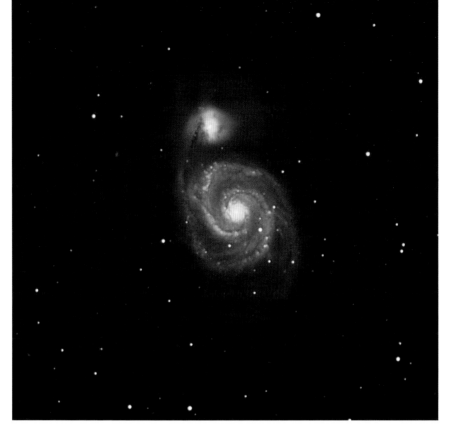

▲ *Final color processed image after full processing including DDP and deconvolution. A few extra tweaks have been made in Photoshop to remove colored pixels, which were a result of various processing techniques, using the clone tool to copy background pixels.*

to deconvolve the background sky as you will not be able to tell what the final image looks like. Pick an interesting area perhaps just away from the core of a galaxy or near the center of a globular cluster.

Now you can set the "number of iterations" to 10 and select "go." The process will run iteratively for ten cycles. You can stop it halfway through but it will only action the stop command at the end of an iteration, so if you want to abort, select "stop" and then wait. Once it completes, look at the area you selected to try it on, and if it has worked well select "undo" and then choose "full image" in the "operate on" section. Then select "go" again. This will take some time to run through, particularly if the image is large, but be patient and wait for the result. You can then save this final version, and if it is part of an LRGB set, start combining – or if not, then stack with other mono frames to reduce the signal-to-noise ratio.

There are many other processing techniques that have not been discussed in this chapter. But the techniques we've covered will get you producing some stunning images, though there is of course much more to learn. With time and the experience gained using the processes described here, you will be ready to look at other more complex processing techniques that can further enhance your beautiful new space images.

chapter 6
A TYPICAL IMAGING RUN

THE CHAPTERS SO FAR have given you guidance and advice on choosing equipment for astrophotography, describing how you can take pictures using DSLRs, smartphones, webcams and specialist astronomical CCD cameras. If you follow my directions, you will be able to get some great astronomical pictures – and if you spend time working through the previous chapter you will be able to take those pictures and process them to within an inch of their life to reveal stunning hidden detail. There has been a lot of new information presented to you already, so this final chapter is somewhat of a summary to bring it all together. Everything that precedes this chapter has been based on how you get to take pictures using various different techniques and equipment, but when it comes to actually getting out under the stars there is a fair bit of planning required – not only to optimize your imaging time, but also to ensure you do not wake up the next morning with a gazillion images of which you have no idea what they are! Believe me, I've been there!

This chapter takes a look at a typical evening with me out under the stars, so that I can share with you just how I go about taking pictures. A great example of this is an evening spent getting pictures for this book. When the idea for this astrophotography title was discussed, I was keen that I would provide the majority of the pictures – however, despite best intentions and all that, the timing was not great. My telescope system used to be set up inside an observatory in my back garden, but having sold my house to move into rented accommodation (pending starting to build a house – and observatory, of course – on a nearby plot of land) my equipment was usually only set up when I needed it. With the need to get images for this book, I decided to set it up semipermanently outside, but I needed

◀ *During the winter of 2013–14 the author stored his entire optical system (minus CCD cameras) outside in the elements. They were protected by a layer of insulation and a further waterproof layer.*

▶ *The author's cable management system using the Hitecastro hub, which keeps trailing cables to a minimum.*

to protect it from the Norfolk weather. To protect it from the cold of the night, I needed to insulate it and so put together a huge cover made of cavity-wall insulation acquired from my local builders' merchant, and then on top of this lot was a waterproof cover. When wrapped up, it was as snug as the proverbial "bug in a rug." I realized how very impressive the insulation material was in keeping the scope away from the frost when, on the hardest of frosty nights, I took the cover off to find that the scope was perfectly frost-free and actually quite warm, while everything else I could see was white with thick frost. This was all a perfectly legitimate thing to do, although there was of course a risk to security of the equipment. In reality, it looked more like a giant plant that had been covered up than an expensive piece of equipment.

I set up the mount on some solid bricks to give a firm foundation and got the mount nicely polar aligned. I used the drift alignment method described earlier in Chapter 4 and managed to achieve a pretty high level of accuracy. At 250× I had a star bang in the center of the eyepiece for a good ten minutes before any sign of it even thinking about wandering off – and that is a good level of polar alignment. Both of my telescopes were attached and all electronics hooked up with exception of the CCD camera and filter wheel as these were generally stored in the garage.

As an interesting aside, I want to say a word or two about cable management. Whether you are using one or two telescopes, you will have a fair bundle of cables if you are imaging. My own setup feels like it has about a million cables sometimes, so that is why I have gone to some lengths to wire it all up properly. I use a USB hub, which allows me to distribute power to devices as well. The beauty of this is that I have one USB cable running to the telescope from the control PC and one power lead running from the power supply. Everything else is connected to the distribution hub and cable-tied in place where possible or by way of cable clips that can be opened and closed to remove for storage. I would heartily recommend spending some time getting your wiring all neatly routed through and fixed where possible. Snagging cables are the second highest cause of imaging problems, with the majority caused by balance problems. If your setup is not permanent, it is well worth getting hold of some Velcro cable-ties that just wrap around anything you can find to hold your cables in place.

With all of this working so wonderfully and worth in the region of $24,000, you can imagine my utter horror when I returned home after a Christmas vacation to see the whole lot had blown over and was laying flat on its side! To cut a very long and painful story short, it seems we had experienced winds in excess of 80 miles per hour while I was away that had blown everything over, although the only damage was to a couple of gearboxes which cost

> **Start-up procedures**
>
> If you have lots of accessories attached to your telescope then it is worth putting together a start-up procedure. I find this particularly necessary when dealing with powered USB hubs. With my setup, I must start up the PC with the hub cable connected but not turned on, then load the hub-control software – only then should I power up the hub and finally choose "connect" from the software. If I try this in a different order, invariably it will fail to work. A start-up procedure that is written down will save much time and frustration during your own setting up.

$100 to replace! I was not just lucky, I was *incredibly* lucky – and following the whole sorry affair I was actually getting a much better view through the main telescope than I was before. Somehow the knock had kicked the collimation into perfect alignment, something that I had clearly failed to do properly before! There is a lesson here for all of us – no matter how heavy you think your telescope is, if strong winds are forecast then pack it away. I was lucky, you might not be. There is probably something to be said about making sure you achieve a good degree of collimation in the optics as well!

Having got it all back up and running, I still had some images to take for this book, including solar shots through a white light filter with a DSLR, a long-exposure shot showing the way the stars move around the north celestial pole (also from a DSLR), and a few shots with the CCD to demonstrate the tri-color imaging techniques.

One very important point to consider about a night's imaging, particularly if you need to set up your telescope having had it stored in a warm room, is to give it time to cool down. It is best to set up your telescope in the afternoon, which has two benefits: firstly it is easier to do when it is light, and secondly it will give the optics the chance to cool down to the ambient air temperature before the risk of dew formation. If you were to take it straight outside at night, then within minutes you would have dew on the warm glass surfaces.

With the telescope outside and set up as much as is possible in daylight, it is time to think about exactly what you wish to image later that night. In my case, obviously I need to start with the solar work when the Sun is as high as possible, but this goes for all objects – they are best imaged when at their highest so that atmospheric distortion is at its least. Planning the rest of the night-time imaging is a little more challenging as you need to think about what you want to achieve.

The best place to start is to make a list of the things you want to image and what equipment you will be using. That way you can schedule tasks so that they are manageable. A good example is that I wanted to take some long-exposure DSLR shots of the sky and also get some CCD images through my telescope. These clearly use different equipment so the two can take place at the same time. In fact, the only single common component in both is me, so I need to schedule the tasks so that I can attend to them both. The obvious solution is to kick off with the DSLR work, which needs to run for a couple of hours, and while it's running I can get on with the CCD work. When I am planning my night's work, I always sketch out how things will work based on the equipment I will be using.

With an understanding of the general order of things, I can then turn my attention to what I will be doing with the equipment. There are some tasks that need to be done first; flat fields, for example, as they are time critical because I use the twilight sky to produce my flats. I tend to leave the dark frames until the end of the observing run if the sky is clear as it keeps something for me to do should the clouds unexpectedly make an appearance. With the supporting frames for calibration scheduled in, I can start to build in a schedule of events:

1. Solar images through Vixen telescope using DSLR and solar filter.
2. Take flat fields with CCD, filter wheel and field flattener in place using the wide-field refractor.
3. Start 2-hour DSLR star trail image.
4. CCD imaging through wide-field telescope.
5. Finish off DSLR star trail images.
6. CCD imaging through wide-field telescope.
7. Take dark frames with CCD.
8. End of observation run.

It is a good idea to stick some rough times against these events if only because it gives you a gauge to when you will be working at imaging through the telescope, so that you can identify which objects should be targeted and in what order. The key times for an observing run like this are to capture flat fields at the onset of twilight and before the sky has darkened sufficiently for stars to become visible. This is usually during civil twilight, which starts when the Sun has set and ends when the center of the Sun is 6° below the horizon. (The time for the beginning and end of civil twilight can be found easily online for your location.) With this time frame in your schedule, you can start to plan the rest. Unless it is midsummer, I do not tend to start any imaging work until the end of astronomical twilight, when the center of the Sun has reached 18° below the horizon. Only then has the sky become properly dark and there is no light scatter from it. If it is the middle of the summer, then I tend to stick to planetary or lunar work where possible or alternatively wait for the sky to get as dark as possible before starting. Unfortunately, from my home in the UK, astronomical twilight never actually ends in the summer so deep-sky work is severely limited. Even the wonders of narrowband imaging only give marginal benefit at this time of the year.

▶ *Unless you have a large monitor, it can often be useful to have more than one computer screen so you can see all the software running – but be sure to cover them in translucent red plastic to help you retain dark adaptation.*

There is one other consideration in planning your observing that might not seem obvious but needs a little thought. Usually my advice is, where possible, to wait until objects are due south and therefore at their highest before imaging them. This means their light is travelling through the smallest amount of the atmosphere so the image will be distorted the least. However, when it comes to imaging with a German equatorial mount the position of the telescope must be considered. This is something that is only of consideration for the German equatorial style of mounts – fork mounts do not have this issue. If you point a fork-mounted telescope at an object on the eastern horizon, it will happily track it through south all the way to the west. A telescope fitted to a German equatorial mount would in theory track objects from east through south to west, but as it passes through the meridian (the imaginary line that passes from north, overhead and to the south) the telescope will get lower and lower and the counterbalance bar will get higher and higher.

There is a very real risk of the telescope hitting the legs of the tripod or pier, which can cause damage to your motor system. This is of no real consequence during visual observing as you will see the telescope getting lower and adjust accordingly. But if you are imaging, you might not be so aware of the telescope's position, so you need to remember that, at some point within an hour after an object passes through the meridian, your telescope will need to perform what is known as a "meridian flip." In performing the flip, the telescope simply points at the same object but from the other side of the mount.

When you are planning your observing run, you need to be aware of the location of the object in relation to the meridian. The best way of doing this is to take a look at a piece of planetarium software and watch the object over the duration of your imaging session, and if it will transit the meridian at some point then you should consider scheduling in a meridian flip. If, for example, you are imaging a faint region of nebulosity and need to capture five red subs, five green subs, five blue subs, five luminance subs and each one is 5 minutes long (for illustrative purposes only – in reality the color subs need to be longer than the luminance sub, as we discussed earlier in this book) then your total imaging time will 100 minutes or 1 hour 40 minutes. If you start your run just before the object is due south and therefore about to transit the meridian, then you should either perform a meridian flip after the set of green subs or, preferably, I would perform the flip before starting so that it has already moved to the other side of the mount. It is something to be aware of and the only real impact of not doing it is that you risk damage to your drives.

Useful software

Throughout the book we have looked at various bits of software but CCD AutoPilot is one of my favorites. With this wonderful piece of software you can automate any of your tasks that use a computer. If you are lucky enough to have an observatory that is computer controlled too, then you could even prepare a script in AutoPilot that will open the observatory, take all the images you need, complete meridian flips at the right time, and then close the observatory once it has all finished!

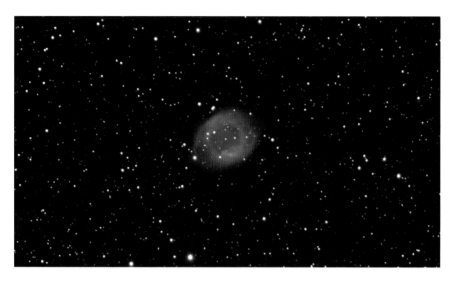

▲ *Most astronomical imaging software allows you to set up a sequence of images. This image of the Helix Nebula was formed out of 25 images (10 luminance and 15 for the color channels), all scheduled automatically.*

You may have realized that an important factor in planning your imaging is to work out how many minutes you are intending to expose for which object and with which filter. It may well be that you image one object over a few nights because either you are trying to get loads of data or you may have been beaten by cloud. Take time to plan all of this, taking into consideration the things we have looked at here, and you will find that you can make the most of your time at the telescope with clear skies. Eventually it will become almost second nature, but for now planning is time well spent. With all the things factored in, your imaging schedule may look more like this now:

14:00	Solar images through Vixen telescope using DSLR and solar filter.
16:45 – 17:15	Take flat fields with CCD with filter wheel and field flattener in place using the wide-field refractor.
19:00	Start 2-hour DSLR star trail image.
19:30	CCD imaging through wide-field telescope;
	5 × red subs at 5 minutes (California Nebula);
	5 × green subs at 5 minutes (CN);
	Meridian flip estimated about 20:20;
	5 × blue subs at 5 minutes (CN);
	5 × luminance subs at 5 minutes (CN).
22:00	Finish off DSLR star trail images.
22:30	CCD imaging through wide-field telescope.
01:00	Take dark frames with CCD.
02:00	End of observation run.

I would stress again that for illustrative purposes in this schedule I have put in a meridian flip halfway through collecting some subs of one object. In this example it would be much better to perform the meridian flip before starting, but in many cases that is not possible so you have to perform it when you can. I have sometimes spent all night grabbing narrowband images of just one object so a meridian flip is unavoidable.

With the plan in place, the time on the run up to the end of astronomical twilight as the sky gets progressively darker gives you a great opportunity to do a few tasks like check focus and connect your computer to your various systems. The focus should be pretty well OK, but be warned: if you have to adjust it too much then your flats will need to be reshot and if you, like me, use the twilight sky then you may well have to wait until the morning sky to get the replacement ones.

The next task is to connect up your computer system and you might think this is a quick and simple job, but as I have found out to my frustration it is a delicate operation fraught with things that can trip you up. You will recall earlier in this chapter that I referred to my power and USB distribution hub, which has software to control it. The hub runs off a 12-volt supply and after many hours of head-scratching I found that I had to power up and connect in a very specific order to make sure it worked reliably. To get everything connected, I have to complete tasks in a certain order:

1. Start up PC with the USB hub cable connected to the PC *but* without power applied to it.
2. Open up the hub software.
3. Apply power to the telescope mount.
4. Apply power to the hub.
5. Select "connect" on the hub software to connect the PC software to the hub.

After this, I can then turn on or off the power to all the other devices using the control software and connect the various other bits of software to their devices. The procedure then continues:

6. In the hub-control software I turn on the power to the Atik 314L+ CCD camera and the motorized focuser.
 (Note that because I have two telescopes mounted next to each other and sometimes use them in parallel, I actually have two motorized focusers. One of them is controlled by its own standalone controller, which draws power from the hub; the other has a controller that is integral to the hub so does not need external power.)
7. Open TheSky software and connect it to the telescope mount.
8. Open Maxim DL software and also connect it to the telescope via TheSky control system and then connect it to the two motorized focusers, to the filter wheel, the CCD camera, the guide camera.
9. Turn on the CCD cooling system and set the operating temperature.
10. Turn on the dew control systems to prevent misting up of the optics.

▶ *Hub-control software allows the author to control power to cameras and other devices, as well as the temperature of the dew straps and the focus to the Vixen VMC260L.*

I would heartily recommend noting down the order of your start-up procedure once you have found one that works for you. On a number of occasions I have started things up in the wrong order and found that I cannot connect to something, so to save you time, a good start-up procedure is worth its weight in gold.

With everything started up and connected, now is a good time to get your guide camera and drive calibrated. As you will recall, this is where your guiding software will activate the telescope mount a little in all directions so that it can monitor the amount of movement in images captured by the guide camera. This is an essential task so the guide software knows how much to nudge the telescope as it tries to keep the guide star centered. With the guide system working and with the sky nicely darkened, it is time to start imaging.

In the planning scenario we looked at earlier, you will remember that I was looking to get some DSLR shots of the polar region of the sky to demonstrate the way the stars moved in that region. Because this is going to run for 2 hours, it is a good idea to get it started and then leave it while working at the telescope. Having set up the DSLR on the tripod and attached the intervalometer, it must be configured to take 30-second-long exposures and, given that I'm after 2 hours of data, this means setting up for 240 exposures at 30 seconds each. I usually set up the DSLR well away from the telescope so should I need to use a torch, I can do so without affecting the exposures. With the DSLR snapping away, attention can then turn back to the telescope.

With the telescope all connected up to the PC, it is simply a matter of now entering the name of the object I will be imaging. In the case of the earlier plan the target is the California Nebula, so with it selected, the PC is told to send a command to the mount to slew over to the nebula. Assuming you are operating a Go To telescope, then for this automatic pointing to work the mount not only needs to be polar aligned but it also needs to know where it is on Earth (either from GPS signal or by entering latitude and longitude), what the date and time are, and also the location of a couple of stars in the sky against which it can work out the position of other objects. This alignment procedure needs to be done at some point before you can use the mount to slew to objects, but it will not affect the mount's ability to track objects across the sky. Depending on the type of mount, you can usually perform either a one-star or a two-star alignment, with a two-star alignment being the more accurate. Once you have chosen to perform the two-star alignment, it is simply a case of choosing a star from a menu on the mount's hand controller and then slewing the telescope manually to point at it, starting off with a low-power eyepiece to identify it. Once the star is centered, confirm it on the keypad and perform a second star alignment. After that, the telescope should know where everything else is.

If you plan to leave your telescope set up outside for a few nights, then it is a good idea to set a "park position." Park positions are used so that you save the alignment data and can turn the telescope on the next time you use it and it will still know where it is, as long as it is not moved while turned off. When you finish your observing run, you simply tell the computer to park the telescope, it will move it to the park position and then you turn it off. This will save time if you are using the telescope again the next night, but one thing you will still have to do again, if you have removed the camera, is to take a new set of flats. If you do not use the park position then you will have to repeat alignment the next night, but that is easier to do with an eyepiece so supporting flats will need to be done in the morning twilight. It is for this reason that if you have a run of clear skies coming your way then you may want to consider having it set up outside semipermanently, but protected from the elements.

With the telescope slewed to the object, select your clear or luminance filter and take a short exposure, perhaps 1 minute, so that you can check it is indeed centered in the field of view. Once the image has downloaded take a look at it, and if you cannot see your target object try stretching the histogram as we did in Chapter 5 (see page 127) to bring the object clearly into view. This step is not done with a view to using it as part of the final image but purely to make sure it is centered in the field of view. Having checked this, it is worth thinking about composition at this point and making sure that the camera is rotated appropriately so that the image is angled nicely in the field of view. For items that are long and thin, such as a number of edge-on galaxies, you may want to position the camera so the long axis of the galaxy runs diagonally across the field of view. Once it is centered and positioned well, then you can take a look at your rotation marks and make a note of them so that should you wish to come back to image the same object the following night or much later, you can easily rotate the camera to roughly the right orientation before you even start. Remember flats will be needed at this position.

Something I have always been diligent about is making notes of exposure times and other settings. For me, this comes from many wasted hours during the days of film photography where exposures lasted many hours, so if you tried to return to the same object but had no idea what exposures worked before, then you could be wasting quite a few hours of clear skies trying to get the right exposure again. Add on to this the days it used to take to get pictures back from the developers (before I turned my hand to developing my own film) and unless I had made notes, then it was hard to know which settings worked and which did not. It is easier today because of the instant results of digital cameras, but it is still good practice to make notes of settings for future use. Just what information to capture will depend on the camera being used. With a CCD camera I make a note of the following information: object,

Date	Time	Object	Telescope	Camera	Exposure	Qty	Bin	Filter	Notes
23-Nov-13	01:15	M51	80mm Starwave	Atik314+	10min	5	1	Luminance	Wind gusting 20mph
23-Nov-13	02:10	M51	80mm Starwave	Atik314+	5min	5	2	Red	
23-Nov-13	02:40	M51	80mm Starwave	Atik314+	5min	5	2	Green	
23-Nov-13	03:10	M51	80mm Starwave	Atik314+	5min	5	2	Blue	
12-Dec-13	22:10	M42	80mm Starwave	Atik314+	5min	20	1	H-Alpha	
12-Dec-13	23:50	M42	80mm Starwave	Atik314+	5min	20	1	O-III	
13-Dec-13	01:30	M42	80mm Starwave	Atik314+	5min	20	1	S-II	

▲ *Extract from the author's imaging logbook, which contains useful information about each image that will aid processing and future observing sessions.*

▲ Setting up a sequence of images is easy once you have the software configured correctly.

filename, telescope aperture and focal length, filter, exposure, CCD temperature and camera orientation. If I am using a DSLR through the telescope, then the settings are subtly different: object, filename, telescope aperture and focal length, exposure, ISO and camera orientation. It is good to get into the habit of recording this information from the earliest opportunity, as you never know when you may want to refer back.

Having oriented the camera and made appropriate notes as I work through the setup, the computer is tasked with taking the images that I am after. I use the scheduling feature in Maxim DL to grab the pictures, which leaves me time to attend to other tasks or even grab a warming mug of tea! You will recall that I mentioned the meridian flip, so halfway through the imaging run in my schedule I have a meridian flip planned and at the appropriate time I will perform this. This is a manual task meaning that I must reposition the telescope on the other side of the mount and recenter the object. There are third-party software items which will allow you to fully automate your imaging run, including sequencing in meridian flips at the appropriate time, but getting all of this to work well requires a lot of experience so it is best left for now. If you perform it manually, then keep an eye on your cables and accessories that are attached to your telescope to make sure they do not get trapped or hit against any part of the mount. However, if you have mounted everything properly and routed cables sensibly you should not have any problems.

I have been asked many times about meridian flips and whether the camera should be rotated following the flip – the simple answer is "no." Rotating the camera halfway through means you will need a whole new set of flats, so keep the camera where it is and you can deal with the fact that half of the images are "the other way round" when you align them for stacking after you have calibrated them. It is easy to visualize if you consider that the CCD camera and the image from the unwanted signals from dust, dark current, etc, will

▲ *Sunrise signals time for bed for visual observers, but for those taking astronomical images this is where the processing work starts and the hard work really begins!*

remain in the same place as long as the camera is not rotated. By performing the meridian flip, you will keep the noise in the same place with reference to the CCD – it is just that the image is the other way round. If you rotate the camera then you will need a different set of calibration files to accommodate.

At some point during your run, even though you diligently set up your dew-zapping solution, you may well find that the conditions are worse than you realized and dew has formed on the optics. Whatever you do, do not try to wipe it off. The best solution is to use a hair dryer on its lowest heat and power setting to blow warm air gently across the optics. This should dispel the dew, allowing you to continue, but not before you have increased the temperature of your dew straps.

Once you have the files all safely stored on your PC, all that is needed is to capture your dark frames. Remember to make sure that you keep the camera at the same operating temperature during this process. Also, do not forget to keep your telescope covered up while taking the exposures as dark frames with stars on them will cause you all sorts of problems. If you have built up a library of dark frames at the temperature you have been working at and at the appropriate exposure, then you will not necessarily need to do this.

Before you turn off all your imaging kit, there is one last important task, and that is to let your CCD warm back up again, so you will find that in most control software including Maxim DL there is an option to turn off the cooler and warm up the camera back to normal temperature. Whatever you do, **do not** just unplug or turn off your camera until it has warmed up and is close to the ambient temperature, otherwise you can mechanically stress the chip and risk damaging it. With the camera warmed up, it is now safe to move the

telescope to its park position, disconnect all devices from the computer software, turn them off and unplug. If you are leaving your telescope and mount outside, do not forget to remove as much of the equipment as you can, as I know from my own bitter experience!

There is an important consideration when putting equipment away, which can save you from hundreds if not thousands of pounds' worth of damage and it relates to dew and frost formation. If the humidity is high, you may well find your equipment dripping with dew, or if the temperatures are low, it may be covered in frost. While you are keeping the formation of dew at bay on your optics with dew zappers, the rest of the system can get really quite wet. Unless it is bone dry then it is very important to give it a chance to dry out before you pack it away, and the best way of doing that is simply to leave it in your house or garage, unpacked so that air can get to it. Leave it like that overnight and by the morning it should be dry enough to pack away.

With all that done, there is one final task that I always perform before turning in for the night, and that is to have a check through the image files. This is more relevant for DSLR imaging where there are many more variables, as you will find that throughout the evening you will have taken a few shots that are no good. These may have been where the focusing was slightly off or you needed to adjust the aperture or exposure a little. I usually take a quick scan through the images, delete the ones that are not needed, and make sure they are named properly and in sensible folders while the evening's activity is still fresh in my mind. Trying to sort through files a day or two later can leave you a little confused, so it is good practice to perform housekeeping on your files straight away after you have finished your observing run.

Hopefully, this chapter has given you a bit of an insight into a typical imaging run. In reality, things will occasionally be very different from one imaging run to the next, and despite all the planning in the world, sometimes you have to adjust your plans to suit the situation. You may find that the atmospheric conditions are too turbulent for high-resolution planetary imaging even though the forecast was good, you might run into problems with your guiding that requires your attention, or you may have computer problems. Whatever happens during your nights under the stars with your camera, the most important thing is to enjoy it. For me, and for many people, there is a real sense of achievement in not only capturing a beautiful picture but also the journey to get there. You will most definitely hit problems along the away but stick with it, be methodical, and before you know it you will be producing stunning images of the night sky and be able to share them with your friends and family. Who knows, maybe your pictures will then inspire others to turn their gaze skyward and wonder at the Universe above them.

appendix
COMMON AUTOGUIDING PROBLEMS

1. Telescope not moving during guiding

If you find that no guide corrections are being made then the problem will be either the software or the hardware. A good way to try and narrow down the problem is simply to connect telescope-control software like TheSky to the telescope mount without all the complications of guide cameras and additional settings.

A good proportion of telescope mounts allow USB connectivity, but there are still many, mine included, which run from the serial port of a computer. Unfortunately, most laptop computers no longer have serial ports so USB-to-serial-port converters are needed. When the computer starts up, it assigns a Com Port number to the converter and this can, rather annoyingly, change with every power-up. Take a look in the "control panel" or "settings" to make sure you are trying to access the mount via the correct Com Port. Once you are sure that you have the correct Com Port configured, try and connect to the telescope and see if your control software can command the telescope to move. The motors will only move by a tiny amount so you will not be able to detect it visually. Instead, put your ear close to the motors and try to listen for a change in noise as they speed up or slow down. If this still fails, it is very likely that it is the cable (or converter if you are using one) or the mount itself so try swapping them.

For guiding to work there is usually a cable running directly from the guide camera to the mount drive system – this is usually different to the cable used to control the mount from the computer. Now if the first test passed and you know the motors are working, try running up your imaging software and make some manual movements of the mount from the guiding window. This should use the guide camera cable to move the mount. If the mount only moves in one of the axes or in just one direc-

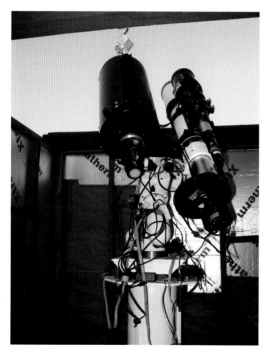

◀ *Poorly routed and managed cables are one of the main causes of guiding problems.*

tion, then it is very likely to be the cable at fault. If there is still no movement at all, it could still be the cable so check that you have the right sort. Be warned that although cables may have the correct plugs to fit in the sockets they may be wired up differently, so double-check you are using the right sort. Alternatively, it could be the software so make sure you have the software configured correctly.

2. Unable to find a guide star

Before doing anything with your guide camera, make sure it is focused. Unlike the camera that you are imaging through, adjusting focus on your guide camera is not a problem because flat fields are not used. If you cannot find a guide star it may simply be that your camera is a long way out of focus. Once you are happy it is focused, then make sure that you take an exposure before selecting to track. This is an important step for the software to be able to identify a guide star to track on – if you choose track without taking an exposure then the system will report "unable to find guide star." Try adjusting the exposure too – longer if you cannot see any stars or shorter if the stars are getting overexposed. Having tried all of these, then there should be no issue with locating a guide star.

3. Guide star seems to oscillate

You might find that the guiding corrections are being made but that the guide star seems to be constantly oscillating back and forth. If this is the case then it is more than likely that the calibration settings are wrong. There are a number of settings in Maxim DL and other pieces of control software – the first to check is the calibration time setting. Try increasing it as that will make the mount move a greater distance across the CCD chip during calibration. If it moved only a small amount during calibration then it may have calculated incorrect values to allow for good guiding. "Aggressiveness" is another setting that you should adjust – try reducing it to smooth out the guiding corrections. If you make it too high, then the guider will be trying to chase perfection when in reality this is never achievable.

4. Environmental issues

Balance and cabling are among the most common causes of guiding issues. A poorly balanced mount will cause the motors to have to work very hard when responding to guiding issues, or it may be that the telescope will drift under its own weight if not balanced properly. You may find that cabling will snag against the mount if left to hang, so make sure you have routed them and have them secured where possible, leaving enough lengths for the telescope to move. When securing cables, move the telescope by hand when switched off to see if the cables get pulled tight – if so, loosen them. Resolving both cabling and balance issues can instantly improve guiding performance.

INDEX

Page numbers in *italics* refer to illustrations or their captions.

afocal photography 69
altazimuth telescope mounts 17–18, *18*, 90
altitude 17–18
Andromeda Galaxy 50, 105, *105*, 108
Antoniadi scale 74
aperture 15–16, 23, 44, 46, 54, 57, 63, 66, 67
aperture priority mode 56
apochromatic telescopes 24
Ashen Light 86
asteroids 84
AstroTrac 48
Atik cameras *27*, *29*, 103, 115
atmosphere 69–71, 74
atmospheric dispersion of light 71
aurorae 54–6, *55*, *56*
AVI files 76, 83
azimuth 17–18

Baader AstroSolar film 63, 79
Bahtinov masks 36, *36*, 83, 98, *99*, 122
Baily's beads 66
balance systems 21, 88
Barlow lenses 72–4
Bayer matrix 33, *33*, 140
bias frames 100–1, *102*, 104, 125, 126
Big Dipper *see* Ursa Major
binning *117*, 118
blur filters 14
blurring filters 132
bulb exposure setting 43, *44*

calibration *see* image calibration
cameras 7, 12–16, 25–37, 38–41
 aperture 15–16, 23, 44, 46, 54, 57, 63, 66, 67

Bahtinov masks 36, *36*, 83, 98, 99, 122
Bayer matrix 33, *33*
blur filters 14
Canon 13–14, 16, 53, 59, 82
CCD (charge-coupled device) 7, 9, 12–14, *12*, 26–39, 58–9, 81–4, 94–7, 100, 103, 108–10, 117, 121–3, 126–7, 140–1, 146, 152–4, 157
CMOS (complementary metal-oxide semiconductor) chips 13
color filter wheels 21, *32*, *34*, 33–4
cooling systems 97
dark current 32, 125
dew shields 40
DSLR cameras 7, 12–16, 25–37, 38–41, 50, 80–5, 121, 146, 151, 155
exposure time 42–5, 46, 49, 62, 66, 67, 84, 98, 111–12, 120, 122
f/numbers 15–16, 42, 44, 46, 50, 54, 57, 60, 62, 66
film 8–11, *8*
focal length 12, 15–16, 46
guide cameras 34–5, 95, 96, 100, 112, 156–7
heaters 40
high ISO speed noise reduction 39, 40, 56, 57, 61
infrared blocking filters 15, 71, 71, 72, 83, 121
lenses 12, 15–16, 15, 40–1, 42, 58
live view 14–15, 43, 62, 65, 83
long exposure noise reduction 39, 44, 46, 47, 57, 61
mirror lock 40, 56, 83, 100

mono cameras 21, 26, 32–3, 109, 112, 113, 120, 127, 134
narrowband imaging 33, 113, 115, 119–20, 127, 138
Nikon 13, 14, 16
one-shot color cameras 26, 32–3, 71, 112, 113, 120, 138–9
Canes Venatici 31
Canon 13–14, 16, 53, 59, 82
Cassiopeia 49, 92
catadioptric telescopes 23, 24, 99
CCD (charge-coupled device) 7, 9, 12–14, *12*, 26–39, 58–9, 81–4, 94–7, 100, 103, 108–10, 117, 121–3, 126–7, 140–1, 146, 152–4, 157
 set-point cooling 32, 97
CCD AutoPilot 148
chromatic aberration 22, 24, 71
civil twilight 147
CMOS (complementary metal-oxide semiconductor) chips 13
color 6, 32–4, 113–23
color filter wheels 21, *32*, *34*, 33–4
Com Port numbers 156
combining images 131–8
comets 84
computer systems 150–1
constellations 45–50
cooling systems 97
curved field 25
curves 129–30
Cygnus 50

Daguerre, Louis 8
dark current 32, 125
dark frames 31, 39, 44, 46–7, 57, 97, *102*, 103–4, 122, 125
deconvolution 140–3

INDEX

deep-sky photography 20, 68, 73, 88–123
dew 40–1
dew heaters 41, 41
dew shields 40, 41
diffraction spikes 98, 99
digital development process (DDP) 140–3
digital photography 7, 11
Draper, John William 8
driven camera platforms 47–9
DSLR cameras 7, 12–16, 13, 25–37, 38–41, 50, 80–5, 121, 146, 151, 155
Dumbbell Nebula 105, 105, 120

Eagle Nebula 107, 107
eclipses
 lunar 62
 solar 66–7, 66
electronic focusers 35, 35
equatorial telescope mounts 17, 18–21, 19, 20, 24, 47, 89, 90
exposure time 42–5, 46, 49, 62, 66, 67, 84, 98, 111–12, 120, 122
eye 6, 114
 cones 6
 rods 6
eyepieces 20–1, 22, 25, 28, 47, 69, 81–2, 88–9, 91, 92, 93, 94, 98, 100
 eyepiece projection 81–2

f/numbers 15–16, 42, 44, 46, 50, 54, 57, 60, 62, 66
field derotators 18
field flatteners 25
film photography 8–11
finder scopes 80, 90, 91
FITS (flexible image transport system) files 135
flat fields 101–2, 102, 104, 125, 126–7, 147
flip-mirror eyepiece holder 108
focal length 12, 15–16, 23, 29–30, 39, 46, 58–60, 64, 68–9, 72, 82, 96, 109
focal ratio 15, 24
focusing 35, 35, 75, 97–100
frame rate 75
framing 109

gain 74, 75
Gemini 53
Gemini system 19
German equatorial mounts 21, 24, 89, 148
Go To telescope mounts 20, 94, 108
graininess 9–10
guide cameras 34–5, 95, 96, 100, 112, 156–7
guide scopes 23, 34–5, 88, 95, 96, 96, 100, 112, 120
guiding systems 10–11, 95–6, 156–7

Hale–Bopp, Comet 84
Helix Nebula 149
high ISO speed noise reduction 39, 40, 56, 57, 61
high pass filters 133
histograms, scaling of 127–9
Horsehead Nebula 107, 107
hub-control software 151
Hubble Space Telescope 87, 119, 142
hypersensitization 9, 10

illuminated reticule eyepiece 92
image calibration 100–4, 125–7
image composition 108
infrared blocking filters 15, 71, 71, 72, 83, 121
iNova PLA-C2 camera 72
International Space Station (ISS) 50–2, 50, 51
intervalometer 44
iOptron SkyTracker 17, 48
ISO speed 39, 40, 43, 45, 46, 50, 54, 56, 57, 60, 61, 62, 63, 65, 121

JPEG format 38–40
Jupiter 47, 68, 72, 73, 75, 86–7, 87

Lagoon Nebula 104
lenses 12, 15–16, 15, 40–1, 42, 58
Leo 53
light pollution 44–5, 54, 126
linear scaling 127–8
live view 14–15, 43, 62, 62, 65, 83

log scaling 129
long exposure noise reduction 39, 44, 46, 47, 57, 61
Losmandy G11 equatorial mount 19, 49
low pass filters 132
LRGB images 116–17, 119, 127, 135, 137–8, 142–3
Lucy–Richardson method of deconvolution 142
luminance 114, 116–17, 118–19
lunar eclipses 62
LX200 fork mount 21

M13 globular cluster 106, 106
M15 globular cluster 36
M51 see Whirlpool Galaxy
M81 galaxy 106, 106
M82 galaxy 106, 106
Magic Shutter 51
Mars 86, 86
Maxim DL 37, 98, 103, 111, 116, 125, 127–43, 153
Meade LX200 fork-mounted telescope 21, 93
median combining 112
Mercury 85–6, 85
meridian flips 148–50, 153–4
meteors 45, 52–4, 52, 53
microns 29
Milky Way 38, 48, 50, 97
mirror lock 40, 56, 83, 100
mono cameras 21, 26, 32–3, 109, 112, 113, 120, 127, 134
Moon 8, 12, 29, 54, 58–63, 58, 59, 60, 61, 68, 68, 69, 79, 81, 82, 82, 85, 85
mosaics 59, 109, 122–3, 122
Mylar 63, 79

narrowband imaging 33, 113, 115, 119–20, 127, 138
NASA 50, 138, 142
Neptune 87
NGC 7000 see North America Nebula
NGC 891 galaxy 106, 106
Nikon 13, 14, 16
noctilucent clouds 56–8, 57
noise 13–14, 31–3, 39, 40, 44, 46, 47, 56, 57, 61, 103, 131, 142

North America Nebula
(NGC 7000) *113*, *114*, *116*,
121, *122*, *123*

off-axis system 96
one-shot color cameras 26,
32–3, 71, 112, 113, 120,
138–9
Orion *46*, *47*, 50
Orion Nebula 6, *7*, *101*, 105, *105*,
109, 119, 125, 135

park position 152
Pegasus *36*
Pelican Nebula 9
periodic error correction
systems 93
Perseus 53
Philips ToUcam Pro 28, 72
photography
 aperture 15–16, 23, 44, 46,
 54, 57, 63, 66, 67
 daguerreotypes 8
 digital photography 7, 11
 exposure time 42–5, 46,
 49, 62, 66, 67, 84, 98,
 111–12, 120, 122
 film photography 8–11
 focal length 12, 15–16, 23,
 29–30, 39, 46, 58–60, 64,
 68–9, 72, 82, 96, 109
 focal ratio 15, 24
 focusing 35, *35*, 75, 97–100
 graininess 9–10
 guiding 10–11
 hypersensitization 9, 10
 image calibration 100–4,
 125–7
 image composition 108
 image processing 124–43
 reciprocity failure 9
 "wet collodion" process 8
Photoshop 37, 47, 50, 116, 125
photosphere 65–6
pinpoint astrometry 136
pixels 29, 71, 103, 118–19, 124
planetarium software 108, 109,
122, 148
Pleiades Cluster 107, *107*
point-spread function (PSF) 142
polar alignment 17, 19–20, 42,
48–9, 74, 90–4, 112
polar scopes 48, 49, *49*, 92

Polaris 17, 19, 42, 43, *45*, 48,
49, 91
Ponzo illusion 12, 58

quantum efficiency (QE) graphs
115, 117

RAW format 38–40
rear-cell focusers 99
reciprocity failure 9
reflecting telescopes 22, 24, 99
refracting telescopes 22, 99
RegiStax 37, *37*, 70, 76–9, 83,
125
RGB images 115, 135, *136*, 137

satellites 50
Saturn 87, *87*
scalable dark frames 126
seeing 70, 74
set-point cooling 32, 97
SharpCap 37, 74
signal-to-noise ratio (SNR) 113,
134
skyglow 45, 50
smartphones 50–2, *51*, *68*,
69–70, *69*
solar eclipses 66–7, *66*
Solar System photography
68–87
solar wind 54
Sombrero Galaxy 107, *107*
Sony ICX285AL chips 115, 117
speed *see* focal ratio
sporadic events 52
star alignment 94
star trails 42–5
Sun 54, 63–7, *64*, *65*, *66*, 69,
79–80, 82, *83*, 85, *85*
sunspots *54*, 64, *83*

T-adapters 25, 71
telescopes 12, 16, 17–25, 59,
68–9, 71, 72, 88–94, 146–8,
156–7
 altazimuth telescope
 mounts 17–18, *18*, 90
 aperture 23
 apochromatic telescopes 24
 balance systems 21, 88
 catadioptric telescopes 23,
 24, 99
 curved field 25

equatorial telescope
 mounts 17, 18–21, *19*,
 20, 24, 47, 89, *90*
eyepieces 20–1, 22, 25, 28,
 47, 69, 81–2, 88–9, 91,
 92, 93, 94, 98, 100
field flatteners 25
focal length 23, 29–30, 68,
 96, 109
focal ratio 24
fork mounts *21*
German equatorial mounts
 21, *24*, *89*, 148
Go To telescope mounts 20,
 94, 108
park position 152
reflecting telescopes 22,
 24, 99
refracting telescopes 22, 99
wide-field refractor
 telescopes 24, 31, 81
TheSky (software) *110*, 122
ToUcam Pro *see* Philips ToUcam
Pro
tracking systems 17, 48
tri-color imaging 113–23
Trifid Nebula *119*
tripods 16–17, *16*, 50, 61, 84,
148
twilight *see* civil twilight

unsharp filters 133
Uranus 87, *87*
Ursa Major 42, 43, 48, 49,
91

Vega 91
Venus 86, *86*
Vixen VMC260L telescope *23*,
73, 92, *151*

weather conditions 69–71, 74
webcams 28, *28*, 70–80, *70*,
71, 83
"wet collodion" process 8
Whirlpool Galaxy (M51) 11, 31,
109, *112*, *117*, *124*, *128*, *131*,
132, *133*, *134*, *140*, *141*, *143*
wide-angle lens 42, 53, 56
wide-field refractor telescopes
24, 31, 81

Xi Ursa Majoris 118